KU-315-608

In the Studio

Visits with Contemporary Cartoonists

Todd Hignite

Yale University Press New Haven and London

Copyright ©2006 by Todd
Hignite.
All rights reserved.
This book may not be repro-
duced, in whole or in part, in-
cluding illustrations, in any form
(beyond that copying permitted
by Sections 107 and 108 of the
U.S. Copyright Law and except by
reviewers for the public press),
without written permission from
the publishers.

Designed by Sonia Shannon.
Set in Scala Sans by BW&A
Books, Inc.

Printed in China
through World Print.

Library of Congress Cataloging-
in-Publication Data
Hignite, Todd.
In the studio : visits with
contemporary cartoonists /
Todd Hignite.
 p. cm.
Includes bibliographical
references and index.
ISBN-13: 978-0-300-11016-6
(cloth : alk. paper)
ISBN-10: 0-300-11016-2
(cloth : alk. paper)
1. Cartoonists—United States—
Interviews. 2. Comic books,
strips, etc.—United States—
History and criticism. I. Title.
NC1426.H54 2006
741.5'9730922—dc22
2006003353

A catalogue record for this book
is available from the British
Library.

The paper in this book meets
the guidelines for permanence
and durability of the Committee
on Production Guidelines for
Book Longevity of the Council
on Library Resources.

10 9 8 7 6 5 4 3 2 1

R46494P0084

LEEDS COL OF ART & DESIGN

R46494P0084

9/10/06

741
LRC
S

R4b494

In the Studio

If, for the future, he would choose

a less frivolous subject and restrict

himself a little, he would produce

things beyond all conception.

Johann Wolfgang von Goethe on

Rodolphe Töpffer's early picture-

stories

Contents

Acknowledgments

First and foremost, thanks to the nine cartoonists profiled in this book. Their great generosity with knowledge, time, and artwork, and their patience in the face of interminable nettling, made the entire project possible. This book is a testament to their art and its endless richness.

My special gratitude to Daniel Clowes, first to agree to be visited in his studio, and to Chris Ware, who kindly put me in contact with Yale University Press.

Thanks to John Kulka, senior editor at Yale, for his initial enthusiasm and for expertly navigating this project to completion, and to Dan Heaton, senior manuscript editor, for his guidance and perceptive suggestions. My introductory text and artist biographies have been immeasurably improved as a result of their input, along with the comments of the anonymous reader.

For reproduction assistance, again, primary thanks to each of the nine artists featured, who provided the vast majority of images. In addition, Glenn Bray lent photographs for a number of beautiful original artworks from his collection, and this book is a great deal richer for them; I couldn't be more grateful. I also thank the following charitable souls for helping in one way or another with images: Denis Kitchen; Eric Reynolds and Paul Baresh of Fantagraphics Books; Chris Oliveros, publisher of *Drawn and Quarterly;* John Kuramoto; Philip Nel; Alvin Buenaventura; Monte Beauchamp; Peter Maresca; Bruce Mohrhard; Gary Johannigmeier; and for a substantial amount of early image-production help, Dan Zimmer.

Thank you to Denny and Sandra Hignite, for everything.

My ultimate thanks go to Sara Hignite, my patient wife, who helped immensely with every aspect of this book, throughout its conception and realization, and to whom the whole enterprise is dedicated.

Each chapter is derived from an interview conducted by the author with the featured cartoonist in his studio on the following dates: Robert Crumb, June 28, 2005; Art Spiegelman, March 25, 2003; Gary Panter, April 14, 2005; Charles Burns, March 26, 2003; Jaime Hernandez, March 15, 2005; Daniel Clowes, August 6, 2002; Seth, February 27 and 28, 2004; Chris Ware, February 27, 2003; Ivan Brunetti, February 19, 2005. The texts were subsequently edited by both the author and the interviewee.

Shorter versions of five of these chapters—those devoted to Charles Burns, Daniel Clowes, Seth, Art Spiegelman, and Chris Ware—were originally published in the magazine *Comic Art;* they were all significantly expanded in 2005 for this volume. The chapters on Ivan Brunetti, Robert Crumb, Jaime Hernandez, and Gary Panter were created especially for this book and appear here for the first time.

Unless otherwise noted in individual captions, all photographs of artwork come from the collection of the artist being interviewed or from that of the author.

Introduction

The history of any given art form is usually written first—and often best—by its foremost practitioners. While artists extend the possibilities of a medium by reinterpreting and expanding on the past, they also provide obvious (and not so obvious) background clues for their work; frequently they are the most insightful historians, passionate archivists, attentive readers, and articulate commentators regarding both contemporaries and predecessors, known and obscure. This book takes studio visits with nine of today's most inventive, imaginative, and rewardingly complex English-language avant-garde cartoonists—Robert Crumb, Art Spiegelman, Gary Panter, Charles Burns, Jaime Hernandez, Daniel Clowes, Seth, Chris Ware, and Ivan Brunetti—as an entryway to broader understanding of their wide-ranging achievements. That illumination in turn casts light on the world of contemporary graphic novels in general, and on the diverse, frequently underdocumented history of the comic medium.

The nine artists included represent peak accomplishments of non-genre approaches to the art form over the past forty years. Though the artists possess vastly divergent goals, certain common characteristics are revealed in the overlapping themes, unifying sense of history and craft, and surprising affinities recurrently stemming from seemingly oppositional aesthetics. These cartoonists are all storytellers, and at their best, contemporary comics convey expansive and layered visual narratives, which beautifully implement every available formal device and historical precedent in the service of externally or internally unfolding events (however poetically discursive), all in a manner

unique to the comic language; the recent history of the form has been marked by continual experimentation, but rarely for its own sake.

Without overemphasizing direct causal lines of influence, we can derive from these studio visits context for nine of the most complex visions in any medium, a framework that provides a deeper insight and fuller picture of the circumstances behind and the choreography and realization of the artistic process. The resulting portrait, forged through an interplay both within each chapter and between the chapters themselves, reveals subtle but telling clues as to how aesthetics are born, shaped, and realized within a laboratory of ideas, inspiration, and previously unspoken connections across comics and related artistic production. Variegated layers unfold of a history fraught with the weight of sharply differing opinions as to function, possibilities, and limitations. Though artists may be sometimes a bit reluctant to comment specifically on their own work and its underlying themes, these cartoonists are among the most enthusiastically insightful and enlightening guides to the art form's sprawling past (by necessity in many instances since critical and in-depth examination of the medium's history is still a young field), and a great subtextual sense of their own aesthetic bubbles to the surface. Particularly in as self-aware and relatively young a medium as comics, its most sophisticated art represents *the* history, constantly looking back while simultaneously pointing forward, and in well-digested and transmuted form, all of these cartoonists reference forebears in myriad, often intuitive, ways.

One of the most distinctive themes to emerge in these conversations is an emphasis on eccentric visions, rather than any sweeping claims regarding historical movements or styles. The empathy with and respect for often wrongly forgotten or unjustly dismissed artists instructively reinterpret and complicate received wisdom regarding the merits of past mainstream commercial comics created in radically different social, economic, and cultural climates. Possessed of a pointed appreciation for the individual creator's goals, limitations, and achievements, practitioners provide the keenest insight into all forms of comics (comic books, newspaper strips, gag cartoons, caricature, woodcut novels, illustrated books) and their use in numerous other contexts. Anecdotal or fine-tuned formal analysis, these comments illuminate the creative process and chart a pantheon of often ephemeral, bittersweet histories. Such revelatory interpretations of the medium's peculiar spark both deepen our readings of the artists' own work and provide a fresh entrance into the formal mechanics of comics and how the medium manages to achieve its often contradictory, frequently jarring, and strangely poetic resonance.

Each studio visit then affords an idiosyncratic view of specific strains of comics, and each, with its particular focus and interlacing detours, proved happily impossible to plan or structure in anything resembling a firm way. This unpredictable, roundabout nature, evident from the outset, brought on the realization that the overlapping, complementary, and disparate threads heightened and juxtaposed throughout are telling on numerous levels, and together weave a narrative that resonates on more layers than could have been anticipated. The combination of potent imagery and insightful, often humorous commentary provides a good sense of the complexity of the art form's "visual writing," an image-text dialogue at the core of this book's structure.

Although the text is the result of "in the studio" conversations conducted in a manner similar to a traditional interview, my focus (and interest) was always on foregrounding the work itself; such a behind-the-scenes look at individual objects, rather than a predetermined agenda, dictated the direction and tone of each chapter and proved much more revealing of the creative

process and overall informing aesthetic than a standard interview. To varying degrees, these artists are collectors themselves, so the process of creating is intertwined with other art: the working studio is also library, archive, and museum. Since the emphasis here is indeed on the art, I would urge all readers to consult the accompanying bibliography and seek out everything available by these cartoonists. This book serves as an introduction to nine singular bodies of work and augments what has been understood to be the history of the comic medium; it is no substitute for the comics themselves.

I should also stress that while each artist from this small group was chosen for his highly individualized aesthetic, immense contribution to the art form's present and future, and strong connection with the past, the field is richly diverse, and these are certainly not the only artists doing important work. But by crafting movingly dense narratives, heightened by manipulation of the many formal intricacies—those subtle but crucial elements unique to comics, located somewhere between image and text—and informed by an embrace of the medium's history, the artists highlighted here represent undeniable pinnacles of the form. Because of their groundbreaking work, future generations face a boundless terrain to explore. It should be noted as well that to a great degree the cartoonists included have a deep respect for one another's art and in many cases would no doubt list one another among their inspirations. I took this as somewhat of a given and, while the artists in the anthology are occasionally mentioned instructively in other chapters, I attempted to explore more obscure and less immediately apparent interrelationships, thus avoiding obvious repetition in these discussions.

Through variable and divergent paths, the goal of each studio visit—and of the book collectively—is to delve deeper inside the abundant past of comics by accumulation of cross-references, affinities, and shared points of reference, while also expanding discussion beyond an accepted insular history to arrive at a new, complicated and nuanced portrait of the language and of its remarkable, and frequently misunderstood, formal grammar. These chapters offer a reexamination of previous modes of comic making through the eyes of the first generations of fully autonomous artists to work in the medium, and an illumination of their own justly celebrated work through immersion in the art integral to its formation.

> The fractured surface of the comics page, with its
> demarcation into different images, shapes, and symbols,
> presents the reader with a surfeit of interpretive options,
> creating an experience that is always decentered,
> unstable, and unfixable.
> —CHARLES HATFIELD

> God is in the details.
> —LUDWIG MIES VAN DER ROHE

Comic books tell stories through boldly inked and often clearly defined lines and images, graphically contouring forms, characters, and events that may seem obvious at first glance. But there is no verisimilitude in this highly symbolic language. Comics are mazes, ambiguous labyrinths of slowly accreting significance, disjointedly registering through minor, frequently nonlinear bursts of visual and textual information, and partially remembered, often falsely occluding details from the medium's past. The language's tightrope walk of word

and image, nervously skittering above the chasm of illustrated text and captioned illustration, operates in a manner dissimilar to any other visual medium, and the interplay between—and balance of—the two is the obvious key to comics as a unique art form. The varied formal and conceptual approaches on display here broaden awareness and shed light on comics' essential in-between nature, which the best work rigorously explores as an integral source of its art: in between text and imagery, single iconic image and narrative sequence of panels, immediate clarity and nebulousness of "meaning," unfettered artistic expression and past market-driven straitjacket.

While these nine cartoonists fondly look to the inventiveness of newspaper comic strip art from the medium's golden age (the early 1900s through the 1930s), replete with highly personal visions brought to glorious fruition in the large-format Sunday page, their work is undeniably and profoundly informed by the joys and confusions of reading genre comic books as children. The humble pamphlet's influence is immediately apparent in a critical approach to storytelling devices and recontextualization of character types, but more fundamentally so in an ingrained fascination with an intuitively conceptual approach to the comic language as a whole. This is a direct reflection of the young reader's attempts at deciphering curious disjunctions of meaning and conflicting messages evinced through peculiar combinations of art and narrative voice, whereby a broad style of rendering often mythic archetypes is undercut by the language's complex narrative effect, which begged for penetration, a rippling of its cool, cheaply printed mechanical surface.

The nature of the commercial comic book's predominant breakdown of every responsibility (plotting, dialogue, lettering, and penciling and inking backgrounds, main characters, secondary characters) has historically led to a good deal of highly inventive, beautifully crafted artwork, and bizarre, powerfully resonant iconic imagery, particularly in the pioneering improvisation in the early days of the format, yet it has precluded to a great degree fully realized works of art—which of course was never the goal. But in their myriad subtexts and flashes of roundabout insight, these elliptical tales of superheroes, funny animals, wisecracking teenagers, sweaty criminals, and outer-space adventurers sometimes achieved just that, and inspired many young readers to find art by sifting through their texts and subtexts, searching for comics' poetic core. The complicated, mechanical storytelling and unique formative power of harsh imagery and violent, off-register hues bleeding through from the backs of pages indelibly brands impressionable minds, and in their mature work these cartoonists heighten and exacerbate such tension between ingrained symbolic depth and the page surface's rigidly ordered boxes.

So it is no wonder that the best contemporary comics are characterized by a richly multileveled approach, translating the fertile wellspring of complex childhood interaction with genre entertainment—whereby the goal of maximum salability collided with coded personal voice—into adult manipulation of the form (and its multiple necessary skills) for artistic ends. It is also then no wonder that the studio visits presented here produced the odd combinations and detours found in these wonderfully varied wanderings. Past market constraints as discussed in these conversations are additional layers, crucial background elements that play on the collective memory of what the form has subconsciously been thought to represent; themes of difficulty, struggle, and obscurity dot reminiscences of overlooked craftsmen and frustrated artists alike. For the attentive reader, subtle whispers and recurring clues to such underlying sensibilities emerge, primarily through an ingrained devotion to the vanishing craft of cartooning (particularly when surprisingly epitomized in the humble knock-off, copy, or fake)

and its necessarily obsessive attention to detail, a humorously tempered melancholy regarding the comics' industrial roots. Unceasing invention is informed by an internalized understanding of this historical spark of the language, its traditional function, and the way in which deceptive meaning is derived in small doses often through mannered means. On one level the form of this book and content of the interviews constitute a tribute to this undeniable power and flexibility of the comic language.

With underlying differences in approach, goal, and effect, the work of each cartoonist in this book is shaped by the diversity of disciplines and histories that they look to, encompassing endless types of drawing based on caricatural shorthand, innumerable modes of fiction and journalistic writing, and graphic design from all periods—but most important, the in-between nuances, their offshoots, and that amalgamated effect not found outside of comics. Each is a master at exploiting every element of the language (storytelling flow, timing, pacing, place, design, and packaging, and all overlapping shades), unpredictably manipulating single components to play off others. The heart of comics is a singularity collaged and transformed from clipped external elements; conceptual sophistication, formal experimentation, narrative invention, and a highly honed craft tradition are the constant.

While cartoonists must exploit multiple disciplines to realize their work, the best comics, perhaps more so than any other art form, rely on a gradual accumulation and interplay of deceptively revealing suggestion, seemingly unrelated snippets, discordant detours into humorous "light" incidences, partially hidden clues somewhere between writing and drawing, convoluted relationships, contrasts, and details, fragments both formal and conceptual, textual and visual, to achieve their resonance within such a symbolically loaded and complex system. Larger themes are manifested through the build-up of subtly relevant minor chords, connections revealing themselves in a manner of expression unique to comics' mysterious voice. The ambiguous nature of the language has always functioned in this manner: meaning as ordered through individual sequential panels is inherently fractured, so both underlying concepts and overall essence coalesce as in no other medium, begging to be deciphered, even in the most seemingly straightforward and innocent narrative.

These studio visits come to life within such a web, wherein seemingly casual bits of information add up to create a genuine portrait of the deep, fundamental nature of an artist's work. Nothing is trivial, everything resonates with "prayer," as one of Jaime Hernandez's characters observes; "God" is indeed in the details, and nothing is insignificant, everything is a clue in an art full of splintered meaning and uncertainty. This is where comics' flickering poetry resides. Single, authoritative voice is forgone in favor of decisive cross-sections, modest but expansive emotion is arrived at through intricate formal rigor; as in any art form, the multivalent medium of comics is in large part the message. Profound insight into wildly divergent aesthetic goals is brought to light through a common inspirational source, a strange middle, which within comics' fundamental disjunctions somehow makes perfect sense.

Meaning in comics is a trembling indeterminacy, a potency of emotion that fluctuates and vibrates in and out of panel borders, not wedding but decisively welding form and content. Comics welcome such tenuous shades and elastic connections: this slow-burning, rhapsodic building toward the harmonious universal through accumulation, in the mind of the reader, of seemingly humble-in-import but masterfully composed hints of past lives, previously reined in, but no longer hampered in their full-blown expressiveness.

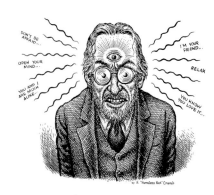

by R. "Harmless Nut" Crumb

b. 1943

1. Robert Crumb

Robert Crumb stands as the foremost artist of the past forty years to work in the comic medium. Two generations of cartoonists have looked to him as an ideological role model, both in terms of the expertly crafted realization of his aesthetic and, if not specific subject matter, then certainly his complete freedom of content, markedly lacking in concession or self-censorship. Nobody has been more significant to the move away from genre restrictions or commercial imperatives of any kind toward a personal vision than Crumb: his example of dogged introspection and total rejection of the medium's most egregious pandering to a juvenile market has provided encouragement to a generation of inventively autobiographical, socially engaged, and artistically committed cartoonists.

Following employment as a commercial artist, Crumb began his mature work at an early age with the explosive 1967 publication of *Zap*, the blueprint for the underground movement. With an absolutely id-emptying cocktail of drug-altered consciousness, anticonformity, cultural alienation, sublimated sex and violence, and the twin poles of spiritual transcendence and philosophical delusion, Crumb's command of storytelling subtlety, pacing, and characterization made apparent from the outset that the artist was not only a jaw-dropping prodigy but an astute pupil of the form. There followed staggering productivity in the late sixties through the early seventies, a tidal wave of groundbreaking reinventions of historical comic narrative and character archetypes, savagely transmogrified and regurgitated into the period's social upheaval. After the much-commented-upon, taboo-decimating first wave of underground creativity, Crumb's dissection of his newfound fame was to become a hallmark of his aesthetic; as in his re-contextualization of humble cartoon symbols, the fluid use of "R. Crumb" as character was exploited for unflinching autobiographical confession and to uncover the dynamics of his sexual obsessions, both colliding with his broadly merciless cultural critique.

Crumb's contrariness as a generational spokesperson and his lack of easily pegged position are crucial to his output as a whole: to lay bare and eviscerate the tangled

Robert Crumb, *Self-Portrait with Third Eye*, 2001. Copyright © 2001 by Robert Crumb.

Robert Crumb, "Cradle to Grave," *Mystic Funnies* no. 3, back cover, 2002 (Fantagraphics). Copyright © 2002 by Robert Crumb. Used by permission of Fantagraphics Books.

contradictions of the hypocritical mainstream social fabric and continue to explore the lot of a perpetually questioning, conflicted human being within this cultural hegemony is the essential and underlying component of all of Crumb's work. Deflation of the spectacle, in all meanings of the term, and lack of comforting resolution are constants, particularly in a story such as "I Remember the Sixties" (1981), which complicates and muddies overarching readings of the historical moment. That his art is not easily pinned down and certainly doesn't lend itself as illustration of any single theory is a testament to its continuing strength and relevance, and an exemplary aspect of the comic medium at its best; this is an unavoidably integral characteristic of his comics that has remained problematic for critics attempting—typically by taking elements out of context instead of bothering with the messy loose ends of multivalent art—to massage his unsparing worldview into a defined art-world or political camp.

Crumb worked steadily through the 1970s, and in 1981 he began editing *Weirdo*, an anthology of not only comics but also fringe writing and artwork, further demonstrating his allegiance to expression far removed from any mainstream definition of artistic merit. In the best tradition of satire, Crumb's art has always functioned on the micro and macro levels simultaneously, addressing a plethora of personal and political themes within a multiplaned narrative framework that rewards not only multiple readings but also a broader understanding of the history of comics, caricature, and the conventions of the language's artifice. His overriding distrust of high culture represents a complex, deeply personal statement regarding a society constantly and callously feeding on itself, filtered through a demanding and critically psychological self-reflection. Such introspection has been fully realized in his sketchbooks, which have always represented a major aspect of his oeuvre, and, like his comics, demonstrate the artist's highly analytical approach combined with the most impressive draftsmanship seen in the medium.

Crumb's work is a touchstone for inquiry into any aspect of serious contemporary cartooning. He continues to produce masterful work, both alone and collaboratively with his wife, Aline Kominsky-Crumb, an autobiographical comics pioneer and a highly important cartoonist in her own right. ■

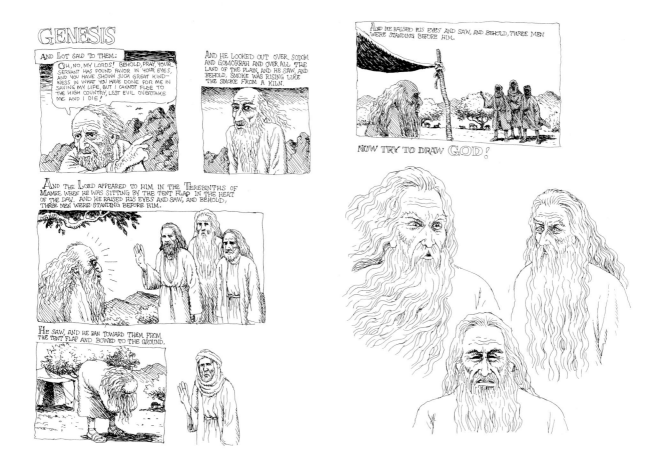

Robert Crumb, sketchbook pages for forthcoming Genesis adaptation, 2004–2005. Copyright © 2005 by Robert Crumb.

I'm going to be doing all fifty chapters of Genesis, including every word. Straight from the original—I'm not leaving out anything. I'm mixing three different translations from the original Hebrew: one is the King James Version, which I like for some of its English poetic aspects, and then a couple of Jewish versions from the Torah, which, in the early books, is very, very close to the Christian version; Genesis is almost word for word exactly the same. Modern Hebrew scholars have gone back and really studied the old Hebrew seriously and so therefore have gotten somewhat more specific meanings out of some stuff than was possible by the guys who did the King James Version in the 1600s, or whenever it was, Elizabethan times. But yet some of the poetic aspects of King James are nice; they always use the word *behold*. "Behold, I saw" this or that, and the new guys don't use that. It's very dramatic and, you know, biblical: "Behold!" So I kept that in, aspects of language like that.

I haven't broken down the whole thing yet, just a couple of pages at a time. [As of this visit, Crumb had completed the first four pages of his adaptation.] I don't know how long it'll wind up being, at least a couple hundred pages, something ridiculous—it's going to take me years. You have to break it down for illustration, you know; it's an interesting challenge, because for one thing, you have to read it very, very closely. Like, here it says: "And God made the two great lights, the greater light to dominate the day," obviously the sun, "and the lesser light to dominate the night and the stars." Now, you have to figure out, there's no comma after night, "night and the stars," so the lesser light is to dominate the night and the stars both, and you can tell when you read this very closely that they didn't understand when they wrote it that the sun made the light of the day. They thought the sun was just put in the light, that

the light was already there in the day; they didn't understand that the earth's revolution caused the sky to light up in the day. They placed the great light in the daytime and the smaller light in the nighttime with the stars: "God placed them in the vaults of the heavens to give light upon the earth and to rule over the day and over the night, to divide the light from the darkness."

So, you've got to do an extremely close reading. It's really interesting and full of surprises, what is actually in there when you read it closely. And you know, believers tend to gloss over the stuff that makes them uncomfortable or that they don't get. But it's in there, you know, so it's going to be illustrated, so . . . Like the fact that there are two different versions of the creation of man—one follows right after the other. First God creates man and woman, creates them both together at the same time. Then that part ends, and he gives them the animals to dominate and rule over. Then it begins all over again, saying that God creates man, just Adam by himself, then he creates the animals, and seeing that Adam is still kind of lonely, he creates the woman to keep him company. The scholars in the annotated version of the Torah, they explain that it's two different writers and they've combined two different versions of the creation story, just stuck them together. I'm just going to illustrate it as it's written—there's the first story, and then when it ends the second story will follow. I'll just illustrate it the way it's written.

The point is to do it literal, as it's written. And I had this problem for a long time: "How am I going to draw God?" In the EC version, the *Picture Stories from the Bible,* they don't show God, just this voice coming out of the sky or the clouds, because in the Jewish tradition you don't ever actually make an image of God, it's against the religion to make an image. But when you read Genesis, many times God is actually there talking to someone, God is an embodiment with a male image. At one point Abraham is sitting under his tent flap and three men approach him, and as they get close you realize that two of them are angels and one of them is God. And he talks to them, God appears and they talk and debate, and at one point he debates with Abraham over whether or not to save Sodom and Gomorrah. Abraham keeps saying, "If there's fifty decent people left in Sodom and Gomorrah, are you still going to destroy the cities?" God says, "Well, okay, if there's fifty decent people, I won't destroy them." Abraham then says, "Excuse me, I know I'm just a humble human being who doesn't understand these things, but what if there are forty people?" God says, "Okay, if there are forty I won't destroy them," and it goes all the way down to if there's ten [laughter]. "Okay, if there are ten decent people, I won't destroy Sodom and Gomorrah." So, God is on very familiar terms with them.

The old, severe patriarch with the long white beard is how everybody sees him, the Old Testament God: kind of Charlton Heston mixed with Mel Gibson, you know, with long hair and a beard. He's a very severe, scary guy, but has compassion and mercy in certain times. But he's tough, he's hard. There's one sequence outside of Genesis, it's in Deuteronomy, I think, where Moses and the Israelites are at the Jordan River, about to cross over and attack Jericho, but God is angry at the Mideans, these local people whose women had come over and given diseases to the Israelite men. So God tells Moses, "Wipe out the Mideans." Moses sends his army over there to wipe out the Mideans. He says, "Just kill them all and burn their cities." The Bible describes how they kill all the men and burn all the cities, then bring the women, children, and animals back to the Jewish camp. The army comes back with all these women, children, goats, and sheep, and Moses says, "What is this? God said kill them all. Why are you bringing back these people?" The general says, "Well, women and children?" And Moses says very angrily, "God said kill them all! But I'll let you keep the young girl virgins, but kill everyone else, all the boy children and all the women who have ever slept with a man." So they kill everyone else. God said to kill them all [laughter]. It's tough, hard-ass stuff. ■

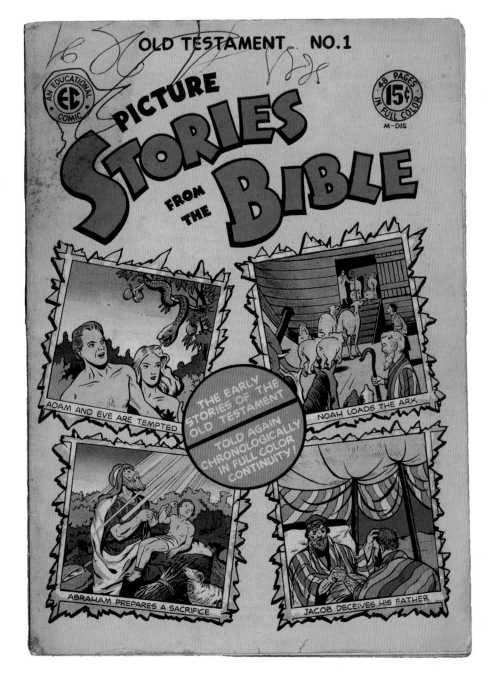

Picture Stories from the Bible
no. 1, 1946 (E.C.). Copyright
© by William M. Gaines,
Agent, Inc.

These E.C. versions aren't well done, the drawing's not very good, sloppily done. And they also just make shit up to gloss over and fill in whole passages. They have Eve saying, "Mmm, this apple tastes really good" [laughter]. If I'm going to be doing this and don't want some fucking Christian fanatics to kill me, I've got to say, "Look, it's all in there, I didn't change a single word, I just illustrated it as it's told." You know, "Onan is spilling his seed on the ground"—he's jerking off onto the ground; it's in the book, so I'm just illustrating what's there. It's not sinful, it's in your holy book. So, we'll see what happens. If they want to kill me or not. ∎

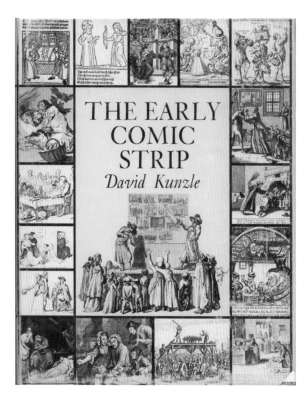

David Kunzle, *The Early Comic Strip: Narrative Strips and Picture Stories in the European Broadsheet from c. 1450 to 1825,* 1973 (University of California Press). Copyright © 1973 by David Kunzle/ University of California Press.

My awareness of this whole history was something that happened gradually, since that stuff is not available. Where are you going to see it? You'd have to go to some library that specializes in that and ask to look at it. It's not reprinted anywhere, and it's not known. So when I got that big book by Kunzle, it was a total surprise, how much material there was, and I'm sure that's still just a drop in the bucket, you know, what survived, what he could get his hands on, and what he could actually show—I'm sure he could have done twice as much. Some of them are so crude, those little, tiny postage stamp–sized panels of, like, husband-and-wife squabbles done in Russia or Germany or Czechoslovakia. Incredible stuff, but totally obscure. If you try to inform people in the art world about this history, they know nothing about it. A complete underground, unknown, history of popular art that the general art world knows nothing about. When Alfred Fischer, the curator of my show in Germany [at the Museum Ludwig in Cologne] came, I showed him this book and some other things and he was just speechless; it was all completely new to him. The crude, lowest level of popular arts. Who knows what existed before the beginning of printing? Before that I guess everything was done in monasteries or in cathedral nooks and crannies where they have all the gargoyles and stuff like that.

These first printed sheets were sold in the street for a penny, you know? The average people liked them and would laugh and get a kick out of them. They printed song sheets and cartoons and all kinds of stuff. Real crude songs, another real underground thing, these old ballad sheets with songs making fun of the king or the cardinal, some politician or whatever. All this stuff has existed since the beginning of print. An English guy that I got to know six or seven years ago, he wrote to me and sent me these working-class satire magazines that came out of England in the early 1800s, kind of Luddite working-class magazines with powerful, crudely drawn cartoons, kind of woodcut-type cartoons in them that you just never, ever see.

He said these things have never been reprinted, and they're like a level below stuff like George Cruikshank and that kind of thing, which is a little more middle class, satirical also, but slightly more polite. I started reading the text from these magazines, which is actually highly literate. I guess England was fairly literate by that time, the 1830s or '40s. The text was very interesting because it was directed at working-class people, so it was about kind of more gutsy subjects. Really interesting, but so buried and obscure. This guy that sent them to me is always looking for them but can only find copies one by one in piles of old prints in London or wherever, flea markets, one here, one there, never many in one place, that kind of thing. Incredible stuff.

All of this type of thing is just on a really low popular level, they're more lurid and raw than the polite stuff. You know, polite society was very oppressive on culture, always, up until modern times. Now that's all changed 'cause everyone thinks they gotta be a rebel and like hip-hop or something. In the old days, polite society had this idea of gentility and all that, which affected all the arts on the top level. "The top world," as one guy called it; he coined the term when talking about music: "top world" music and "underworld" music. I remember going to the Louvre once, and there were so many people waiting to get in I didn't even go in the museum, I only went into the postcard shop. Just thousands of postcards showing all the great works of art they have in there, and after a while it's just the same thing over and over: beautifully rendered, but the subjects are always treated with a kind of gentility, the poses are all very, like, sensitive and delicate, and the subject matter always has to be very touching and sentimental, 'cause that's what the upper classes wanted, that's what they demanded. They had, as they still do, pretentious ideas about what made something "fine," about what makes art fine or music fine. It had to express "fine feelings," you know? That's how they saw it. There was always kind of an interchange between the upper and lower classes culturally, but so much of it was just this—the people who were paying the most money and got the most skillful artists, you had to cater to their tastes, so, whew . . . When you find that underworld stuff it's very interesting because it doesn't have that; it's much more lurid, crude, and raw. That's the stuff that absolutely interests me—Brueghel and Bosch, and other less well-known artists, that's where you see those themes before printing. Some gallery in Austria wanted to have a show of my work and Brueghel's work, side by side. I said "no, no, no"—the comparison would start to reveal all the weaknesses in my work [laughter]. That guy could draw like God; I don't want to be put next to that. He's the best—nobody ever topped him as far as I'm concerned.

I went to see a Hieronymus Bosch show in Rotterdam a few years ago and, again, it was so fucking crowded that you couldn't get near the pictures at all. But I wandered into this one room where they had contextual stuff, other work from the period that was in sort of the same vein, and that was really an eye-opener. They had these things called fool's dishes, which were absolutely great: they were the size of an ordinary dinner plate, made out of wood with a painting in the middle and usually a red background, and black and white writing on the edge of the plate, some kind of little funny rhyme or folk saying. Every one had this wacky grotesque image painted in the middle, detailed, Bosch-style. God they were great. I really wanted one of those things: a fool's dish [laughter]. Low-class art of the time, but they were the popular art of the time, and appealed to ordinary people's sensibilities. It's all changed now in modern times. Just in our lifetimes it's changed. Look at the comic books that came out in the forties, they were just like that: crude, lurid, low-level, working class . . . all those artists came from working-class backgrounds, all of them. Jack Kirby and all those guys. They thought of themselves as entertainers, not *artistes*. Not like us [laughter]. ∎

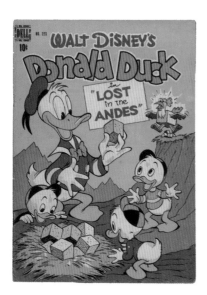 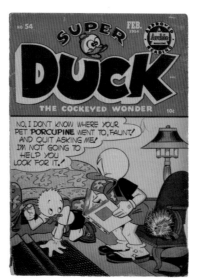 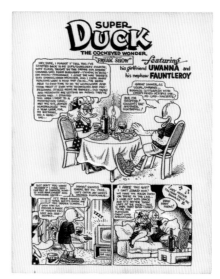

When we were kids, my brother Charles and I always saw [Carl] Barks's *Donald Duck* stuff as the finest, the top, and everything else had this crude knock-off quality to it. Yet at the same time, there was something in you that was drawn to stuff like that, *Super Duck*. There were even worse ones: there was this one called *Wacky Duck* . . . just *so* bad. Totally violent and vulgar [laughter]. The morality in those things: he's always smacking his kid, Fauntleroy. He's always hitting him, whacking him, slapping him really hard and stuff. God. And he's always trying to pull some scam, get something for nothing, and it always backfires on him. Real crude stuff. We seriously collected the better stuff, Barks and *Little Lulu,* and some of the other Disney titles, then as a sideline collected bits of *Terrytoons, Super Duck,* things like that, more casually. We weren't as serious about them. We always called Barks "the good artist" because nobody knew his name. We mostly looked at funny animal and humor comics and didn't look at the other stuff too seriously. I was never into superheroes at all, neither Charles or I was ever interested in them. Just the humor comics: funny animals and *Little Lulu.* Never liked *Archie* or any of that teenage stuff, either. It was only later that we discovered E.C. and got into that, then through that the older adventure and earlier horror comics, just for the artwork.

Since I've gotten to know Pete Poplaski, who's always been into the superhero genre very heavily, I've had a lot of discussions with him about it. We come from two different schools of comics, you know; I was into the humor stuff and he was obsessed with superheroes and adventure comics. He has a pretty interesting, in-depth analysis of the superhero

thing, although he's so into it he dresses up like Zorro. It's interesting, the different attitudes we come from; he was just never into humor comics as a kid. It's almost a different kind of nervous system that dictates it, a neurological difference. The kind of kids who liked superheroes wanted to be superheroes or emulate that, see themselves in that role or something. Some kind of Boy Scout thing . . . I don't know. Charles and I had this totally other attitude . . . it was almost like we were sissies in a way [laughter].

When we did our own comics, it was very intuitive and instinctive—we tried to emulate those we liked, and the humor comics just happened to have the best stories: those stories really stood out, and they still stand out. The humor comics of that period have the best storytellers—Barks and [John] Stanley. Some of the others from the period I now like, *Super Duck* or something, just for the wackiness of them; the subtext is so interesting. But at that time we quickly went through and lost interest in *Looney Tunes* or *New Funnies,* because the stories really weren't that good, weren't that interesting. Barks just stood out head and shoulders above the others. ∎

Carl Barks, *Four Color Comics* no. 223, 1949 (Dell). Copyright © 1949 by The Walt Disney Co.

Super Duck Comics no. 54, 1954 (Close-Up).

Robert Crumb, original art for "Super Duck the Cockeyed Wonder in 'Freak Show,'" splash page, *Mystic Funnies* no. 3, 2002 (Fantagraphics). Copyright © 2002 by Robert Crumb. Used by permission of Fantagraphics Books.

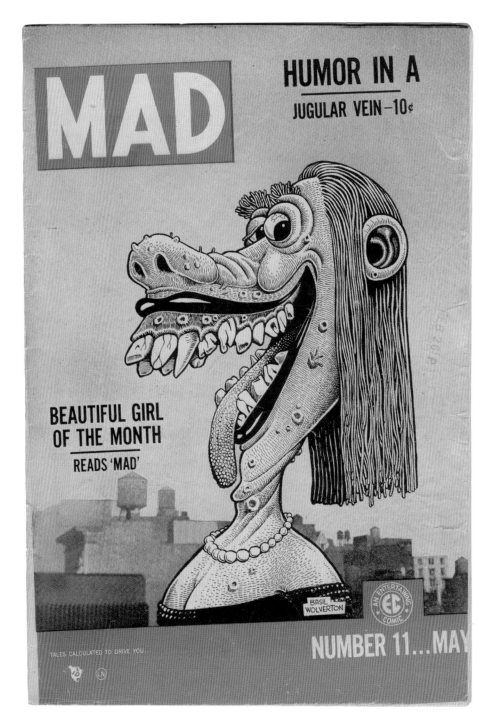

Harvey Kurtzman and Basil Wolverton, *Mad* no. 11, 1954 (E.C.). Copyright © 1954 E.C. Publications, Inc. All Rights Reserved. Used with Permission.

[Harvey] Kurtzman is one of my heroes. When I saw *Mad* at around ten or eleven years old, I didn't quite get it: "This is so strange. What is this about?" When he started doing those satires of real magazine covers, it was just incredible. It was the first time I'd ever seen satire; something actually making fun of something that was a serious institution in America. That was a real eye-opener. Of course, a lot of people who grew up in the fifties have said that— the fifties were pretty square, you know. I saw that parody of *Life* magazine on the newsstand and thought, *"Oh my God!"* Unbelievable . . . it was such a *violent* ridicule of *Life* magazine [laughter]. ■

Harvey Kurtzman, Will Elder, and Jack Davis, *Humbug* no. 2, 1957 (Humbug).

Robert Crumb, *Weirdo* no. 4, 1981 (Last Gasp). Copyright © 1981 by Robert Crumb. Used by permission of Last Gasp.

Robert Crumb, original art for *Weirdo* no. 16, cover, 1986 (Last Gasp). Copyright © 1986 by Robert Crumb. Used by permission of Last Gasp. Collection of Glenn Bray.

Robert Crumb, original art for *Weirdo* no. 21, cover, 1987 (Last Gasp). Copyright © 1987 by Robert Crumb. Used by permission of Last Gasp. Collection of Glenn Bray.

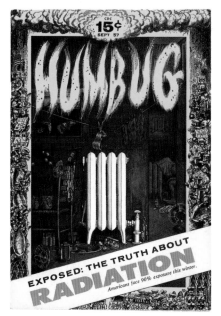

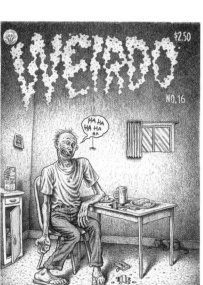 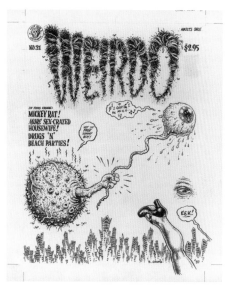

I enjoyed drawing those. I was competing with Kurtzman; I wanted them to be as good as those early *Mad* and *Humbug* covers. I wanted them to be right up there with those.

Those were the days you had to do everything with zipatone, or those contact sheets, Pantone colors. Boy, that was tedious to do all that color work, to cut it out with an X-acto knife and peel away the stuff you didn't want over a light table. Whew, it was a week of work just doing the color. Now I don't do anything like that, I just make a photocopy, spray mount it down on a thick piece of cardboard and watercolor it; a much easier process. ■

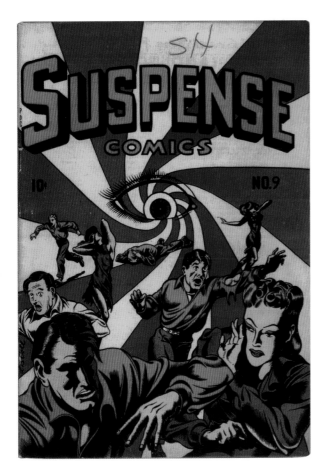

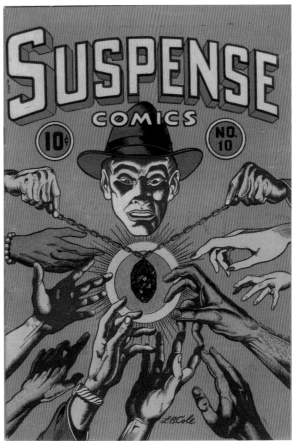

I love L. B. Cole. His early covers for *Suspense Comics* are really noir: spirals, figures falling down through space, big spider webs, just great. I was kind of too young for these when they came out—I was born in '43, so by the time I was aware of them, we already looked upon them as old comics. I started really seriously collecting comics when I was nine years old, around 1952, and so some of these were still around, but we weren't allowed to bring this stuff home. We had to look at these at the drug store or the Salvation Army.

The covers for these are great, but the insides for a lot of them are pretty terrible, not worth bothering with. Gil Kane, who knew Cole, told me that he worked very slow, too slow to do interiors, so he mainly did covers. They had to work fast to do that shit, it was all cranked out, hacked out. According to Kane, Cole was a real brute [laughter]. He was a rough character, and he was actually the manager of a comic sweatshop for a while, real rough and hard to deal with. The colors on these early ones are all totally primary: just bright red, blue, yellow, almost no subtle colors. Which is great—they really work, a really powerful form. I always wondered how much the artist had to do with the cover coloring. Kurtzman said they would get photostats of the covers, then watercolor the artwork to indicate the colors; the color engravers were these old German guys. ∎

L. B. Cole, *Suspense Comics* no. 9, 1945 (Continental Magazines). Copyright © by the estate of L. B. Cole.

L. B. Cole, *Suspense Comics* no. 10, 1945 (Continental Magazines). Copyright © by the estate of L. B. Cole.

Another guy that I liked from that period, though I don't think he did covers, was Jay Disbrow. Such a dark mood. I used him as a reference when I was in my brush period in the eighties, trying to do that same kind of dark tone. It's interesting because this work was coming out in the same period that the film noir thing was going strong and has that same darkness: the same kind of chiaroscuro lighting and all that stuff. Violent, despairing stories, just like a lot of those movies of the time . . . somebody's always falling down a vortex . . . [laughter] ∎

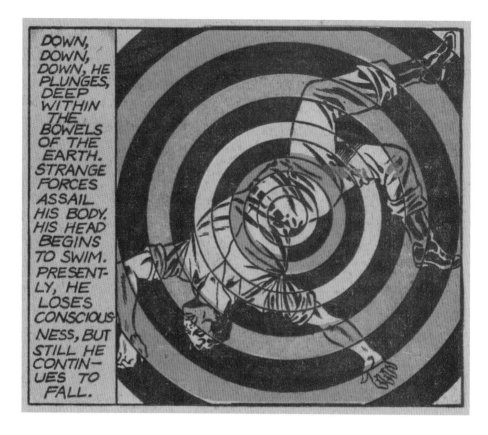

Jay Disbrow, "The Beast from Below," *Blue Bolt Weird Tales of Terror,* no. 112, detail of interior page, 1951 (Star). Copyright © by the estate of Jay Disbrow.

Jay Disbrow, "The Djinni of Bazra," *Blue Bolt Weird Tales of Terror,* no. 112, detail of interior page, 1951 (Star). Copyright © by the estate of Jay Disbrow.

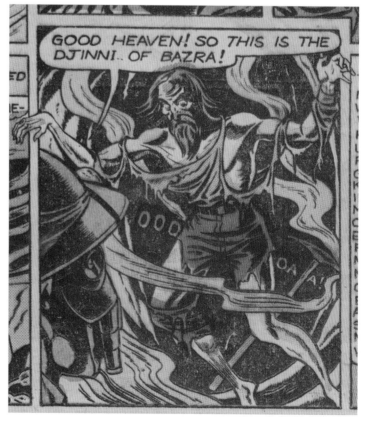

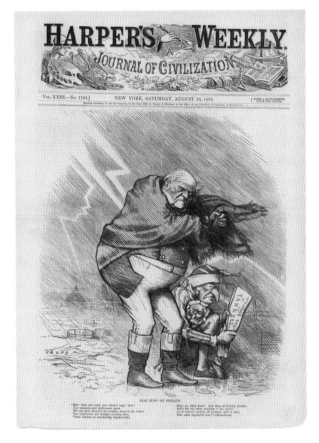

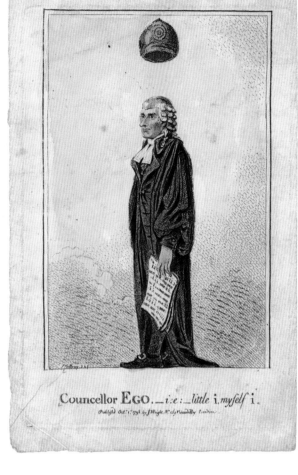

Thomas Nast, cover for *Harper's Weekly*, August 23, 1879.

James Gillray, *Councellor Ego*, hand-colored etching, 1798.

These are always about some specific incident, and you have to research the background. I have a book on [James] Gillray that explains the political specifics of each image; everything was very topical and he just cranked them out. Again, I discovered him much later, in the seventies. It was just not readily available when I was a kid: you're just a victim of whatever the current pop culture is when you're a kid, unless your parents are specifically into culture and guide you, which my parents didn't. They just watched TV—my mother read popular magazines and my father read the newspaper, that was it. We're all victims of history: what's buried, we're not exposed to. What's pushed in our faces when we're young and in school, that's what we get our background in, mostly. Unless somehow by some quirk of fate we end up having a very curious intellect, scratching below the surface.

The first one of the "old guys" I discovered was Thomas Nast, and I found his work through history textbooks, where they reprinted his stuff to represent whatever subject they were talking about from the period. It struck me instantly, partly just because of the wondrous crosshatching. But also the flavor of the time was so powerfully captured by his artwork, even if you don't understand specifically the topic, what the images are about. It's the same with Gillray: he captures his time so strongly, it doesn't matter that you don't know what it's about.

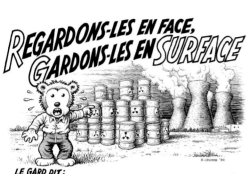

Robert Crumb, two illustrations for
projects related to the village of Sauve,
France, 1994, 2002. Copyright © 2002
by Robert Crumb.

I remember when I was about seventeen discovering in the back room of the library
these bound volumes of *Puck* and *Judge* from the nineteenth century. I started go-
ing every day to look at them, then began surreptitiously extracting some [laughter].
They were just so beautiful, I was totally amazed . . . all this buried stuff.

Nast's crosshatching was so inspiring to me, it's so powerful—there's so much
depth in the drawing, the way he does it. His crosshatching was more lively than
most of the other engraver-artists from the period. Probably a lot of credit goes to
the engraver, but I've seen some of his actual drawings the engravings are based on,
and he would crosshatch with a pencil pretty precisely to show how the crosshatch-
ing was to be done. The engraver was following his directions closely. Then later, in
the 1880s, when offset printing first came in, then you start to see Nast working with
pen and ink, and they're actually not quite as strong as the engravings in a way. The
engravings really pop right up, the black ink.

I tried crosshatching early when I was still living at home in my teens, and
I couldn't pull it off the way Nast did—I couldn't make it look as clean and nice.
Then I went through this phase in the mid-sixties with this vertical shading tech-
nique. I don't know what I was trying to prove, come up with some stylistic gimmick
or something, then I went past that when I began doing *Zap Comix*, being very
influenced by early cartoon strips like *Mutt and Jeff, Krazy Kat,* stuff like that. I was
very interested in making my comics look like that and intentionally kind of avoided
crosshatching. I was too intimidated to try crosshatching properly. That was the drug
period in my life, the late sixties and early seventies, and I think my drawing deterio-
rated through that period. It got worse and worse—by '73, whew . . . I look back and
it's really embarrassing, it's so badly drawn. Then I stopped smoking pot and taking
LSD and all that and I immediately got interested in drawing again for its own sake,
the technical aspects of drawing, and got interested in crosshatching again, really
got into perfecting crosshatching as much as possible. But it sort of bothers me to
look at my drawing from that period, the *Arcade* work and earlier. It was a couple
of things: one is that I was trying to meet the demand. There were so many small
publishers and they all wanted to publish my comics because my stuff sold well, so I
tried to help keep all these little publishers afloat. There were five or six of them, so
I was doing a lot of work . . . and all the drugs and all that, I just lost touch with the
actual drawing itself. I really did. I look at my sketchbooks from that time and the
drawing got really sloppy.

When I look back at my work . . . in '67, '68, I was so inspired by LSD that the
visionary thing was very strong. That's what really put my work over in the beginning
was the LSD inspiration. Then that kind of went away and I was kind of lost and con-
fused for a while there in the mid-seventies. Directionless . . . and the fame thing, my
life got so complicated . . . uggh, it was a mess . . . the ex-wife, the IRS. I have these
sketchbooks from that period in the mid-seventies and they're full of this, like, *ago-
nized* writing, reflections of what I should do and whether I should just quit trying to
do comics altogether. I was really lost . . . I was just lost there for a while. It was very
lucky for me that I stopped doing drugs; if I had continued to do drugs I would've
never found my way back. ∎

I picked up a lot of tricks of the trade, a lot of professional stuff, when I worked at the greeting card company. I didn't use any Wite-Out in those days: Strathmore paper was so good back then you could scratch it out with an X-acto knife and then draw over it and the ink wouldn't spread all over, the paper was so hard; later the paper was really inferior. Phoebe Gloeckner told me recently something that really surprised me—that Strathmore still makes that highest-quality paper, but you have to order it, you can't find it in stores, it's too expensive. When I first started using it in the early sixties at the greeting card company, it was all that quality. Then they gradually came out with two, then three different qualities, and then eventually stopped selling the best. I'm doing my Genesis comic on the back of bad, used comic pages from around 1960 on that nice Strathmore that I bought from a guy. There is humor comic art on the back, but I bought it for cheaper than the cost of new paper.

Partly why I think my drawing went downhill in the early seventies is because I was constantly trying so hard to keep up with that demand, and becoming real self-conscious of being a spokesperson for my generation and all that crap [laughter]. It was tough. All that debate, and the problematic sexual aspect of my work and all that, with the feminists and everything, it was all very confusing. I didn't know what the hell I was doing. And also that was the time when people were really talking about "the revolution," you know, so you wanted your work to be part of the solution, not part of the problem, and all that stuff. "Jesus, is this revolutionary enough?" "Gosh, I don't know." I remember when I was doing that "Pete the Plumber" story, thinking, "Hmm, I don't know, this isn't very revolutionary. This is too mystical, it's not really a practical outline or map for socialist takeover." I could never do overtly political stuff.

Robert Crumb, original art for "Lenore Goldberg and Her Girl Commandos," *Motor City Comics* no. 2, interior page, 1970 (Rip Off). Copyright © 1970 by Robert Crumb.

Robert Crumb, cover for *Yellow Dog* no. 6, 1968 (Print Mint). Copyright © 1968 by Robert Crumb.

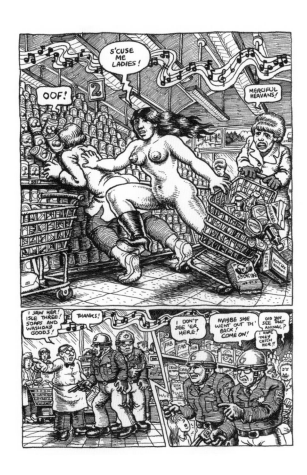

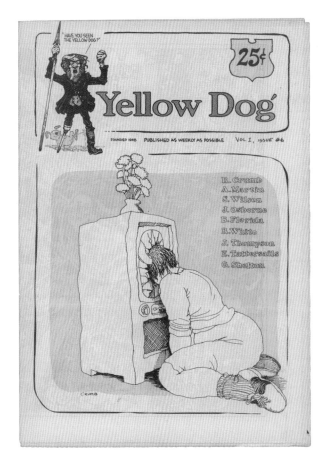

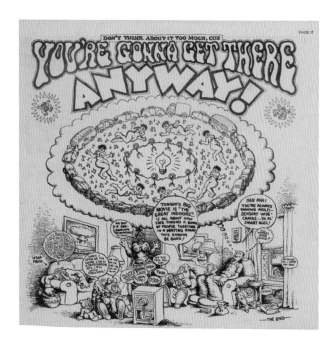

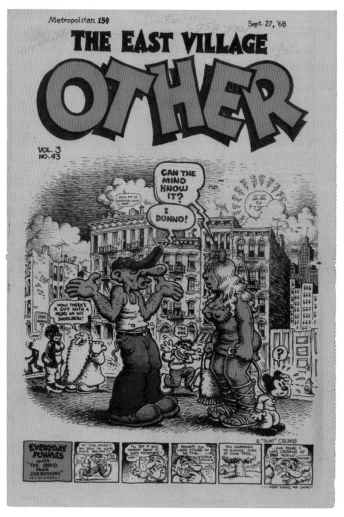

Robert Crumb, "You're Gonna Get There Anyway," *East Village Other*,
December 1–15, 1967. Copyright © 1967 by Robert Crumb.

Robert Crumb, cover for *East Village Other*, September 27, 1968.
Copyright © 1968 by Robert Crumb.

(Opposite) Robert Crumb, cover for *Gothic Blimp Works* no. 1, 1969.
Copyright © 1969 by Robert Crumb.

Spain [Rodriguez] was one of my best pals back in those days, he's still one of my best
friends, and he was very overtly political. He had a much clearer, concise idea about that stuff.
He was much better educated politically than I was. I was more of a mystical, instinctive-type
artist. My tendencies were both more religious and mystical than they were political, really
deep down, but I tried, you know, I tried to be political. The problem with anything political in
those days, and it's still true, on the left, or on the right, anything, is that you just can't please
anybody if you try to be political. Even Spain, who's done so much volunteer work for free for
these different political organizations, the Socialist Workers Party, this, that, and the other
thing, and they just nitpick him to death. You can't please them. Everybody thinks they're more
left-wing than thou. It's just a thankless job.

I couldn't do party line. I just couldn't do it. They wanted me to, but . . . A lot of times it
was just too confusing, like with this "Lenore Goldberg" story: I wanted to be pro-feminist,
and yet I still had my sexual fantasies. So this hippie sensibility—where at the end she ends
up in a commune having a baby—a lot of feminists were very angry about that, they thought
that was a real *sell-out*. I had her giving this guy a blowjob at the end of the story, and they
didn't like that at all. All I can say is, it's a good thing we didn't win the revolution [laughter].
We would've ended up with people like Abbie Hoffman and Eldridge Cleaver at the helm;
we would've been in big trouble. Big trouble. It would've been such a Stalinist purge and a

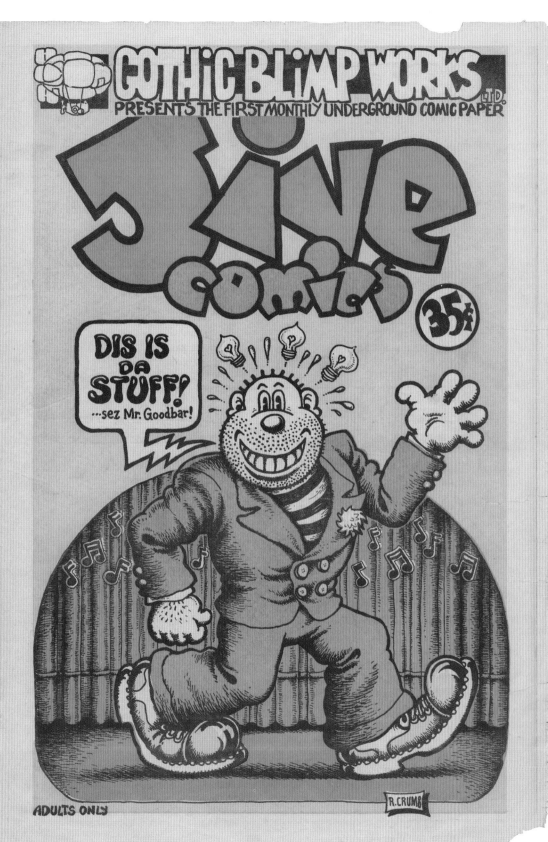

Robert Crumb, cover for *Gothic Blimp Works* no. 2, 1969. Copyright © 1969 by Robert Crumb.

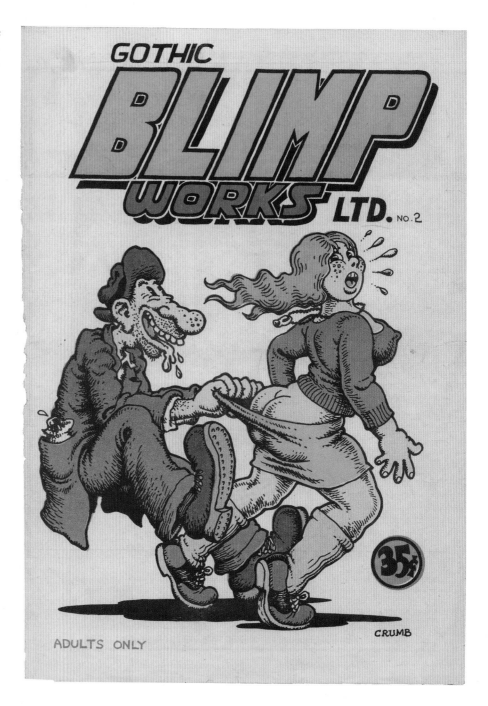

clean-up, gulags, and everything if those people had actually won the revolution. Ohhh, boy . . . All those people that were the top names in those movements back then were all egotistical assholes, it turned out, every single one of them [laughter].

I saw *Zabriskie Point* recently, this movie that came out in 1970 by Antonioni. It was so bad—it was so fucking lame. The beginning shows these students in some university somewhere having a discussion about the revolution, and Kathleen Cleaver is there, Eldridge Cleaver's wife, a Black Panther, totally hard-line revolutionary. They're all talking about how they're going to take over this university, and some meek, bespectacled student says, "Well, what about the students who want to finish their studies and get their degrees?" She says, "Well, they'll just have to get out of the way of the revolution!" ■

When I was working for that left-wing paper *Winds of Change* in Davis [California] in the late seventies and early eighties, I just got so disillusioned with that whole thing. Even though politically I kind of agree with them, but oh, man, it was a thankless job. They just nitpicked the artwork to death. Basically, they wanted you to be their hand, to draw their idea. But every person had a slightly different idea and there were endless debates . . . whew. A lot of my work for them was really inspired by Thomas Nast, but the people who ran the paper didn't like any of that stuff. They said it was too negative, it would alienate the people, blah, blah. This one woman editor said one of my drawings was going to give her child nightmares. "Sorry!"

They wanted typical revolutionary art showing happy people out in the fields growing organic vegetables. Happy scenes of happy idealistic futures we could have. That just didn't interest me at all. I tried, I really did, to be a good left-liberal artist, give 'em what they wanted . . . I tried to be selfless and lend my talents for the cause. I did actually try to draw stuff like that, but I'd always feel so embarrassed by it afterwards. People planting a tree? A bunch of happy hippies planting a tree . . . ughh, it was lame [laughter]. ∎

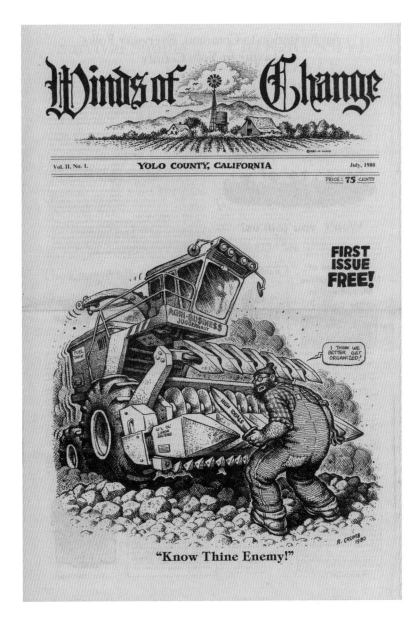

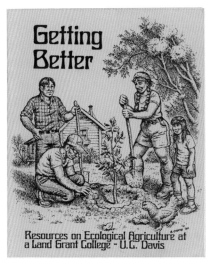

Robert Crumb, cover for *Winds of Change*, July 1980. Copyright © 1980 by Robert Crumb.

Robert Crumb, cover for *Getting Better: Resources on Ecological Agriculture at a Land Grant College—U.C. Davis*, 1980 (Alternative Agricultural Resources Project). Copyright © 1980 by Robert Crumb.

Another totally underrated, forgotten, great, great artist [Boris Artzybasheff]. Incredible work. I'd see his stuff cropping up into the fifties, on *Time* covers, then I started looking through piles of old magazines and found *Fortune* magazines from the 1930s. The ultimate level of skill, but completely obscure. There are also all these German Expressionist artists I like whose work you rarely ever see. You hear about George Grosz and Otto Dix, but there are so many others whose work is incredible that you never see, a whole other genre of work that we've barely scratched the surface of. It's too negative. If you go to art bookstores, it's always the same ones, Picasso, van Gogh, Renoir, the Impressionists, which is sweet, people like it. But this stuff is just too disturbing, people don't want to see it. I remember discovering Otto Dix when I was in my twenties and was just awestruck. Robert Williams got a hold of some little book of his work and I'd never seen it before—it was years before a book on him came out in America. Again, that period of the twenties and thirties when there was all this incredible work being done outside of the big names. I guess a lot of it is economics. It behooves the art world to push certain people, have certain people held up as the kings, the popes of the art world, and sell their books. Product recognition has a lot to do with it.

Where do you end with this stuff? There's just so much rich work out there to discover. It's just that academia's interest in this stuff is so lame. It's funny, even with old music, it's the same thing. When Terry [Zwigoff] was doing that documentary about Louie Bluie, he wanted to get a National Endowment for the Arts grant to pay for it, and they told him they liked his idea, but to get the money, he had to have endorsements from two ethnomusicologists, accredited academic ethnomusicologists. The movie is basically about black string bands from the old days and he couldn't find two guys in academia who knew anything about that. He finally got an endorsement from Alex Haley, who did *Roots*—he didn't know anything about it, but that was impressive—and from some other guy who also didn't know anything about it but just gave the endorsement to help Terry get the money. There's a big difference between a collector-archivist and people in academia, it's a totally different thing. In academia they get locked into this thing of having to narrow it down and narrow it down to this very particular specialty that they focus on, and they're very proprietary about it, so that it scares them to actually scan the culture at large as we do and just pick out, "Oh, this is interesting," or, "That's interesting from this whole different area," and then look into it; that's a waste of their time. There are probably exceptions, but it gets narrower and narrower as there get to be more academic specialists and specialties. You have to be so specific about "your" things, and if someone else who's not *the* expert volunteers some information, then it's almost a threat. ∎

(Below) Boris Artzybasheff, *Repressed Hostility*, c. 1940s. Copyright © by the estate of Boris Artzybasheff.

(Opposite) Boris Artzybasheff, *Executive of the Future*, c. 1940s. Copyright © by the estate of Boris Artzybasheff.

Robert Crumb, poster
for the twenty-seventh
Festival International de
la Bande Dessinée, An-
goulême, 2000. Copy-
right © 2000 by Robert
Crumb.

This is a full watercolor painting—weeks of work. Then they didn't like it. They were embar-
rassed. They were trying to make the Angoulême festival more of a family affair, so they only
put up five copies of it in these hidden corners of the festival. And they had somebody else do
a more family-oriented poster and they put those all over the place. Dirty bastards . . . boy that
was annoying [laughter]. ■

Everybody from the underground's first generation stood out because they came out of isolation. Everybody started in real isolation; there was no comic scene when Spain started, when [S. Clay] Wilson started, when I started. Rick Griffin, Robert Williams—there was no comic scene, so everybody developed completely on their own and when we all came together we were all highly individualistic, you know? There was no influence from any other contemporaries; we influenced each other a little bit, but that was after we'd developed individually. I guess it was kind of revolutionary at the time.

Wilson was a total original. I wrote the introduction for his new book and I realized thinking about it: "Where the hell is Wilson coming from? Where did he get that?" He completely came up with something on his own that no one had *ever* done before in the history of the world. It was totally new, what he was doing, you know? All stops pulled out—it was incredible. When I first saw his stuff, I thought, "Oh my God! He is not holding back anything!" Any crazy, violent, twisted sexual image that comes into his mind, he's drawing it. It was very inspiring in a way. ■

S. Clay Wilson, "Captain Edward St. Miquel Tilden Bradshaw and His Crew Come to Grips with Bloodthirsty Foe Pirates," *Zap Comix* no. 3, 1968 (Apex Novelties). Copyright © 1968 by S. Clay Wilson.

Rory Hayes, he was really from the Twilight Zone. It hit me immediately when Gary Arlington first published *Bogeyman* no. 1. When I saw that it struck me instantly as something powerful. It was like the raw, crude, psycho high school–kid artwork carried to its nth degree, to its highest degree. I remember when we put his work in *Snatch Comics*, Janis Joplin came over to me and said, "Look, I have to talk to you, this is serious." She was real serious about it and said, "You know, I think you guys are making a big mistake putting this guy Rory Hayes in your comics. The rest of you guys are doing this kind of funny stuff about sex and all that, but this guy is just sick, he's a psycho" [laughter].

Then everyone else had to get into the *Bogeyman* act, so Rory didn't even get to do the covers anymore. It's too bad about Rory, actually. It was such a crazy scene. For a while he was living in this place on Valencia Street [in San Francisco] that Don Donahue owned. Rory just went under with drugs . . . he was innocent, he was like a . . . he just didn't know how to control that stuff and nobody was there to help him.

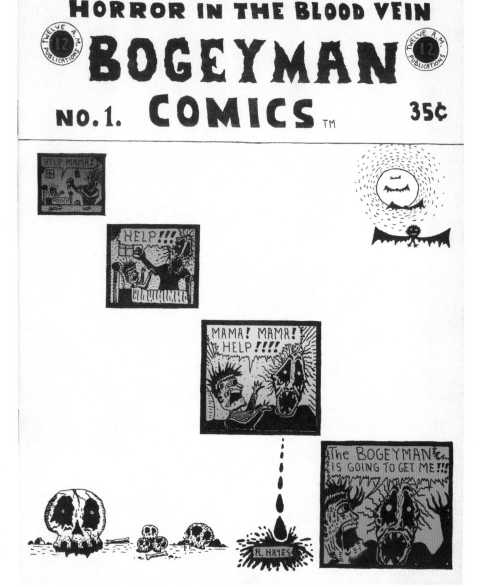

He came up to Potter Valley once when we were living there, way out in the country—he came up with Gary Arlington or somebody, I forget who—we had a swimming hole, and Aline [Kominsky] was living there at the time, this was like '73. Aline said she was going to the swimming hole, and Rory asked if he could come, and she said, "Yeah, sure." They went down there and Aline took her clothes off and jumped in the water, then Rory took his clothes off and jumped in the water, and then he started *drowning!* Aline said, "What's the matter?!" "I can't swim, glug, glug" [laughter]. Aline had to rescue him. I don't know what he thought, I guess that he could try to learn to swim. He was really crazy, really fucked up on drugs. It's truly a shame. I don't know what would have become of him otherwise. A rhetorical question, I guess . . . ∎

Sophie [Crumb] did these beautiful homemade comics when she was eleven or twelve years old that were more influenced by the old homemade comics by Charles than by anything else. When I first showed her Charles's homemade comics from when he was a kid, she just fell in love with those, in love with his style, this simplified Disney style that he had as a kid. And she imitated that—it was very eerie, actually. Very spooky in a way, how she picked up so heavily on my brother Charles's homemade comics, how she picked up very specifically on this thing that Charles had been doing when he was about eleven or twelve. ■

(Opposite) Rory Hayes, *Bogeyman Comics* no. 1, 1969 (San Francisco Comic Book Company). Copyright © by the estate of Rory Hayes.

Sophie Crumb, two covers and interior page from homemade comics, 1990s. Copyright © by Sophie Crumb.

Charles Crumb, three covers and interior page from home-made comics, 1950s. Copyright © by the estate of Charles Crumb.

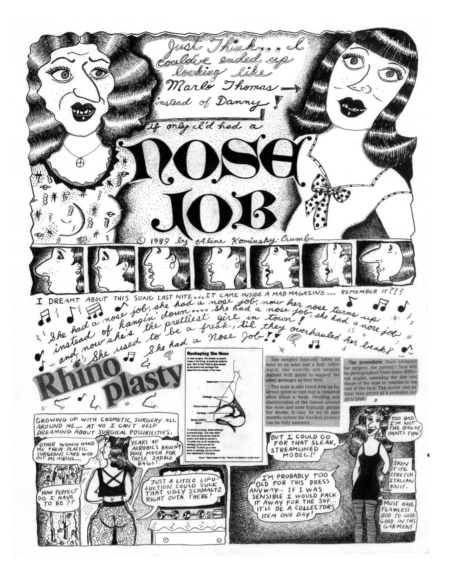

Aline Kominsky-Crumb, original art for "Nose Job," *Wimmen's Comix* no. 15, splash page and detail of interior page, 1989 (Rip Off). Copyright © 1989 by Aline Kominsky-Crumb.

After the initial guys who converged together in *Zap Comix*, that was immediately followed by a second wave of highly individualistic artists, like Justin Green and Aline. Aline was more inspired by Justin Green than anything else; when she first saw his work she said, "I could do that—just straight autobiographical comics." She was like the first woman to really do that, to do straight, right from the real experience of her life comics. A lot of people were put off by the crudeness of her drawing, but again, like with Rory Hayes, it's very strong, even though it's primitive and uneducated. Aline's art education didn't do a thing for her [laughter]. She went to Cooper Union and got a degree from the University of Arizona, and it didn't educate her at all, it just didn't take at all. She's completely straight from this crude kind of . . . I don't even know. But the rawness of it is actually quite refreshing in a way. I find that much more interesting than very slick, smooth comic art. It's real instinctive. It's actually really hard for her even to stick to the story, she has so many tangents she gets into. Sometimes I try to tell her, "Why don't you just write out a rough outline or something?" and she says, "Nah, I can't work that way." Her tools, her equipment are all really bad and everything. She's just real crude about it. Incredible. ∎

Robert Crumb, "Walkin' the
Streets," *Zap Comix* no. 15,
splash page, 2004 (Last Gasp).
Copyright © 2004 by Robert
Crumb. Used by permission of
Last Gasp.

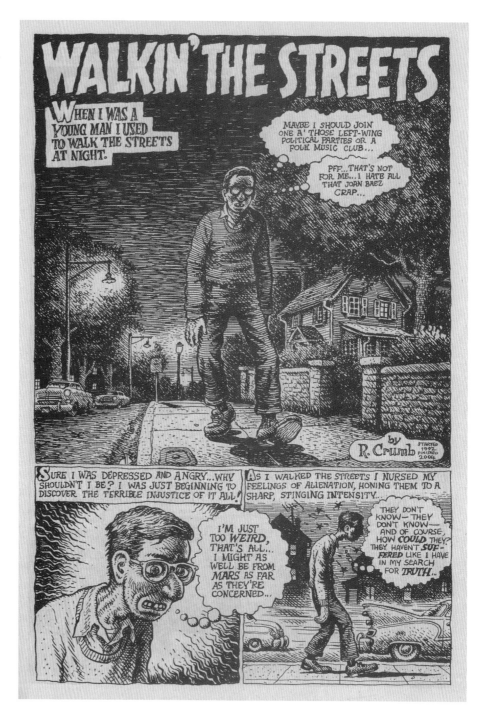

I started this story in 1992, and got four pages into it . . . and I don't know, I just stopped. I
got stumped with it somehow, and I didn't know where to go with it. Then I was looking at it
twelve years later and it just came to me, exactly how to go on with it. Thinking about it later,
it was maybe that my brother Charles actually died right around that time, maybe that's what
stopped me from going on. I'm not sure. He died in '92. ∎

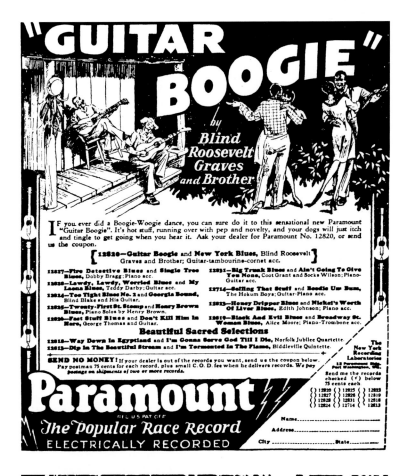

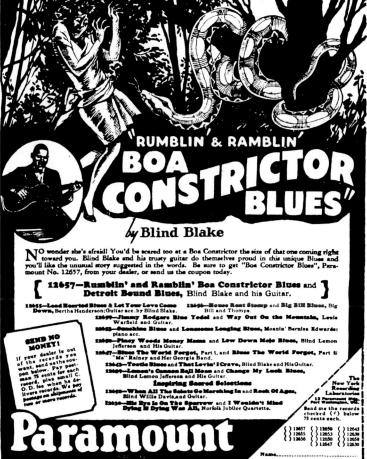

The old music is the same thing as that old popular print stuff, it's this underworld culture that's buried and hard to find. A lot of people who reissue these things on CD, it's the same story, there's not enough of a market, it's really hard to get the stuff out there, it's a very small market and big stores don't want to bother with it. It's tough.

It's impossible to track down any of the artists who did this work, as there are no names attached to anything. This one company, Paramount, a very cheap record company out of Wisconsin that did race records—they did these ads for black newspapers for their blues records, which are just so great. They did hundreds and hundreds of them, all through the twenties, but the farthest anybody has been able to get is to find out where the artwork was actually done, which was Milwaukee. The company went out of existence in 1932 and nobody cared, you know, for decades nobody gave a shit about it, so it just all kind of vanished into the mists of time. The lettering is really tops and I've wondered whether there were different artists that did the drawing and lettering, but I just don't know. I've stolen lots of design ideas from these, I use them a lot. Steal from the best, that's my motto. ∎

Paramount Records advertisement for "Guitar Boogie," *Chicago Defender*, November 2, 1929.

Paramount Records advertisement for "Boa Constrictor Blues," *Chicago Defender*, August 25, 1928.

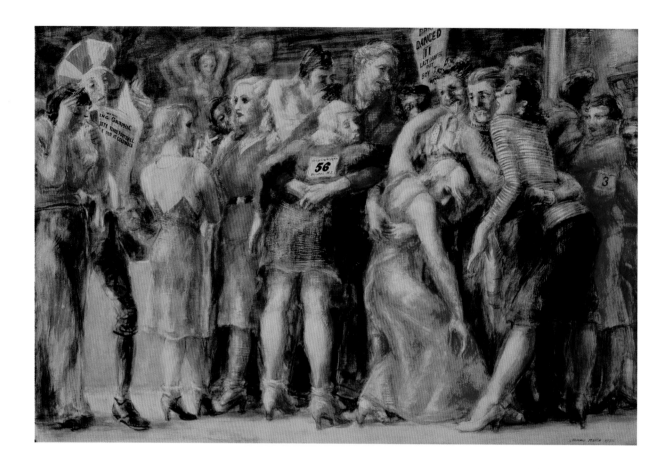

Another whole area of art that I'm really interested in is the social realist period of American art from the teens, twenties, and thirties. Boy, I love some of that stuff, but again it's hard to find. A lot of those artists are totally obscure now. Reginald Marsh's paintings of everyday life around New York, the subways, the beach, railroad yards, street scenes . . . just people. They're fabulous. ∎

Reginald Marsh, *Zeke Youngblood's Dance Marathon*, 1932. Tempera on gessoed canvas mounted on masonite, 24 × 36 in. Collection of Munson-Williams-Proctor Arts Institute, Utica, New York, 57.197. Copyright © 2006 Estate of Reginald Marsh/Art Students League, New York/Artists Rights Society (ARS), New York.

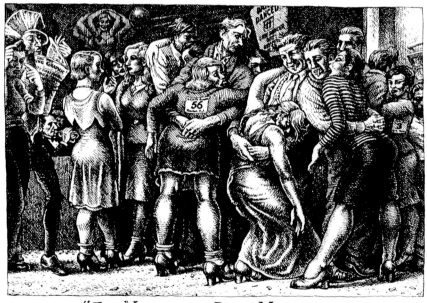

"ZEKE YOUNGBLOOD'S DANCE MARATHON, 1932
—— *Copied from* REGINALD MARSH

Robert Crumb, drawing after Reginald Marsh's *Zeke Youngblood's Dance Marathon*, c. 1996. Copyright © 1996 by Robert Crumb.

I used to do these casually on placemats and just leave them in the restaurants. Then this Dutch publisher said, "Hey, let's publish some of those," and the whole thing obviously changed into something that became real self-conscious, and I could no longer leave them in restaurants. Then Paul Morris was able to sell them for a lot of money, so now every placemat drawing has to be a fucking masterpiece [laughter]. I can't just doodle casually on a placemat anymore. There's no place left to doodle casually unless I get myself one of those magic slates that you can whoosh, erase. ■

(This page and following) Robert Crumb, original art for seven *Place-mat Drawings*, c. 1995–2004. Copyright © by Robert Crumb. Images courtesy Paul Morris Gallery, New York.

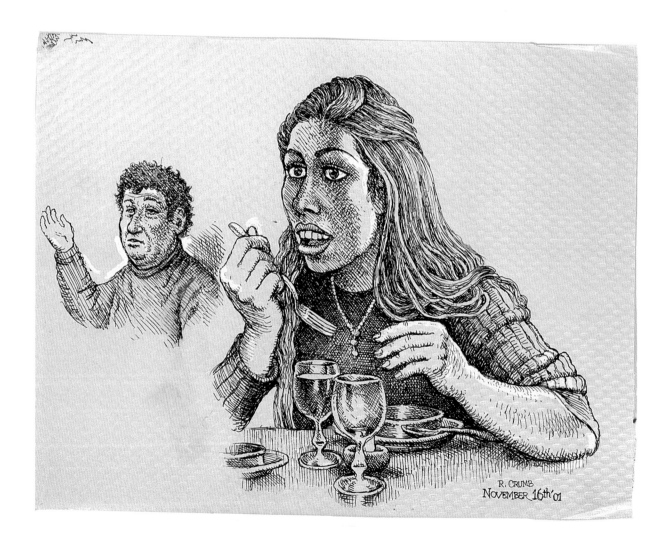

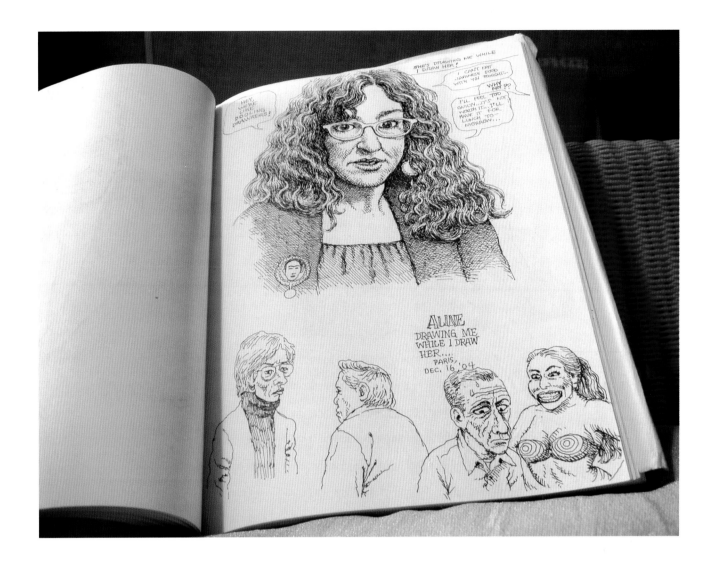

I don't draw as much as I used to. I'm too much of a celebrity now, I'm too self-conscious. It's hard to draw casually, it carries too much weight. It's the curse of success and fame. I've had to deal with that since I was twenty-five—it started in the fall of '68. I remember it well. Everything changed then and it's never been the same. I have to fight self-consciousness and people *constantly* wanting this, that, and the other thing. Constantly; it's a constant battle. But then everybody's life is a constant battle, it's no different for anybody else. ■

Robert Crumb, original sketch-book drawing, c. 2005. Copyright © 2005 by Robert Crumb.

b. 1948

2. Art Spiegelman

Throughout his omnivorous career, Art Spiegelman has been one of comics' leading lights, as well as the most articulate historian, eloquent theoretician, and passionate champion for the advancement of the medium. Following a crash course in comic art history through his employment in the 1960s at Topps Chewing Gum (freelance employer of many top cartoonists), his personal work began in the underground heyday and was immediately marked by a rigorously sophisticated deconstruction of the comic language's singular formal properties, informed by modernist art theories (and an awareness of their discrimination toward narrative art in general) and armed with an inherent discernment of the broad cultural biases against comics as a legitimate art form.

Having published short pieces in numerous venues, along with coeditor Bill Griffith, Spiegelman launched *Arcade: The Comics Revue* in 1975, a crucial anthology that offered an oasis of creativity following the dispiriting gradual dissolution of underground publishing and distribution. *Breakdowns,* a collection of Spiegelman's work up to the time, was published in 1977 and remains to this day one of the most salient statements regarding the comic medium's conceptual and formal possibilities; the title itself reflects the ongoing duality of personal introspection and investigation of the medium's structural properties. The themes of his most important sustained work, *Maus: A Survivor's Tale,* were introduced in an early three-page strip ("Maus," 1972), done in a more traditionally "cartoony" style, and in an overtly expressionistic autobiography dealing with his mother's suicide ("Prisoner on Hell Planet," 1972). *Maus* was serialized in its final form in the early 1980s in *Raw,* the seminal anthology of international avant-garde comics and underappreciated classic comic book and newspaper strip work, which Spiegelman coedited with Françoise Mouly. Led by Spiegelman's example, artists featured in *Raw* exemplified comics' fully realized plasticity, capable of dealing with virtually any subject matter, from the Holocaust to gag cartoons, and the editors' scrupulously intellectual approach to the form's history brought to the surface lurking psychobiographical subtexts of nearly forgotten genre comics. Not only does *Raw* re-

Art Spiegelman, self-portrait from *Maus: A Survivor's Tale,* vol. 1, *My Father Bleeds History,* undated (Pantheon). Copyright © 1973, 1980, 1981, 1982, 1984, 1985, 1986 by Art Spiegelman. Used by permission of Pantheon Books, a division of Random House, Inc.

Art Spiegelman, "Dead Dick," *Lead Pipe Sunday* no. 1, detail of lithograph, 1990 (Corridor). Copyright © 1990 by Art Spiegelman.

LEAD PIPE SUNDAY

"The color comics weekly! Ah, there's the dif!...Polychromatic effulgence that makes the rainbow look like a lead pipe." WILLIAM RANDOLPH HEARST. *NY Journal*, 1896.

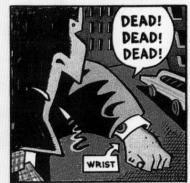

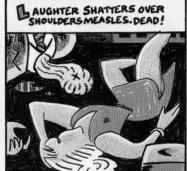

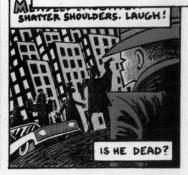

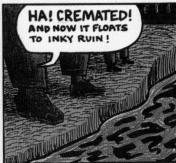

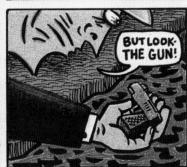

main the most essential English-language affirmation of the medium's sheer variety and achievement, it also has served as a brilliant primer for innovative use of design and printing technology (format, paper stock, color), bringing an art-world sophistication to comics.

The eventually collected *Maus* has become the most critically praised graphic novel in the history of the form, winning Spiegelman a Pulitzer Prize in 1992. The story of his father's captivity in Nazi concentration camps is a dense miniature of unparalleled emotional power, and has served as the benchmark for much subsequent comic art. Spiegelman's criticality regarding the form adroitly intensifies the inherently emotive subject matter: there is a constant back and forth between dense, "raw" expressionism, delicate touch, and stifling, cramped rigidity of scale and format, resisting sentimentality and proving the degree to which form crucially dictates narrative effect. Always politically active, Spiegelman chose as his next major project a dense, multilayered response to the events of September 11 and to what he felt to be America's increasingly repressive political climate following the attacks. *In the Shadow of No Towers* took the format of golden age Sunday newspaper strips and exploded it, seamlessly blending formal punch and ever-more-complex storytelling devices and structures. Spiegelman's boundless variety of storytelling and image-making tactics have expanded comics technique from traditional ink on paper to a variety of hand-rendered and computer-driven approaches, challenging the possibilities and definitions of narrative in the medium.

The most consistent politically and socially engaged "art" cartoonist, Spiegelman continues to complicate the formal structures and cultural position of comics, while as an illustrator (most notably for the *New Yorker*), editor, and historian (in essays, lectures, and comic strip appreciations—most significantly his critical study of 1940s comic book pioneer Jack Cole), he has demonstrated a remarkable breadth of knowledge and polymath erudition regarding past and present cartooning, critical writing on the medium, and the tangled relationship between comics and the institution. Through his technical innovation and heralding of underexamined past and present masters, Spiegelman has single-handedly expanded the medium's range. ∎

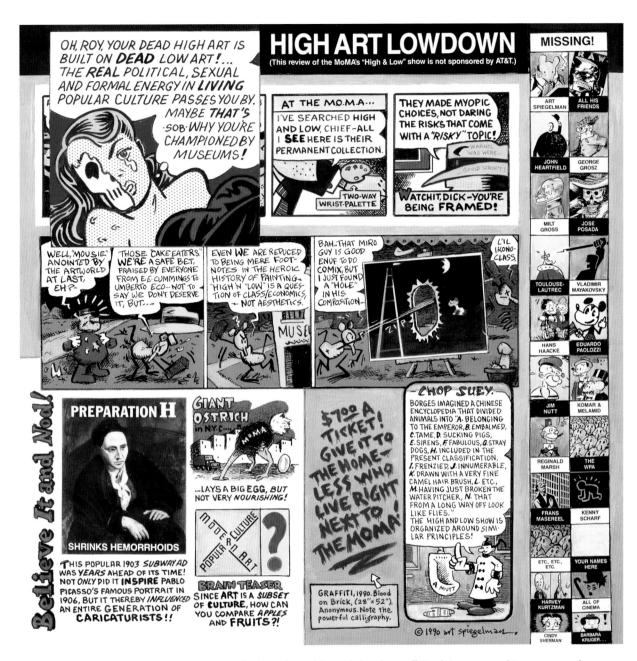

Art Spiegelman, "High Art Low-down," *Artforum*, December 1990. Copyright © 1990 by Art Spiegelman.

Dense. I was thinking about this, and also the stuff I'm doing now, and it was my mother who kind of gave me permission to become a cartoonist—we would doodle together—but somehow the thing I really got from my father was that he taught me how to pack. His thing was, you might have to leave at any minute, so it's important to know how to get as much as you can into a suitcase. And there's something about getting as much information as you can into a box, so it unpacks in your head—dense with possible meaning. With this, I thought, you could write this as an essay or if you took enough notes and figured out how it all worked together you could make it into one page. ∎

Winsor McCay, original art
for *Dream of the Rarebit Fiend*,
1905. Copyright © by the estate
of Winsor McCay.

This somehow gives a sense of the vertigo of the spiral staircase inside the Statue of Liberty. From the outside, it's this nineteenth-century statue, and inside it's the height of modernism: she's some kind of stately broad, who inside is really wild. Inside, the structure is very related to the Eiffel Tower.

In a way, this strip reads better than *Nemo*. He does it to be read more: where *Nemo* is very take-your-breath-away, this was more for grown-ups, because it wasn't the Sunday page. I ended up liking these better when I was going through [Winsor McCay's] material under the aegis of Woody Gelman, who was a major collector and my patron at a certain point—he had an amazing collection and really rescued a good deal of material from oblivion. Also, the punch line is always somehow related to who's having the dream. It rewrites the strip in a way each time.

The French right now are really into *Sammy Sneeze*—there's a reprint out now in France —they see it as the ultimate conceptual strip. Strips were often based on narrow concepts, and that is about as narrow as it gets: the kid sneezes and something falls over. It keeps building up, so eventually when he knocks a city down with one sneeze, pretty much the game's over [laughter]. ■

Harvey Kurtzman, original art for "Marley's Ghost" proposal, c. 1959. Copyright © by the estate of Harvey Kurtzman.

Jack Davis, original art for "Marley's Ghost" proposal, c. 1959. Copyright © by Jack Davis. Private Collection.

Pure [Harvey] Kurtzman. It's kind of a graphic novel *avant le lettre,* like he wanted to sell a book publisher on doing "Marley's Ghost" as a full-length story. As far as I know he did only a handful of pages. Whatever I paid for the original, it cost more to deacidify it because there was rubber cement everywhere. I can't afford to buy the companion piece that's kind of ugly but interesting, which is by Jack Davis. When Kurtzman couldn't sell it on his own, he got a page drawn by Davis following his breakdowns, and it's vintage Davis, just the difference between an artist and an illustrator. Everything's there except the rhythms, the beats, and the shapes. So it's got a lot of anecdotal junk, the room is filled with stuff in that one, and this is just so pure. ∎

Art Spiegelman, *Full House*,
lithograph, 1992 (Corridor).
Copyright © 1992 by Art
Spiegelman.

I'd love to do more printmaking, but I haven't had the excuse recently. There's something about drawing on stone that's so sensual; usually drawing just isn't for me—part of the reason I like printmaking is that it feels like drawing on velvet. ∎

This is from the last year of *Terry and the Pirates*; [Milton Caniff] wanted to leave without it being possible to continue the strip after him, so he packed every panel with gems at the end. I wasn't exactly going out and looking for a Caniff, but now that I have it I like it a lot. It's kind of masterful. ∎

Milton Caniff, original art for
Terry and the Pirates, daily strip,
1945. Copyright © 1945 by Tri-
bune Media Services. Reprinted
with permission.

Chester Gould is one of my longtime heroes. I'd heard that Jim Nutt used to cut out panels and give them to students to use as compositions for paintings. It's really true, every one of these . . . he just did amazing things with this character coming out of the other's shoulder. It's all information, like cartooning as charts by somebody a little bit psychopathic. Say you've just got one tiny head between two others: you've immediately got the entire room full of cops. ■

Chester Gould, original art for *Dick Tracy*, daily strip, August 25, 1958. Copyright © 1958 by Tribune Media Services. Reprinted with permission.

Chester Gould, original art for *Dick Tracy*, single panel from daily strip, June 12, 1944. Copyright © 1944 by Tribune Media Services. Reprinted with permission.

so dreamlike and unmitigated, with a lot of raw power. He believes in this Old Testament, wrathful superwizard who lives on an asteroid enough to present it with a straight face. There's no contemporary postmodernist smirk. It can only now be looked at through the eyes of, "Oh, what a weird guy," but its intensity is actually what makes it come back. It gets to the heart of what that comics-making thing is: this very intense distillation of a person, because you're putting yourself out there so directly in terms of both writing and drawing. And he did write and draw, which is part of the pleasure; it's not like he was an illustrator for some pulp writer making a few extra bucks. It's his world and he was hired not because he was a great draftsman but because he could do a finished page for ten dollars or whatever. When one gets to looking at it, it's clear that it's goofy, but it's also not funny [laughter]. It has that Rory Hayes intensity in its own way. From what Karasik has been finding out, it appears Hanks was a full-time drunk and ladies' man; [Will] Eisner also once told me that he was a bit older than the rest of the pack and had just answered an ad. In a sense, he's in a category with Basil Wolverton and Dick Briefer—though each of them may be more talented. But there's something in their work that is also tapping into the same part of this fantasy world, where you're ultimately dealing with archetypes, rather than what most superhero and regular comics deal with, which are stereotypes. ∎

Paul Karasik has been trying to research Fletcher Hanks, and I believe he managed to meet with and interview his son, so he's not as totally mysterious as I thought when I first saw his work—but almost. He was really rediscovered by Jerry Moriarty, who's got a great, fresh eye for what he looks at and who has really been an eye-opener to me. For example, I never cared about George Wunder, who took over *Terry and the Pirates,* viewing it as just second-rate Caniff. But after seeing originals in Jerry's overcluttered loft, I realized that he was sort of interesting. It's almost as if he was drawing Reynolds Wrap aluminum foil: everything is made of wrinkles, and the same wrinkles, and they're on everything—the faces, the hair, the clothes, and somehow everything is made of this weird buckled surface. All of a sudden I got this fresh look, and among the many things that knowing Jerry allowed me to see was his collection of old comics by this artist named Fletcher Hanks.

That's a pretty easy one to get into—as soon as someone shows it to you, it's immediately "Oh my god!" And that "Oh my god" has to do with—if he wasn't a cartoonist, which is in the category of outsider art, he would have been an outsider artist. It has to do with the unimpeded pipeline to his id . . . I've not thought about that much, but it's so much a result of the deep part of his brain, that what comes out is

Fletcher Hanks, "Stardust," *Fantastic Comics* no. 5, splash page, 1940 (Fox Features Syndicate). Copyright © by the estate of Fletcher Hanks.

Fletcher Hanks, "Stardust," *Fantastic Comics* no. 5, detail of interior page, 1940 (Fox Features Syndicate). Copyright © by the estate of Fletcher Hanks.

Boody Rogers, *Babe* no. 4, 1949 (Feature Publications). Copyright © by the estate of Boody Rogers.

(Left) Boody Rogers, "Mrs. Gooseflesh," *Babe* no. 4, page 8, 1949 (Feature Publications). Copyright © by the estate of Boody Rogers.

Boody Rogers also vaguely connects to this tradition, an offshoot of Wolverton, because the good-old-boyness of the humor keeps on leaking over to some other, much more intense tone rather than the ha-ha gag that passes the time and fulfills the page count. So his *Babe, Darling of the Hills* is actually in its own way much more disturbing than the intentionally disturbing *L'il Abner,* even though it was an "imitation" of it. And it's a lot more weirdly sexy than *Smilin' Jack,* on which he was a longtime assistant to Zack Mosley. Here is another one of those cases where it's a pipeline to a personality, and his personality was very kinky. In the tradition of humorous comics— since he didn't have the same . . . boundaries in mind as other people did—what is in good or bad taste, what can be said out loud, what can't be—he wound up saying a lot of things out loud that weren't supposed to be said: sort of S&M stories for kids about riding women around and treating them as horses. There are many that have this quality—stories about people playing baseball in the Ozarks, where one of the outfielders is right next to a cliff, so when he steps back to get the ball he dies. It's a little bit out of the bounds that have been set up elsewhere, as the guy doesn't quite bounce back; he's not like the Roadrunner [laughter]. So, that's the charm of his work. ■

The New Yorker advertises itself as the best magazine in the world, but that was really this magazine called *L'Assiette au Beurre*. Essentially, when Françoise [Mouly] and I got together, one of the first things we were going to publish was a book on [Rodolphe] Töpffer, and at around the same time we were asked by Woody Gelman to put an anthology together of this French turn-of-the-century cartoon magazine. Now, Dover has put out a book but it doesn't give the full sense of what this thing is—an amazing magazine. Woody liked to put people to use, and since Françoise speaks French, he thought she could translate it and I could edit it, but we ended up doing both parts together. He had an almost complete collection of the magazine, but then he died, and his son, who doesn't really care about this stuff except to turn it back into capital, asked if we had anything of Woody's to return. It was a really hard ethical dilemma, but we ended up giving them back, heartbroken, because we'd done a lot of work toward this proposed anthology and it was nice having the magazines around, and we knew he couldn't care less. So, they all got auctioned off. But then, somehow, miraculously, Françoise found out that this same collection was up for sale by the person Woody's son had sold it to. While a lot of Woody's collection got scattered to the wind, this run went as a chunk to Richard Marschall, actually, and Françoise found out, so for my fortieth birthday I got the nearly complete set.

What makes the magazine amazing is that while there were these other beautiful cartoon magazines ranging from *Puck* to *Simplicissimus,* here, every week, would almost invariably be one artist doing the whole issue, and the artist would decide the subject, and do it any way they wanted. Politically it ranged from left to right, so it would've included people who were Dreyfusards and anti-Dreyfusards, and also included things that weren't political at all. For instance, the themes you get: such as this one, Vallotton's "Crimes and Punishments," which is rare because it's genuine lithographs, rather than offset; "Society's Monsters," a freak show; "The Aesthetes"; "Money"; "Balloonists"; "Insane Asylums"; "Child Prostitution"; a good one making fun of Art Nouveau by Kirchner. Every issue is just stunning, because in France, and

(Opposite) Boody Rogers, *Sparky Watts* no. 8, 1948 (Publication Enterprises). Copyright © by the estate of Boody Rogers.

L'Assiette au Beurre, various covers and interior pages, 1902–1907.

L'Assiette au Beurre, various covers and interior pages, 1902–1907.

(Opposite) Art Spiegelman, *In the Shadow of No Towers*, April 29–May 27, 2003. Copyright © 2004 by Art Spiegelman. Used by permission of Pantheon Books, a division of Random House, Inc.

Europe in general, that high/low thing was never as high a wall. Picasso worked for Els Quatre Gats; most of the painters worked for cartoon magazines, that whole Daumier tradition. *L'Assiette au Beurre* had Kupka, Duchamp, Duchamp's brother [Jacques Villon], and Juan Gris. The one way that spilled over to American comics was with Feininger, who was an American but was hired as if he was a German to do his take on the *Katzenjammer Kids*.

That whole approach to color and thinking about the spaces and shapes rather than the anecdotal information . . . this is the natural crossing-over point, where you get both high and low, this is the magazine that did it. The fact that one week it'll be somebody like Caran d'Ache, who was sort of a right-winger, and then it would be Jossot the week after, and the subject would be whatever the guy needed to make; also every once in a while there would be an issue that was done collaboratively. To get a real sense of this, you need to see a chunk of pages together by somebody, rather than a drawing by each person. When you see an image from *Simplicissimus*, it looks just as interesting, but when you hold an actual issue, you see that it's mostly all text with just a few pages with nice pictures on them. *L'Assiette au Beurre* is a wholly visual magazine on a given subject. Great and very inspiring to me when we were doing *Raw*.

I got to meet Al Hirschfeld a year before he died and did an interview with him, and I asked, "You were in Paris then, was there something in the water? Everyone was doing such interesting work." And his response was: "Nah, it was just cheap real estate." ∎

The strip *In the Shadow of No Towers* came about when I was talking with a German editor that I know, who used to be the publisher at the German house that published *Maus* and then became the minister of culture of Germany, and now he's in charge of *Die Zeit*. At some point I was grousing about working for editors—even though I've been one often, I don't like working for them. So it began with the idea of having no editor and having all this real estate at once, running the strip as a full broadsheet-size page.

As far as the medium, it's a little of everything—sometimes there's no ink or paper. Some elements are drawn and scanned in, some drawn on the computer directly, sometimes doodles are scanned in then totally reworked, some are old-fashioned comic strips done on Bristol board. Usually I plan the page on Quark, then start figuring out what I need to do to get the components together, each of which is done a different way—sometimes little

paintings, often with flat computer color or painting on the screen. This represents the first time I've used so many approaches at once; it seems appropriate for the format.

It's as if it's a weekly, except it takes me five weeks to do it once a month. I don't know how any of the cartoonists I admire were able to do a daily strip. I can't understand it; I'm working my butt off and if I get one done inside a month I'm ready to rest for two months. On this one, I get a grid, then I violate it all over the place. I can't act as intelligently as Chris [Ware] and Dan [Clowes] and think if I do it a specific size I can subdivide it and make a book out of it. Instead, each page is a different set of layout problems, starting with a grid and then violating it everywhere. Each section is then a different approach. I go back and forth so much between the computer and drawing board, with a scanner between the two, that I lose track of how specific elements were done. Very often, I'll print something out, trace over that, refine it, scan some terrible sketch in, clean it up, print it out, bring it back . . . a total back and forth. I've read how Dan uses this $10 piece of Bristol board—now I've done that once, and it makes me nervous [laughter]. I just work on any shitty substrate that I don't think I'm going to feel tense about losing. Half the originals are done on tracing paper, or whatever else is around. ■

The stars & stripes are a symbol of unity that many people see as a war banner. The detailed county-by-county map of the 2000 election—the one that put the loser in office—made it clear that we're actually a nation UNDER *TWO* FLAGS!

DEM. REP.
GORE 48.4%
BUSH 47.9%
NADER 2.7%
OTHERS 1%

The United Blue Zone of America The United Red Zone of America

This page was very difficult to figure out—it's about the red zone of America and the blue zone of America, going back to the 2000 election. When I first saw this map, I realized that I've never been in the red zone of America. Even when I go to a state like Mississippi, I'll be in the one light blue county—there's a college there or some artists I know live there. So, I've never been in the America that believes in creationism, even though I've traveled around the country. This strip is about that. Some areas are painted, there's a section that's a pick-up from something I did in *The New Yorker* that I needed so I revised it a bit: the United Blue Zone and United Red Zone of America. There's a textbox that explains it—to do this right, I had to do this Escher-like weaving of the pictures, which is much harder than I thought. When I sat down, I thought, "Well, I should put this Escher background in," and two days later I'm going, "Oh, damn," and still working on it. Everything is colored on a different layer, so I could tweak the intensity, just trying to work it so things would stand out but not overwhelm.

On every strip, there's some reference back to this one picture, which was only doable on the computer screen, which is the image of those glowing towers. I know it looks abstract, but that's what I saw, and that's what Françoise saw—what the towers looked like right before they fell. So here there are no originals to speak of—there's never quite a finished piece of art. I'm stuck with the printed version being "the original." I used to say that, but I didn't have to put my money where my mouth is.

I'm thinking of the strip—it's a series of ten—as my pri-

vate Crunch gym. I'm getting my comics muscles back, to try and devote myself to working toward a book of some kind. I have thoughts about a long project, but I'm reluctant to jinx it. Essentially, once I take on a book, I'm gone for eight years, knowing how I am. This strip is the right exercise for what I'm thinking of, in the sense that I want to be able to do something that weaves through different styles, but also addresses what I was doing in *Arcade* and *Breakdowns*, which was much more visibly and overtly formal than what came in *Maus*—more overt, although when you begin looking closely at the *Maus* pages, you realize that they're all specific structures, but that aspect was all subsumed in letting the narrative go unimpeded. This was a very good exercise in self-effacement, but after thirteen years, it was like "Oh god, this is great, I don't have to draw in two-inch-high panels anymore." These pages are a means for me to find a way to deal with narrative, but still move back into the kind of things that get me up in the morning. For one thing, on these large pages, what is so much of a pleasure is that the shape of the panels is as important as anything in it. Here you can really make that function. So the best of them deal with these things formally—it takes forever to figure out. It's not that the *drawing* takes forever, although it takes time, but figuring out what it should be. Comics are this bastard form because you always have to work design off of content. If you go too much in one direction, you'll end up with a great Fillmore poster. It's a matter of figuring out where you can sit between those things that still has enough of a structure holding it together.

As far as writing process, I don't think I've ever scripted it in a way such as: "Panel one: he says, she says, long shot . . ." I was trying to figure it out—I've done it almost every which way except the one in which you actually sit down at a typewriter and type a comic script. But the way it tends to work is that there's a paragraph describing what is supposed to happen on the page, and then it's a matter of parsing it out into little thumbnails of what units of information can make up a page. The thing that takes me forever is figuring how few words can you get it said in. I tend to be way too verbose otherwise, and that's where the computers come in real handy. In a way, here it's a futile exercise because the pages are appearing in French, German, Dutch, Italian . . . I'm not even lettering, I'm just taking some out-of-the-box computer lettering. Nevertheless in English I'm planning the lettering to take up a certain amount of space. I'll use "go" instead of "walk" to communicate movement without taking up the extra quarter inch of width. Part of writing at this point: how telegraphic can you get? ■

UNCLE SAM
ROLLS UP
HIS SLEEVES!

art spiegelman

This was eventually published as a *Nation* magazine cover, but it was originally presented as a cover for *The New Yorker*'s "Money Issue." But at that point [editor] David Remnick's response was "This is about oil. It's a money issue" [laughter]. It was a rough sketch that I never did a full finish on, I just cleaned up the sketch. It ran in *The Nation* and then a group called the Syracuse Cultural Workers wanted to make a poster of it, which I did and glued up and carried in a march. ■

Art Spiegelman, original art for proposed *New Yorker* cover, 2003. Copyright © 2003 by Art Spiegelman.

(Opposite) Art Spiegelman, *In the Shadow of No Towers*, detail, March 11–April 2, 2003. Copyright © 2004 by Art Spiegelman. Used by permission of Pantheon Books, a division of Random House, Inc.

BACI DA
NEW YORK

art spiegelman

INTRODUZIONE DI PAUL AUSTER

Art Spiegelman, *Baci da New York*, 2002 (Nuages). Copyright © 2002 by Art Spiegelman.

This is a book accompanying a European exhibition of my ten years at *The New Yorker*. A lot of those covers started off as sketches directly on the computer screen that I'd send in to see if it got the OK, which if it did I would enlarge and eventually make into a painting. All were paintings except for two or three that seemed to make more sense done on the computer.

Right after I left *The New Yorker*, I felt like I'd had an ice pick removed from my brain that I didn't know had been there. "Hey, it feels better without an ice pick!" Then I had three weeks of freedom before the book was coming due so I had to relive every one of those ten years. The book reproduces every cover—even the ones I dislike—and some of the interior work, as well as including a comic supplement. There were a few high points, but there's a lot of stuff in there where I was just being a working stiff, doing the gig. Although it started out shiny, idealistic, Goodman Beaver–like, by the end it felt like Topps Chewing Gum for grown-ups. So between putting this together and the new *Little Lit* book, I'd done a lot of work, just not enough comics. They're hard, comics, as Crumb says. ■

 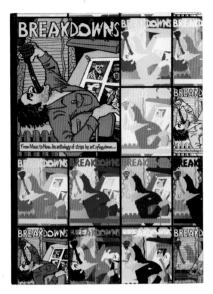 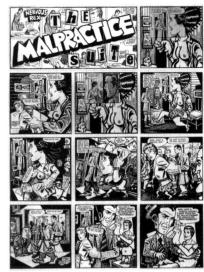

I have two projects planned for the foreseeable future that I'm currently working on. One is a twentieth-anniversary edition of *Maus*—it's crazy to me, it seems like about five years ago that the first volume was published. Right now it's called "Meta-Maus," and it's going to be something like the CD-ROM in book form: it'll include transcriptions of conversations with my father, the notebooks, paths not taken, rough sketches and drafts, documentation and photos, things like that. The CD-ROM itself is almost useless, as it's built on HyperCard, and nobody born after a certain date knows what this is. So it's being mounted onto another platform and will be part of the book. I'll probably get myself interviewed—or interview myself for the book, since I now know every single question that can be asked.

This project will be interrupted at a certain point with the other that I'm working on, which has gotten out of control and is basically a re-edition of *Breakdowns*—that's the innocent-sounding aspect of it. What it's turned into now is actually a rather enormous project. It's the "Re-Breakdowns" in the sense that what started out as just a new introduction to this first book of mine is now turning into a really involved project, which is a comic strip introduction that is likely to be as long as *Breakdowns* or longer. It'll probably be called "Portrait of the Artist as a Young %@?*!" Basically, the memoir of a memoirist—thoughts that are kind of catalyzed by those strips, either from the time they were made or from the early childhood mistreatment that led to them. I just didn't realize how much work I was getting into, "Oh, yeah, a reprint, good!" I have no idea how long it will take, I'm just sort of walking down the road to see where it goes. It's become so much more involved . . . partially because I needed to shelter myself from the outside world after the *No Towers* book, which did very well, but didn't change my government [laughter]. I may be one of *Time*'s most influential people of 2004, but it didn't even get me a subscription to *Time* magazine, let alone have an impact on the world. ∎

Art Spiegelman, *Maus: A Survivor's Tale,* vol. 1, *My Father Bleeds History,* interior page, 1986 (Pantheon). Copyright © 1973, 1980, 1981, 1982, 1984, 1985, 1986 by Art Spiegelman. Used by permission of Pantheon Books, a division of Random House, Inc.

Art Spiegelman, *Breakdowns: From Maus to Now, An Anthology of Strips,* 1977 (Belier Press and Nostalgia Press). Copyright © 1977 by Art Spiegelman.

Art Spiegelman, original art for "Nervous Rex: The Malpractice Suite," *Arcade: The Comics Revue* no. 6, splash page, 1976 (Print Mint). Copyright © 1976 by Art Spiegelman.

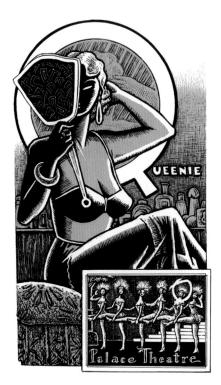

(Above and opposite, bottom right) Art Spiegelman, finished plate and rough for *"The Wild Party": The Lost Classic by Joseph Moncure March*, by Joseph Moncure March with drawings by Art Spiegelman, 1994 (Pantheon). Copyright © 1994 by Art Spiegelman. Used by permission of Pantheon Books, a division of Random House, Inc.

This is a lead-plate novel by Otto Nückel titled *Destiny;* I think it's the only one he did. One thing that's kind of neat is that these were inspired by silent film, which was in turn I think inspired by comics. The sequences become like storytelling in vignettes; this builds up to be this really tragic story about an unwed mother and her sad end. Graphically, he's a lot more intense than Lynd Ward, and a lot more narrative than Frans Masereel, so it's interesting. There was a bit of a fad for this kind of stuff for a while—at least ten or twelve people doing woodcut novels. These all happened around the 1930s—right as the talkies were about to enter—the culmination of the silent film language.

I feel like these books sort of beckoned me down the wrong alley; when I worked on *The Wild Party,* it started out being fun but by the end of it I never wanted to see another scratchboard sheet as long as I lived. I'd done these

sketches before I started the book that made me feel like illustrating it would've been fun, but I talked myself out of it. The illustrations were fun to do, as they were sort of relatively relaxed and free, but I opted for this solution instead, going back to the woodcut novels . . . painful [laughter]. Usually laying things out is the only fun part, but as soon as I have to lock things in, I'm up against my inadequacies. I can never make it anywhere near what I would like it to be. I have perfectionist tendencies but with the hands of a butcher, and the patience nowhere near necessary to the occasion, so I aim at something and end up falling so short that I end up doing it over and over again, so by the time it's over I wonder if I haven't killed it. For this language, that tightness is definitely of the period, but I could've caught the period and still made goofier drawings that would've been fun to do. This was all about wanting to set up shop somewhere that wasn't *Maus;* again it was a project I had wanted to do years before, around the same time we wanted to do the Töpffer book. Seemed like a good idea at the time. ■

(Above and left, also opposite, top right and bottom left) Otto Nückel, four pages from *Destiny: A Novel in Pictures,* 1930 (Farrar and Rinehart). Copyright © by the estate of Otto Nückel.

Even though Harold Gray's politics make him very unlovable, his strip is amazing. What's interesting about Gray really isn't his politics, it's the fact that somehow, despite everything, the strip actually accomplishes that essential trick of making these characters seem alive when you're reading it. There are very few strips that actually get me to drop my guard enough to get a tear in my eye. I don't know how he does it—the stories are predictable, stupid . . . part of it is that it has this intensity of conviction. He believes in it, so he bullies you almost into believing in it because he does. This *Annie* page was the one Harold Gray did on his deathbed, the last before his lights went out. ∎

Harold Gray, *Little Orphan Annie*, Sunday strip, July 21, 1968. Copyright © 1968 by Tribune Media Services. Reprinted with permission. This page, the artist's original version of his last Sunday strip, was altered for publication, likely by Gray's assistant Robert Leffingwell. Reprinted from Harry McCracken's "Annie's Real 'Daddy': Harold Gray, Cartoonist and Mythologist," *Nemo*, no. 8 (August 1984): 46.

One of the few unsung Golden Age greats. Milt Gross's Sunday pages are amazing and one thing I really love about his work is it just looks like he was having fun. The one thing that comics ain't the way I do them is fun. *He Done Her Wrong* is his masterpiece, but all of them are great— Kurtzman's *Hey Look!* came from somewhere in a way, you know? The pages are so intensely active. By the time Kurtzman got through looking at this stuff and dealing with it, he'd turned it back into agony again. But this genuinely has that pleasure of following the line: "Look, I made a nose!" ∎

Milt Gross, *Nize Baby*, Sunday strip, September 11, 1927. Copyright © by the estate of Milt Gross.

Harry Grant Dart, *The Explorigator*, Sunday strip, July 5, 1908.

I just got a batch of crumbling Sunday pages from 1908, containing a cartoonist I didn't know that much about, Harry Grant Dart. He was one of these people inspired by McCay to do good fantasy pages. You can tell that the engravers were jazzed at the time, they were interested in what they were doing, so it was still fun—color printing wasn't to be taken for granted. Part of the appeal was the scale, and part of it was the McCay influence to really lay into the page. It's no wonder that comic sections were looked forward to. I just figured having some of these strips around would make it more plausible for me to work that hard on my pages. ■

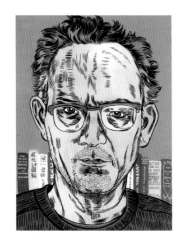

b. 1950

3. Gary Panter

Rising to prominence in the late-1970s Los Angeles punk scene, Gary Panter brought a fine-art sensibility to his comics work from the outset. His main character through the years, the perpetually wide-eyed Jimbo, forever stumbling toward salvation in an absurd picaresque landscape, found an appropriately discordant context in the Los Angeles punk newspaper *Slash*. Panter's avant-garde music-and-art-damaged "shaky line" resonated within this vibrant scene, epitomizing the period's slash-and-burn aesthetic even while transcending it, scrambling farther and farther afield with attention-deficit-disorder angularity. Such Situationist-via-punk, cut-and-paste disjunctions of formal and narrative space and tone, hallmarks of all of Panter's work, were introduced in his epic strip *Dal Tokyo* (which continues today) and coalesced to pitch perfection in self-contained Jimbo narratives that appeared in *Raw*, beautifully liquefying his fundamental conceptualism with far-beyond-Cubist fracture.

To bizarre effect, Panter has the ability to cumulatively communicate roiling elements littering an entire story—morphing background detail and warping emotional tenor, for example—as single panels. When "complete," Panter's comics not only crackle and rupture form and narrative from panel to panel, page to page, but also collage an entire tradition of strategies for pictorial depiction of space in individual panels, forcing eruptively simultaneous reading to arrive at a dizzyingly rich, open-ended "story." His most immediately striking invention is a firmly nonlinear approach to narrative, whereby voice spews from a collision of interweaving, metaphorical sources—high, low, and medium, from Renaissance texts to contemporary pop music stars—which accrete meaning as the narrative ambles along. Such a starkly revolutionary approach draws on the disjointed, unintentionally surrealistic nature of many early mainstream American comics to create an entirely new way of dealing with visual perception in the medium, as important to comics as the shockwaves of Cubism were to Western painting.

Panter's stories operate outside the concerns of traditional character interaction and psychological development, wherein past genre props are tantalizingly laid bare as

Gary Panter, self-portrait, 2005. Copyright © 2005 by Gary Panter.

Gary Panter, previously unprinted strip, 1992. Copyright © 1992 by Gary Panter. Collection of Glenn Bray.

©1992 GARY PANTER all rights reserved.

signposts in a disorienting wilderness, and the concepts of movement and stasis are reimagined and turned on their heads. Both image and text are expressive to the point of obliterating any traditional notion of narrative progression. Impatient with customary conceits such as delineating lines and descriptive words, the totality spirals toward pure visual and textual poetry, hatch marks loosed from their function ("off-register" in every way), instead aggressively expanding and jagging into swirling signifiers of unhinged psychological space. In Panter's comics, the iconic melts into its shadow at an alarming tempo, and character roles are frequently displaced and shifted, as the reader's orientation and identification are destabilized. In short, all established codes of the medium have become conceptual mile markers, the skeleton for his oddly fragmentary and skittishly episodic opera.

As with Crumb, Panter's sketchbooks have always represented a crucial aspect of his output, functioning in a surprising middle ground between loosely sequential comic adventures and the singular space of paintings. Each sketchbook drawing is an entire story in a single image: foreground and background space expand in myriad backward and forward directions creating beautifully—perfectly—stunted narratives that actively insist upon interpretive dreaming. Never confined to only the comic format, Panter's *Gesamptkunstwerk* incorporates set design (notably the 1980s children's television program *Pee-wee's Playhouse,* for which he won three Emmy Awards), gallery installations, and clothing and commercial product design. Throughout Panter's career, his overall vision has been to create organically consuming environments in all media. The full realization of such an engulfing aesthetic, brought to life in the perilously tumbling formal space of his comic pages, can be found in his recent collaborative light shows, which manifest a truly ineffable synaesthesia through total sensory disruption. Panter's importance lies in mining entirely new territory for the medium: cracking open comics' spatial time and place, and foregrounding the phantasmagoric concert of the language's fragmented nature and the imagery's symbolic power. ∎

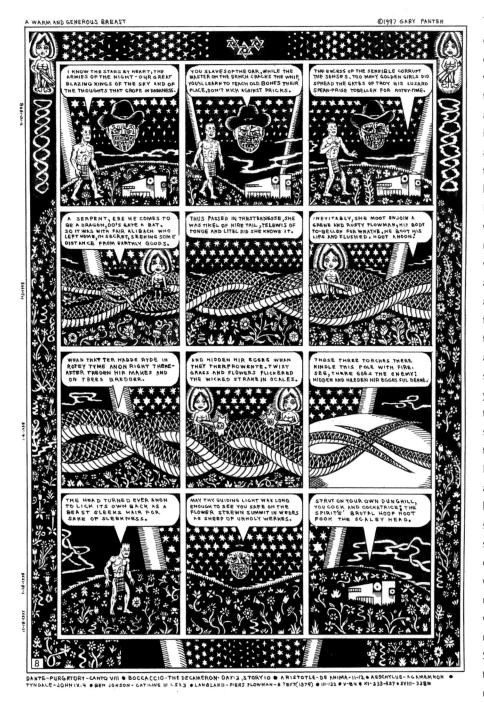

Gary Panter, *Jimbo in Purgatory*, interior page, 2004 (Fantagraphics). Copyright © 2004 by Gary Panter. Used by permission of Fantagraphics Books.

The idea behind the series of Jimbo stories in the *Zongo* comic was that the title would be published quarterly, so I started it as simple as I could, thinking that every issue would be a little tighter and more refined. I went through seven issues, the last issue being a version of Dante's *Inferno* with Jimbo, which was a lot tighter than no. 1; they really didn't sell very well and I couldn't draw a quarterly comic anyway and have it be financially feasible at all. So I decided to do a version of *Purgatory* after the comic ended and spent the next three or four years—it took three years to draw and another year or so to do the reading—on this. Years ago my friend Ric Heitzman had talked about building a folly in his backyard. A crazy thing with sculptures and cactus and stuff, and I started thinking of my comics as like that in a way. The readership is small, my work is difficult and not very communicative—it's not Matt Groening or Art Spiegelman—and I think that the people who read my work are happy to go with me when I change—or there are a few people who are and a lot who complain about it. So I decided to really push it as far as I could when approaching *Purgatory* and it evolved into this . . .

Gary Panter, sketchbook drawings relating to *Jimbo in Purgatory*, c. 2003. Copyright © 2003 by Gary Panter.

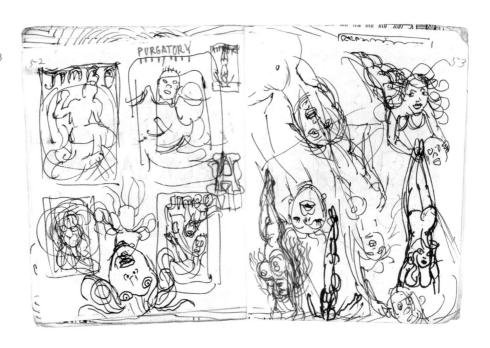

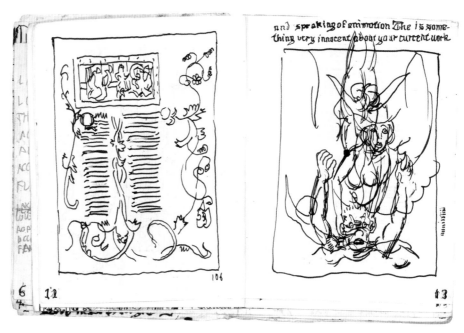

procedural thing. It's not a really friendly comic for reading, though ultimately it is a reading list of satires; in a way, that's probably the subtext of it. But it was a procedure starting from the premise that Boccaccio's *Decameron* was an encoded version of the *Divine Comedy*. With that faulty premise—probably not a true premise, but pretending that it was true—I set to find out which stories of *The Decameron* matched the cantos of *Purgatory*, then I did word counts and gridded the whole thing and would look for motifs that I could leap off of. So it became a replacement mosaic in a way where I used quotes from other pieces of literature to illustrate

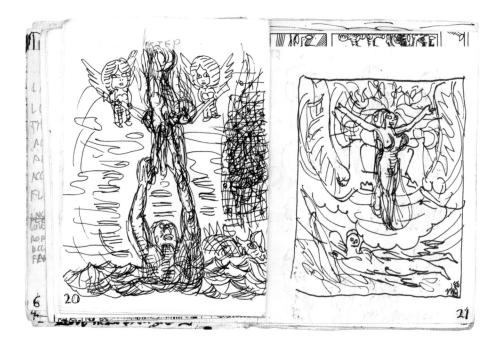

those motifs. If it thunders somewhere, or if the light goes out, then I could look for light in poetry or plays, and that's kind of how I proceeded.

I could do about four or five square inches a night . . . it's funny that people consider it really loose and scratchy and stuff, when for me it's like really trying to make it tight. It's that "he can't draw" sort of thing . . . I can draw pretty good [laughter].

I think that coming out of painting, the things that are currency in painting aren't in comics, like process and systems and those sorts of things. That's why a writer like Ben Jonson will appeal to me a lot, because he's not warm or romantic, there aren't great dynamic plots or anything, but there's this love of language and of building, and that sort of thing, which I tend to gravitate toward. Again, it contrasts me with Matt Groening or Art Spiegelman, who are great communicators, whatever you think of their messages, and I think they're fine, but they're great communicators and if I'm a great anything it's an experimenter: taking something apart and reassembling it some other way. I'm reading a biography on Ben Jonson now, and I need to go reread a lot of stuff that I just lightly touched on when doing *Purgatory*. If you ask me about some poet I quote in *Purgatory*, I might not really know very much about them. Like I couldn't tell you very much about Dryden; I intend to go back and reread it. I could tell you he's not a joker, but that's not very much [laughter].

I'm very partial to the art object, so I like thinking of my comics as having another life outside of publication. That makes me create them differently, on good paper . . . and also, a lot of the things that make them presentable for a museum are those aspects that make them more like old-timey comics in some ways: the paper's better, the tools are archaic, the ink is acid-free. I'm always thinking about those things . . . making them durable. It changes the way I make comics; when Charles Burns and I started making *Pixie Meat*, we worked on the crappiest paper possible, just to get started, and we kind of regretted it immediately. ■

(Right) Gary Panter, original art for "Cubist Cola," previously unpublished strip, November 25, 1976. Copyright © 1976 by Gary Panter. Collection of Glenn Bray.

Gary Panter, original art for "Cubist Cola," previously unpublished strip, December 8, 1976. Copyright © 1976 by Gary Panter. Collection of Glenn Bray.

Gary Panter, original art for "Cubist Cola," previously unpublished strip, 1976. Copyright © 1976 by Gary Panter. Collection of Glenn Bray.

The concepts that underlie Jimbo actually emerged in college, about '72 or '73, and one of the initial inspirations was a poem by a high school friend of mine, Max Watson, about what if all cultures and times came to the same place on one night in the town square of Sulphur Springs, Texas. Just the idea of these Egyptians and Mayans milling around together was a leaping-off point for my interest in Japan and the local culture, and kind of a science fiction—an alien view, in a way, is really what I'm after. So I had this point of view and I was making a lot of notes about it after I finished school. I was working as a janitor, making lots of notes

Gary Panter, original art for
Dal Tokyo, two sequential
strips, no. 45 and no. 46, 1984.
Copyright © 1984 by Gary
Panter. Collection of Glenn
Bray.

about what came to be *Dal Tokyo,* and what it was about. I used to rave about it all
the time and then when I moved to Los Angeles and saw *Slash,* I wound up talking
to the people there and actually found a home for the character [Jimbo], and had
a place for all of these things I wanted to work on . . . I had done a few things for
Wet magazine, but it really wasn't Jimbo. So once I got going I could analyze this
whole world I had in mind: "Oh, I'm doing Jimbo stories but we don't see Dal
Tokyo very clearly." Over time I started trying to make it clearer what Dal Tokyo
was.

All this just sort of fell in with punk: my stuff was scratchy and dark and really inspired by a lot of weird art things, like Dubuffet, and Hockney, and Eduardo Paolozzi, and Peter Saul, the Hairy Who, all those sorts of influences, and it just fell in with this scratchy—punk was like the revenge of the ugly kids, so this fit right in. Then I just sort of winged it after that [laughter]. ■

Gary Panter, original art for "Jimbo," *Slash,* 1978. Copyright © 1978 by Gary Panter. Collection of Glenn Bray.

Gary Panter, sketchbook drawing of Los Angeles, 2001. Copyright © 2001 by Gary Panter.

Punk was one of those things to scare mommy and daddy by looking scary, but it was actually mostly supernice people and nice runaway kids. There was a lot of humor in it. I never saw a stabbing or guns, maybe a few fistfights, but it wasn't like how I perceive hip-hop music with shootings and so on. It was a nice bunch of people. Most of the first generation of punks in L.A. were all out of art school and being very creative. ■

Gary Panter, cover for *Slash*, August 1979. Copyright © 1979 by Gary Panter.

Gary Panter, original art for "Durch Kompon," strip, 1978. Copyright © 1978 by Gary Panter. Collection of Glenn Bray.

I was a little shy, and there was a bit of a surly attitude then . . . I got to know The Screamers, The Weirdos, The Zeros, and various bands . . . but a lot of the bands I didn't know, and I couldn't draw them fast enough to get much from trying to. I did a lot of illustration during that time, so I became very visible . . . that's the neat thing about it is that it goes out quickly in multiples and blows down the street.

When I'm working on paintings, there's usually some sort of series involved, so there is some visual experiment that's continuing at an incremental rate. I'll paint a certain way for a year or so, then it'll change. Whereas with illustration work, I can change with every single illustration . . . and in my early comics, my style changes from panel to panel. It was the same in illustration back then: I was trying to solve people's problems, but I could think up solutions far outside of what I normally do, and if it seemed appropriate, I'd do that. I've said it before, but I draw a giant distinction between commercial art and personal art. Moscoso used that term in an interview, and I thought that was very appropriate, to call it not fine art, but personal art. So comics, paintings, poetry, and all those things are on one side of the line. ∎

(Above) Gary Panter, illustration of Exene Cervenka, *The Rocket*, early 1980s. Copyright © by Gary Panter.

(Right) Gary Panter, illustrations for *Gripping Typos*, cover and interior page, 1980s (Andresen Typographics, text by David Lees, conceived and designed by Clive Piercy and Rod Dyer, Dyer/Kanh, Inc.). Copyright © by Gary Panter.

(Opposite) Gary Panter, *Saturated Defense*, wall mural in the home of Glenn Bray and Lena Zwalve, Sylmar, California, 1985. Copyright © 1985 by Gary Panter.

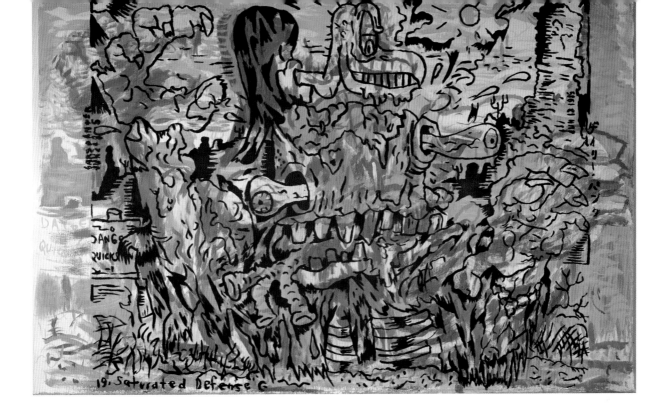

I went to painting school and have been painting all my life, so I'm really aware of the traditions, and am totally into . . . whether I want to or not, painting is often about painting. There are formalistic aspects and historical aspects and then what you hope the painting will do around people. So I think about the way the painting's being made, but then on the other hand about color, color experience and memory. I do like the idea that the paintings go into people's homes, and they're in front of them eating breakfast. I like that part of it. That they're mood control devices a little bit, or enhancement devices. In comics, none of this is an issue—formalism certainly is a part of what I do in comics, but the formalities of comics are very different.

Painting until postmodernism—this is my terrible paraphrase—was about people staking stylistic claims. "I'm Josef Albers, I'm going to make boxes the rest of my life. This is my territory, stay away from it." It almost became a quest for novelty, which by the mid-seventies seemed exhausted. People are shooting themselves and cutting their penises off as painting, now what's left? For me, when I was learning about what I wanted to do with painting, with the ideas of the CoBrA group and Hockney, I could see people reaching back to their childhood, and that really said something to me, because on the days I would sit around without an idea, I realized that my childhood interests were pretty much the same as my adult interests visually. Then I didn't lack for ideas after that: it's still monsters, dinosaurs, sci-

ence fiction, and sexy girls. So now I don't have to have a day wondering what I should do.

What I've done is stake too much claim, because I'm all over the place. So if I do one illustration—this is a crazy, egotistical thing to say—but I think some people have taken one illustration I've done somewhere and based a career on it, in some ways. I don't look at that in some horrible selfish way . . . it's egotistical for me to say that, but because I can keep changing . . . every illustration is different, so are you claiming everything you're doing? Not really, I'm just moving forward and trying to figure out what I want to do next . . . discovering myself.

Early on, in this predicting-the-arc-of-art game—"Where are we going? Well, I'll step there and they'll give me all the money" [laughter]—I had a notion that the next generation of Pop artists . . . guys going and looking at the mass of media in sort of a McLuhanesque way, taking out important or random icons and repositing them . . . It seemed to me that you'd want to do your own narratives, your own illustrations, and tap those things and make art out of them. So I thought the next step would be warm Pop art as opposed to cold Pop art: warm, narrative Pop art. That was the arc that I thought I was on in a way. But once I started to have things appear in media and do comics, I quickly realized that I didn't like doing paintings with those concerns—that painting was a total other activity and I just had to develop it separately. I think maybe people are doing that now in painting, some of the *Juxtapoz*-type artists. ■

Gary Panter, *Dal Tokyo,* strip no. 112, April 26, 2005. Copyright © 2005 by Gary Panter.

I've done over a hundred of the new *Dal Tokyo* strips now. It's appearing in a Japanese reggae magazine called *Riddim,* put out by my friend Mr. Ishii, who's also my agent in Japan. I'm thinking about these stories that are happening in this city and I'm not particularly being true to one, and I'm not, like, plotting ahead to find out how to make really exciting denouements and conclusions.

So there's a randomness in it, of me proceeding ahead blindly . . . but now, what's been happening in the comic for the last year, basically, is that a war broke out between these monsters that divided into four, and they're fighting in this city, and all the denizens of the city are fleeing. They flee to the coastline and are hiding there, then they're destroyed by a wave, accidentally. I tend to draw these things before they happen . . . but we won't go into that, because it's madness [laughter]. But that's what happened. So all the characters went down to the sea, and a lot of them have washed away, but there's this girl robot now, who the story is following, and she's going somewhere, but I'm not quite sure where she'll end up. So I'm following her, following her . . . the warring factions are asking her to join up with them in a subscription kind of sense to fit into their scheme. She refuses to join, because she's part of this movement that's been going on in my comics for years, which is about kind of a robotic revolution, of robots coming into their own and having their own political entities. There's always reference to the new Dixon, so this girl is either the new Dixon or related to the new Dixon . . . so I know all those kinds of things, I know the moment that's happening and where it is in the city, but the story I tell in that month is like her riding a cicada, fleeing from the forces of one of the four warring entities or something. A few months ago we were following the Crystal Boy to this meeting . . . so . . . I don't know.

Storywise, I don't know what to say about it in a way. It's just a part of my life and I kind of proceed with it, and I like approaching it in a certain way that is like the love of language . . . in a manner related to Dekker's *The Gull's Hornbook,* which is about arcane criminal languages. So I tell the story, I draw the visual part, then I look around the environment for the words that can say what the strip needs to say. I'll just start flipping through books or catalogs or newspapers or look at signs on the highway until something speaks in the voice of the character, then I write it down.

Jimbo is in this world and he's appeared maybe once or twice in this story, just walking through. I guess everyone likes to get better or evolve toward something, and I wish I would evolve to something like *Turok, Son of Stone* or *Magnus, Robot Fighter* or something I would like. When I'm thinking about this next *Paradise,* or whatever the next comic will be, I'm trying to think of it that way: "How can I make this like a more conventional type, or types, of comics that I've enjoyed?" And I won't necessarily end up there, but that's the attempt. I'd like to get all these things together, Jimbo and *Dal Tokyo,* all at the same place at the same time. And I hope I will. I'm making lots of notes for the next one.

Sometimes I reach a certain point where I wonder if I should just give up Jimbo. "Is this old hat? Do people want any more of this freckle-faced character walking around? Why am I doing this?" But then I always come back to him. I haven't revealed as much about him as possible, because I don't really want to speak directly about male-female relationships. And that's really what concerns people, the foibles and mistakes and temporary successes of living and relationships. But everyone makes comics about that, and then everyone does confessional comics, talking at the bar comics, and so in some way, I've kind of stuck to the action-adventure genre, a kind of abstracted version of that; because speaking about personal relationships is so much stickier and more painful and potentially troublesome [laughter]. You know, one part of me would love to just thrust Jimbo into all of this crazy sexual stuff, and maybe *Paradise* is where it's called for in a way. I do think about it and feel like it's a failing that I've just been so guilty . . . that I've never really done comics with women in them very much. It's kind of a guilt thing. I don't know . . . I started that *Cavegirl* strip and I still think about her and wonder, you know, what to do, but I just have to puzzle it out. ∎

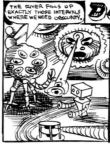

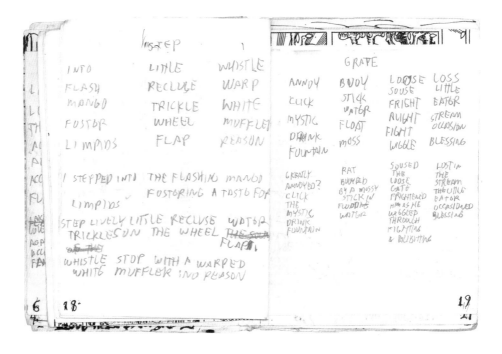

I discovered the Situationists much later in life, and I didn't really know the history. There was a lot of talk about them in punk times, and I learned a bit about them from Claude Bessy, the editor of *Slash,* who was French. That was my first notion, but it wasn't really until Greil Marcus's book [*Lipstick Traces: A Secret History of the 20th Century*] came out that I really had any idea. It was really only later that I realized that the détournement is kind of what I do in my comics—taking one source and changing the application. Since I'm continually looking for words in the environment to say the things I want to say, I guess I've accidentally grown closer to the Situationists in this regard. These new strips are a story that is very unclear—it's almost like Surrealist poetry at this point. Again, there's a story in my mind, but it's a story about the city as much as it is about characters; you're constantly meeting new characters and following one for a little while and then the narrative goes with another character. ∎

Gary Panter, *Dal Tokyo,* strip no. 113, June 5, 2005. Copyright © 2005 by Gary Panter.

Gary Panter, sketchbook word list, 2001. Copyright © 2001 by Gary Panter.

Gary Panter, fabric print design for the clothing label A Bathing Ape, 2004. Copyright © 2004 by Gary Panter.

I think there's been interest in me in Japan because it was real obvious in my work that I was interested in Japan. So I think that mirror kind of thing was interesting . . . this isn't a reason, but there's always that cliché of the Japanese copying everything, and I've copied and been influenced as much as I could by the Japanese—and continue to be.

Keiichi Tanaami, the poster artist, was someone I was influenced by really early on in the seventies, but I didn't know who he was. I'd just see bits and pieces of his things in design magazines, and I had some confusion about who he was. These new books have come out on him now, and it's very exciting to see masses of his stuff. He grew up during World War II and had a lot of experiences that informed his work, began making posters in the fifties, worked as the art director of Japanese *Playboy* for years, but psychedelic work and the psychedelic sixties are kind of what he's most known for. You see a synthesis of the Hairy Who, Robert Crumb, Victor Moscoso, and Heinz Edelmann's *Yellow Submarine* informing his work into kind of a new thing—it doesn't look like everyone else's stuff, but a new version. So these books coming out are inspiring a lot of young artists now, the Dearraindrop group and so on . . .

I recently had a show in Japan at Bape Gallery, which is the Bathing Ape clothing company. Back in the winter I designed a bunch of patterns and logos for them that they've applied to all kinds of clothing. That was my big job last year—they turned out really great and crazy; this stuff looks like weird pajamas to wear on the street, almost. They're superwarm, so you could climb Everest in them. I have a lot of hobbies, so I like the idea of jumping into these different areas. They're a real interesting company—kind of like hip-hop clothing gone crazy. A lot of work I do for them turns out odd, or perhaps misunderstood, which is a good thing, you know? This definitely doesn't look like normal clothing. ■

In Sulphur Springs, Texas, there was a music shop that had records, but there was also a drug-store closer to my house that had records, and that's where I saw *Freak Out!* [by the Mothers of Invention]. And I did freak out when I saw it [laughter]. That wasn't a Cal Schenkel cover, and neither was *Absolutely Free,* which was by Frank Zappa, but after that, Schenkel did most of the rest of the covers until the 1970s. I'm influenced by all these things . . . but the Hairy Who and Cal Schenkel are big. Schenkel had a real sketchy, scrape-y line, a really kind of per-sonal something . . . I've always liked crummy-looking stuff ever since I was a kid; I preferred stuff by the kids in my class who couldn't draw. ■

Gary Panter, album cover for
Frank Zappa, *Sleep Dirt,* 1979
(Warner Brothers). Copyright ©
1979 by Warner Bros. Entertain-
ment Inc.

My father painted in our house trailer until we had a house, and so I got the art bug really young. Picasso, Miró, Klee, all the Dada and Surrealist artists, George Grosz, more obscure people like Arthur Dove. Picasso and Dalí were really big, as they typically are for young people. For me, living on the border of Texas, weird Mexican signs and print jobs were very big. Mexican wrestling–type promotions and monster movies—a lot of pop cultural stuff, mass culture that scared me or fascinated me as a kid.

Dinosaurs led to a lot of things like Charles R. Knight, finding out who did what. I used to check out this book from the library, *Prehistoric Animals* by Zdenek Burian, who illustrated in gouaches or watercolors that look like photographs. I would check it out over and over again from the library. The *Oz* books, [Sir John] Tenniel, that type of drawing fascinated me from a young age. In the South, we had *Grit* magazine, so I could read *Mandrake, Nancy, Lulu,* or whatever was in there all day long when we went to visit some old friends' house. They'd be out on the porch in a giant stack. Newspaper comics fascinated me because I couldn't figure out how they were done. Al Capp . . . my father could copy these things—he could copy anything with a beautiful, steady line, but he didn't do full-blown comic strips. They look strange when you're a kid and you don't have that ability to stay focused on something for days, or whatever it takes to be Al Capp or [E. C.] Segar . . . ∎

Gary Panter, *La Maravilla Enmascarada/Oozing Tentacles*, limited edition offset print, 1987 (Nathaniel Bohlin). Copyright © 1987 by Gary Panter.

Gary Panter, serigraph accordion book, edition of 250, 1988 (Edité par l'A.P.A.A.R.). Copyright © 1988 by Gary Panter.

Famous Monsters of Filmland no. 1, 1958 (Warren).
Copyright © 1958 by Warren Publishing Co.

I don't know why boys like monsters. Why is it? It probably comes out of just pure existential trauma and primal worries and tragedies and weirdness. There was some weirdness and tragedies that happened to me when I was very young. And I also had to deal with Christianity and having really strange feelings about that. It's very death-obsessed; you go to church and all they talk about is how you're going to die and burn in hell forever or sing hosannas forever, and that gives you something to think about. Dinosaurs, big sharp teeth . . . that probably leads to monsters. And then there was Forrest J. Ackerman, with kind of a minischolarship school in a way; he was such a loci for that stuff. If you started reading *Famous Monsters of Filmland,* you quickly started thinking of yourself as a little scholar. That starts kind of a collector or intellectual prototype, and it served me. I started a monster drawing club in the fifth grade and all the kids drew five hundred–page monster books that we put together. I really liked the other kids' drawings better—I could draw in some kind of quasi-adult fashion and people thought that I drew the best, but I knew that the guys who were just going nuts were the best. Danny Sickles's older brother drew the Teenage Frankenstein, like, beyond Rory Hayes [laughter]. It all becomes part of tapestry . . . dynamic imagery.

Relations are kind of really interesting and really boring at the same time. I'd much rather see a Bruce Willis movie than some European . . . *The Piano* or something. Any movie makes me cry. Any big picture or semblance of humanity or struggle just kills me, so then when you get to really exotic, decadent behavior, it's kind of like too much [laughter]. Why don't they just try something else . . . rather than sit around and talk about their problems? ∎

Painting by Gary Panter's father, Mel Panter, c. 1995. Copyright © by Mel Panter.

My father is a giant influence and it would be hard for me not to mention him. He's about half Indian . . . not quite half Indian, and a big part of us growing up in Oklahoma was that there were still people speaking Choctaw. My grandparents worked at the Indian hospital—it was an Indian town, Tali-hina. Since he was half Indian, he was really pink so he was a standout from the really brown-looking people. He ended up doing very flat Native American–type things that I think are very influenced by Woody Crumbo, the silkscreen artist from the forties and fifties who did very flat, stylized things, though my father doesn't seem to remember his work. He was also really interested in cowboy novels and painting, so up to to-day he still vacillates between really flat, graphic, emblematic type of work, and naturalistic Western painting. He's still making work like a maniac. I think our brains are both wired in a similar way where we get excited being creative—it's just some accident, you know? I'm a little bit manic-depressive, but not in a horrible way. I get depressed sometimes and I just have to realize that I'm charging my batteries or something. But for the rest of the time I'm pretty much ecstati-cally trying to make things.

Anyway, he comes out of a superreligious background, the Church of Christ, fundamentalist, you know, "we're all right, everyone else is wrong" type of religion. My grand-father was an alcoholic until he was about forty, and he got jake leg and was crippled; my grandmother was an American Indian who had to be committed a few times for nervous breakdowns and started trying to talk to the rela-tives through light fixtures and things . . . so that was a real colorful place, Oklahoma. Storm shelters, tornadoes, and weird stories that go along with it. ■

Victor Moscoso, Martin Sharp, and Rick Griffin were all giant influences on me. Sixties poster art to me is the strongest thing that's happened in my lifetime, graphically. Underground comics might be the other thing, competing with a lot of other things I like. Griffin I saw a lot earlier, landlocked in Texas dreaming of being a surfer. You could see his stuff in magazines from the time he was thirteen or something, so god knows how old I was. ■

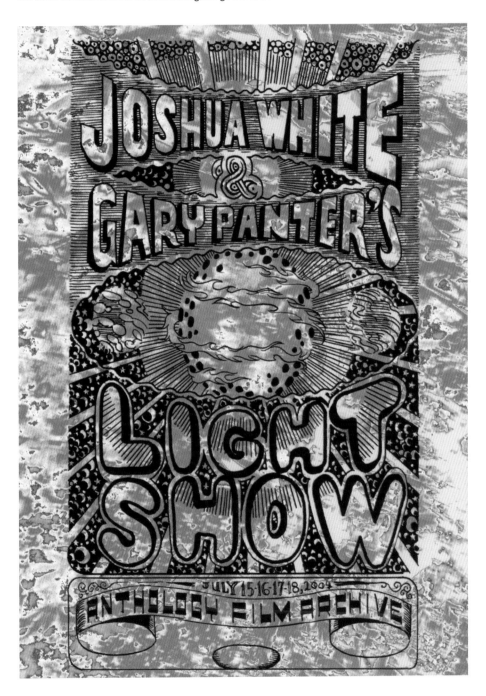

Gary Panter, poster for "Joshua White and Gary Panter's Light Show," Anthology Film Archives, New York City, July 15–18, 2004. Copyright © 2004 by Joshua White and Gary Panter.

Joshua White and Gary Panter, light show installation view, Hirshhorn Museum, Washington, D.C., 2005. Copyright © 2005 by Joshua White and Gary Panter.

Joshua White and Gary Panter, light show installation view, Creative Time fund-raiser at Spirit, New York City, 2005. Copyright © 2005 by Joshua White and Gary Panter.

I was in church, so didn't get to see the original light shows in the sixties. But it was really exciting, living in a small town, to get what was happening through media, looking at *Life* magazine, even *McCall's,* or record covers. I could see something was happening.

It's ephemeral . . . like visual music in a way. I've been doing these small things in my studio for years, reflective objects and distortions, and those are what eventually became the light shows. From doing my little light shows, I met Joshua White, who did the original light shows for the Fillmore East, the best and biggest. We've been working ever since—he's leading that collaboration, which is good. In any collaboration, someone needs to lead it. It seems to me, someone always ends up pushing harder, so I've pretty much just thought, "You're president of our light show." I throw my ideas out there and am interested to see what happens. He's the director and is talking to companies . . . We've got a number coming up. A lot of museums are doing light show surveys now, so we're trying to work with more institutions to help us mount them. We're trying to make them more into us being performers, so the supporting institutions can get the thing on the screen and project it, rather than us moving tons of equipment around from place to place. We've also talked to Broadway producers, trying to find someone to put us in a theater for six months. If you don't have to move equipment constantly, you can continue to build more and more effects. So we're trying to get a permanent home . . .

It's related to painting, certainly. We give the musicians thematic cues, some emotion we're trying to convey: "take off," "flying rhythm," "crash landing." And we'll take an initial visual image—we've used footage of James Brown, initial videos from the seventies of these fabulous girls dancing with these big hats and shoes—to fracture . . . Josh comes up with the simplest ideas: stretch latex rubber over a frame, glue mirrors to it, bounce the picture at it, then all I have to do is touch the mirrors and things rearrange crazily. Then when you take your hand away it all goes back to normal. It's like visual drums or something. Live, improvised with some ground rules. ■

I've always been kind of a music wannabe. I'm surprised that the music I've done hasn't been more noise in a way, but it seems like every time I've been able to record I have some song in mind, or someone asks for a song. A Japanese album I did has a ton of Christian-damage music on it, like I'm going to rave about this but way over there so my parents won't find out about it, even though they eventually will. I play guitar every day and am still working on stuff.

The stuff I did in college with Jay Cotton was mainly making a lot of noise, pounding on the piano with hammers and stuff—this was the seven-inch *Durchfall frum der Colahaus*, a collaboration led by Jay like all of our collaborations. It's a concrete noise piece: we would improvise, me playing on the low keys and him on the high keys. I had quasi-bands in junior high and high school, where I played guitar, but because of the religion, my experience was that the first time we played—we were called the Radiations—at the eighth-grade banquet . . . I thought I had gone there alone, but my parents had secretly followed me and they dragged me off stage as soon as kids started dancing during our second tune, "Wipe-Out" or "Louie, Louie," whatever kids could play back then. So my guitar playing is really stunted because I haven't played around people very much and I don't know the names of anything and I can't

Jay Cotton and Gary Panter, *Durchfall frum der Colahaus* EP, 1978 (Jay Cotton). Copyright © 1978 by Jay Cotton and Gary Panter.

Gary Panter, *Italian Sunglass Movie* EP, 1981 (Index). Copyright © 1981 by Gary Panter.

Gary Panter, *Pray for Smurph*, 1983 (Overheat Records). Copyright © 1983 by Gary Panter.

really retain numbers . . . I can memorize things but it takes me a really long time. I've been working on a terrible version of *Outside Woman Blues* for the last fourteen years [laughter]. I'm trying to get Edwin Pouncey, Charles Burns, and me together to do a record. Charles can play lead lines, which is what I can't do. I can play all kinds of complicated rhythmic stuff that's like leads, but I can't really improvise leads yet—he can actually find the notes. And Edwin—he just coaxes . . . he lays the guitar on a table, turns it up all the way, and then waves his fingers at it and all kinds of racket comes out. It's amazing. ■

Gary Panter and Savage Pencil, original art for *Nutsboy Necros*, collaborative drawing, 1986. Copyright © 1986 by Gary Panter and Savage Pencil. Collection of Glenn Bray.

It's really great to collaborate and it can be really fun, but not all collaborations work. When you go into it, you have to either quickly decide it's a go or that it's not going to work and get the hell out of it. You can waste years and create a lot of enmity. My rule for collaboration is, again, if someone wants to lead it, let them lead, and say yes as much as possible. Every time you say no, you're turning it into words instead of action; I think that almost any direction you go with people that are caring and responsible is interesting, so it's better maybe not to make a mental exercise of it.

Right when I started doing work for *Slash,* I became aware of *Sounds* magazine, and Edwin [Pouncey, aka Savage Pencil] was there doing the "Rock 'n' Roll Zoo" comic. Ideas were in the air—I had done drawings similar to Edwin in high school, and Jay Cotton, Edwin, Matt Groening, and I had all done cartoon versions of *Pressed Rat and Warthog* by Cream, because it's like a little comic. My version had been very much like sounds—attention to the line that's curving and interlocking with other lines in a certain way. I didn't know about Leo Baxendale until Edwin showed me his work . . . so maybe Don Martin was an influence. God knows.

I'm supposed to be doing a new comic for the upcoming *Corpse Meat* that Edwin is putting out. It bookends a little section of *Dal Tokyo* strips that are about these kids finding all these psychedelic flyers and becoming psychedelicized. They're future psychedelic flyers and then farther in the future the kids find them, so the pictures move and they're actually psychedelic so if you touch them you get high. ■

CRAGGY PLANETOID · STREAKING COMETS · FORESHORTENING · COSMIC DEBRIS · COMPLICATED MACHINERY · SIDELIGHTING · DISTANT SUNS · GIGANTIC SPACECRAFT · BLACK HOLES · HEAT TRAIL · TWO-PAGE SPLASH PANELS

I remember staying overnight at my friend David Douglas's house. I was eating bologna sandwiches on white bread with mayonnaise and he was showing me a pile of *Fantastic Four* comics and I wasn't getting it. "Okay, but it all looks like it's made out of melted candle wax or something." But then later that night I saw what he was talking about: that power, the explosive energy, the physics of the whole thing and the interlocking shapes that are operating very much like Mayan or Aztec glyphs. All kinds of stuff at work in [Jack] Kirby. ■

The guy that drew *Tarzan* real chunky [Jesse Marsh]—those things blew my mind, and I would recognize his work when I saw it in comics or even coloring books. ■

Gary Panter, "Homage to Jack Kirby," *The New Yorker*, March 28, 1994. Copyright © 1994 by Gary Panter.

(Opposite) Jesse Marsh, *Tarzan* no. 1, 1948 (Dell). Copyright © 1948 by Western Publishing.

His [Russ Manning's] style is a little quirkier and a little uglier, but *Brothers of the Spear* and *Magnus, Robot Fighter* were really important comics to me. Just the idea that you could be in a room with robots or dinosaurs had a lot to do with it. ■

Russ Manning, *Magnus, Robot Fighter* no. 15, detail of interior page, 1966 (Gold Key). Copyright © 1966 by Western Publishing.

Gene Ahern, *The Nut Bros.*, Sunday strip, May 30, 1948. Distributed by Newspaper Enterprise Association. Used by permission of United Media.

Before I saw Crumb, I was really into *The Nut Bros.*, which ran as a side comic to *Our Boarding House* with Major Hoople. In some ways, *The Nut Bros.* have this goofy way things hook together, almost a Dr. Seuss way, that you see in really early Crumb. Cars, windshields . . . weird connections. ■

I couldn't believe the early underground cartoonists were such a talented crowd. I really took to all of them. Somewhere in print I've probably been critical of Spain [Rodriguez], just because he's standing in a room with these maniacs that finish things out a little bit farther out than him, in a way . . . though I feel like my style is more related to Spain's in some way through Kirby. Moscoso and Griffin were revolutionary for comics. There hadn't been comics that looked like that . . . illustration looked more like that. Griffin's psychedelic wig-out stuff is just very eccentric. All the *Zap* guys: I'd been following Robert Williams from all those hot-rod ads in the sixties, so I knew about his style. Then in hippie days, I'd seen some early articles about his painting—his work struck me as incredibly scary-bizarre. Moscoso takes you to kind of a fluffy place, Griffin takes you to kind of a scratchy, fluffy place, S. Clay Wilson takes you to that junior-high-school place, but Williams takes you to a really scary place. It's kind of like the *Alice in Wonderland* place, like in *Through the Looking Glass,* where the horrible insect forms out of the little ball and the stick. It's just like, "Oh, fuck, what is this?" [laughter] That's what Williams's work is always like.

I'd also been following Gilbert Shelton's *Wonder Wart-Hog* from the early days . . . [Alex] Toth from *Car-Toons*. I was pretty much jumping in every subculture in the world. It was boring out there in Texas, so I was looking at every part of media I could. "What's in there?" You'd look for the shiny stuff, I guess. What a crowd. It had to do with the invention of television and World War II and repression of the comics—it was like this thing they all had in common somehow. It was funny that after them, here came the rest of the hippie cartoonists, and they were good drawers, but they just didn't have these eccentric, shotgun styles. ∎

The next people that stood out from underground comics as being something different . . . I remember fantasizing all the time about sending my work to *Arcade,* but I just didn't think it would fit. Mark Beyer was in there, which excited me, but the other guy was Michael McMillan, who did *Terminal Comics.* He was always different and psychedelic and sometimes really falling apart. Rory Hayes would fit in that crowd as well, not quite hippie comics. Edwin [Pouncey] and Sue Coe and Ian Pollock, Ian Wright, English illustrators that were bringing fine art into illustration art . . . ∎

Robert Williams, "Pee for Free, a Penny a Poop," *Coochy Cooty Men's Comics* no. 1, splash page, 1970 (Print Mint). Copyright © 1970 by Robert Williams.

Michael McMillan, "Rita Markee, Pilgrim to Paradise on La Cock A Roach Cho Cho," *Arcade* no. 2, splash page, 1975 (Print Mint). Copyright © 1975 by Michael McMillan.

Elles Sont de Sortie no. 10, *Pornographie Catholique,* 1982 (Le Dernier Terrain Vague). Copyright © 1982 Le Dernier Terrain Vague.

Guys like Pascal Doury and Bruno Richard had a big influence on me right before the eighties. Bruno came to visit right before, in '78 or so, and started pushing me: "Darker, more, more dark, more shit on the page!" So when I'd go on vacation, I'd take *Elles Sont de Sortie* and look at it on some beach somewhere and it made my work darker. Right at that moment Neo-Expressionism happened, so everyone was scribbling and everything was dark, and the whole Lower East Side thing happened really quickly—and was quickly sewn up. But for me, *Elles Sont de Sortie* had more influence than all that other stuff that happened in the eighties, which was like a lot of things that my teachers, as second-generation Pop artists in the sixties, were trying to escape from. My teacher Bruce Tibbets, his work was very much like Sigmar Polke,

using slide projections and multiple imagery, taking things from all different places; Kitaj and Paolozzi showed ways of proceeding . . . all of my teachers were trying to move ahead from Johns and Rauschenberg. In the eighties, David Salle came along and said, "I don't have to move ahead. It can be one second after Rauschenberg and it'll be great." And he was right. The same thing with all those guys. All the big art stuff is about presentation in a certain way. To get into the art world, you have to make it in a certain proportion [laughter]. And you have to know what that proportion is, and I've always kind of ignored that proportion. ∎

Gary Panter, original art for "Jimbo," *Raw* no. 6, splash page, 1984 (Raw Books and Graphics). Copyright © 1984 by Gary Panter. Collection of Glenn Bray.

Gary Panter, *The Asshole*, edition of five hundred, 1980 (self-published). Copyright © 1980 by Gary Panter.

(This spread) Gary Panter, four sketchbook covers, 1999–2001. Copyright © 2001 by Gary Panter.

I look back over thirty years of sketchbooks and just think, "If I just hadn't thought so much, if I'd just drawn more and not worried so much I'd have more to look at." But back then I was thinking, "I don't want to just sit here and draw girl heads over and over and over," like people do in their sketchbooks. So I guess I'm doing more of that now—letting myself draw stupid dogs and cats and maybe learn how to draw girls even—use them to just spew ideas out.

There are classes of imagery that will head different places. There are pieces of things headed for paintings and things that can never be in paintings, ideas that might be good for animation . . . I'm dreaming in two dimensions about three dimensions a lot, where I'm actually planning buildings and houses, and actually building little architectural models. In my mind, they're all about trying to learn how to actually build something in the future. I can design billion dollar amusement parks in sketchbooks that don't get built, but when the day comes that someone knocks on the door and says, "we need you to design a billion dollar amusement park," I'm ready to go. That's one thing they're about—having resources. They go

Gary Panter, architectural model, c. 2000–2004. Copyright © 2004 by Gary Panter.

back to being in high school. You're in school all the time and when Saturday comes it's like, "What do I do with myself?" I'd be depressed: I want to have freedom but I don't know what I want to do. A lot of being an artist was never feeling that way again. I've just got way too many leads to follow up and I'm happily chasing them in all directions.

One thing I have tried to go for . . . a lot of people will go, "What is this? It's just kind of crappy." If you look at one of my pieces, maybe it's like that, but if you look at a thousand pieces I did, then suddenly you realize that all thousand are screaming about a million more pieces in a way. You're trying to pop a whole world open with a picture, you know? It's a point of view or there's all these ways and things to manipulate in the human psyche, really. In the sketchbook pages that ran in *Raw*, I was trying to get at something that already looked printed.

(This spread and following pages) Gary Panter, sketchbook pages, 1999–2001. Copyright © 2001 by Gary Panter.

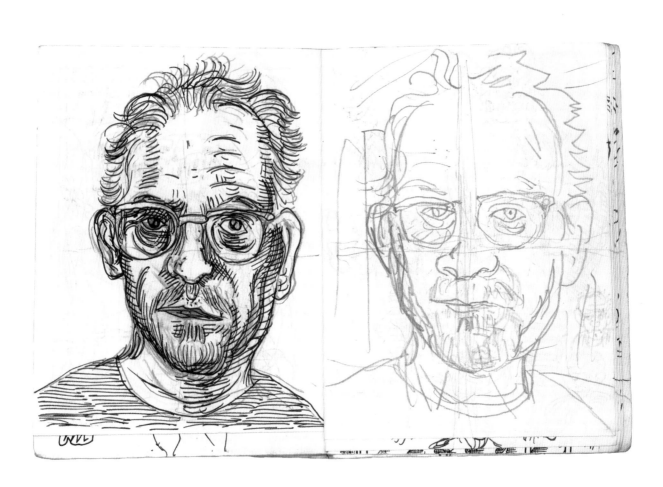

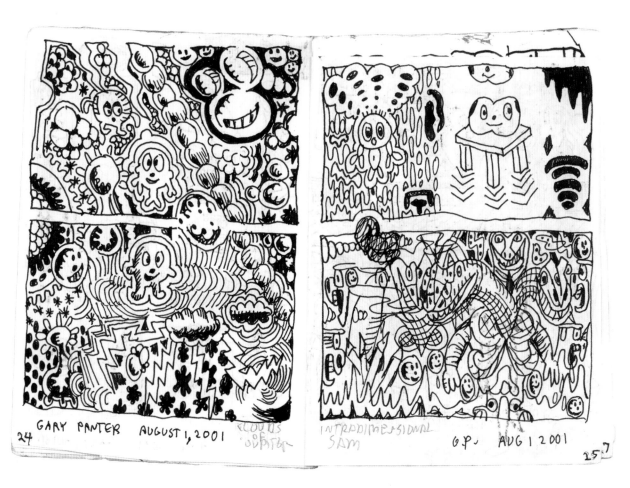

24 GARY PANTER AUGUST 1, 2001 CLOUDS OF JUPITER

INTRODIMENSIONAL
SAM G.P. AUG 1 2001

25

LONDONDERRY 69

GIANTS CAUSEWAY

2 IRELAND 1969 5

Even though it was a bad quality job, it would have the authority of printing. That's another fascinating thing that came out of Pop art or reading McLuhan, that the medium is the message is really simple to me. It's not too hard to imagine that every time you have a new tool, it engenders a new type of thinking, and every old tool engenders a different type of thinking, a different mental state about the image. My students all want everything to be easy, so it's all brush pens, ballpoints, Sharpies, but then they're only going to have this kind of fast-food brain. For years and years I would do strips and not use pencils at all, I just had to be inspired to draw the panel I wanted to draw. It was a waiting game [laughter]. ∎

Gary Panter, sketchbook pages, 1999–2001. Copyright © 2001 by Gary Panter.

It all has to do with the power of the medium: if you see a knife scrawl of a dick in a bathroom stall, it has a kind of power. If you see a total retard mechanic sign somewhere painted with a tar brush on the wrong material, it can just be astounding. That was the thing about CoBrA and all that backward-looking stuff—or Dubuffet's point about madmen and children: you can't really beat them at their game. You can make something that uses those kind of words, but . . . you know, Henry Darger just totally did everything I was trying to do up to that point. He did everything you need to do to make work with this power . . . down to the carbon paper.

What do you do in painting: you can make shape paintings, big paintings, make them out of exotic materials—or you can paint rectangles that refer to landscapes with people on them. And that's what I do now. For years I've just had that traditional approach to painting. And that's what he did. What Ed Ruscha did with those superwide paintings that represent the West and space, Darger was doing that at home, too. ■

Gary Panter, *Jimbo and Valise*, wood engraving, edition of one hundred, 2003 (Buena-ventura). Copyright © 2003 by Gary Panter.

(Below, right) Gary Panter, original drawing submitted to clay animators to create the closing logo for the television show *Pee-wee's Playhouse*, 1986. Copyright © 1986 by Gary Panter.

(Below, left) Gary Panter, sketch of *Pee-wee's Playhouse* exterior, 1986, the initial inspiration for the exterior view of the playhouse; several room-sized models were made of the outside and environs of the playhouse based on this sketch. Copyright © 1986 by Gary Panter.

One thing that *Pee-wee's Playhouse* was is the realization of a hippie psychedelic show. In the sixties everyone sat around and said, "Yeah, man, if we could just get control of the media, then we could do some really crazy shit!" When I met Paul [Reubens], I realized he was on the same beam as that: he was an old—or youngish—hippie, too. When he got me hired onto projects, I was able to retain Wayne White and Ric Heitzman. We all had similar styles and had all been to art school, and we could really function as one, almost. At that point, it was psychedelic blow-out, neglected mediums in a way, puppets—the worst, most embarrassing thing in the world, except when they're good . . . or bad enough. Shadow puppets, puppet plays in Indonesia, which go along with woodcut handbills, hippie light shows with their flyers . . . so *Pee-wee* would be television and marketing and products and color. A lot of what I did with the show that I thought was successful was with color—it was this completely chaotic palette, but I quickly found out that when something goes to video, it looks darker. You have to make colors paler as a general rule of thumb, and we got patterns everywhere. I was learning as I went along—I'm much more capable of doing this stuff now, but back then we were just trying to figure out what to do. It was all about Paul—we had ideas and colors we wanted to use, but it was all about making the Pee-wee world, and Paul was totally involved in the art direction. ∎

Gary Panter, drawing of *Pee-wee's Playhouse* interior, 1986, created early in the show's first season, at which time the set was half-formed, for meetings with the production company to demonstrate how all the pieces of the set might come together. Copyright © 1986 by Gary Panter.

Gary Panter, poster for "Divine Comedy" lecture at New School University, March 22, 2005. Copyright © 2005 by Gary Panter.

The main thing that I stress to my students is the separation of personal expression versus commercial art. I really think that you're just set to get your heart broken if you go into commercial art trying to do your art there. Some people can and it's natural for them, but you really have to serve people, and that's the idea of it. When you do commercial illustration— and I've said this a billion times because someone said it to me when I was in college—you need to take your ego out and put it in a box to be a commercial artist. On the other side, you can be Captain Nemo, and you should be. I try and encourage my students just to stick with it because attrition must be gigantically huge for artists.

I do truly believe that one of the hopes and salvations—and a delusion, too—of humanity is design. And life can be designed in a better way: it feels better, it's nicer, there's less suffering, and it engenders better, nicer thoughts and an interesting world. And we're living in this undesigned, jumbled nightmare, which is kind of fun and crazy, but there's something else out there. ∎

b. 1955

4. Charles Burns

In the early 1980s, Charles Burns began deconstructing romance and horror comics in order to get at the potency in the iconic imagery and buried subtexts, later expanding this formal evisceration into sustained narratives of both humor and anxiety, always characterized by an icy remove. Burns's early single-panel *Mutantis* cartoons introduced his hard-edged, Manichaean style, as well as the themes and types of bizarre characters who would populate his future stories and widely heralded illustration work. Single images and early short and serialized strips appeared in a number of American and European avant-garde anthologies (most notably, *Raw*), demonstrating that his distinctive mood and larger aesthetic were surprisingly mature from the outset, a disorienting black-and-white glow never before seen in the medium.

Burns's art perfectly personifies the antiseptically cool, mechanical style of midcentury comics in order to lay bare (and subvert) the menacing undercurrents hinted at in both teen romance and alien invasion cautionary tales; the stark clarity belies the nebulous and conflicted clues lying just beneath. He pushes impossibly cold, clinical cartoon inking past the level to which it had hardened in the comics of his youth, to jarringly read as somehow mechanically produced prior to reproduction. Burns doesn't mimic but rather isolates and foregrounds the inherent strangeness and alien power of slick artwork and flat authority of the printed image—there's literally no "relief" in his world—which to many an overwhelmed reader appear so flawless as to virtually confound the source, mirroring a common formative confusion by young followers of genre comics. Each panel is dramatically composed, calling attention to the static artificiality of the language, to alternately disarming and humorous ends, and Burns revels in the disreputable elements of subject and style that characterize a good percentage of the medium's cut-rate history, hinting at the horrific that creeps below the surface of melodrama, mining the disjunction between text and subtext, and exploring how the gradual accumulation of seemingly minor but emblematic stylistic clues heightens overall narrative effect.

Charles Burns, self-portrait, 1992. Copyright © 1992 by Charles Burns.

Charles Burns, "The Smell of Shallow Graves," *Raw* 2, no. 2, single-page strip, 1990, recolored by the artist for this publication (Penguin). Copyright © 1990, 2005 by Charles Burns.

WALKING DOWN A COOL DARK ROAD... SAD TEENAGERS WHO WON'T STAY DEAD.

CREEPY CRAWLING IN THROUGH THE BACK DOOR LATE AT NIGHT AFTER MOM AND DAD ARE SAFE IN BED...

THEY STAY A WHILE...MAYBE WATCH T.V., MAKE A SANDWICH...ALWAYS LEAVING *SOMETHING*: A STAIN ON THE SOFA, A CLUMP OF HAIR, A DECOMPOSED FINGER...

...AND ALWAYS THAT SAME ODOR — HARD TO DEFINE...SOMETHING WILD AND ROTTEN...THE SMELL OF SHALLOW GRAVES.

c. 1990 BURNS

(Opposite) Collaged news-
paper comic strips, collected
by the artist's father, 1940s.

In the past decade Burns has deepened and intensified his ongoing theme of the
"teen plague," a dominant strain of his work since the late 1980s, to function as broad
allegory for raging pubescence's intractable fusion of emotional miasma, social and
biological. The ultimate manifestation of Burns's vision is his opus *Black Hole,* which
hones his wrenching dissection of "dark, hidden high school horrors" (not coinciden-
tally, the traumatic postadolescent period in which comic book imagery wielded great
power). Expanding the fearsome leitmotiv of sexually transmittable disease into the
rumbling inky landscape at large, fertile with layered and accruing implication, and
horrifically pregnant with "more than night," Burns's focus has spread outward as
an intricately entangled macrocosm. His ongoing devotion to the exceptional, jarring
density of the cartooning language is immediately spotlit in startling juxtapositions of
normalcy and contamination: the perfectly pitched personification of a bad acid trip's
aftermath sharpens his nightmarish tone and resonating pinpoint characterization,
evincing a deeply internalized and askew reality. Visceral immersion is achieved through
all-encompassing metaphor, as outer space aliens are replaced by the much more sin-
ister alienation of the teenager. Through a constant process of refinement and paring
down to economical precision, whereby style and subject matter are inextricably fused,
Black Hole is the absolute realization of Burns's evocative universe, and as one of the
most sustained, complex, and layered graphic novels to date, stands as a watershed
monument. ■

This is a scrapbook my father put together that I've been looking at all my life—I've even
"stolen" a few of the images for my comics. It's made up of a bunch of comics he cut out
of daily and Sunday papers, but it took me a long time to figure out that there's some logic
behind how they're arranged; it started out as his reference file of cartoon heads and bodies.
Up in the corner of each page is a notation, like F (Female) Standing or M (Male) Fighting. He
must have lost interest with it after a while and ended up filling the book with the rest of the
strips he'd clipped. It's one of my most prized possessions. ■

Charles Burns, *Tales That Are Strange*, homemade comic book drawn when the artist was in sixth grade, 1966. Copyright © 1966 by Charles Burns.

Ah yes, meet "Doctor Shreaded Head." I guess that should be "Doctor *Shredded* Head," but I was never a very good speller. Back in 1966, when I drew this cover, there was already a comic out there called *Strange Tales,* so I had to call mine *Tales That Are Strange*. The comic consists of three short stories, including one called "The Leaches." It's got some pretty great dialogue: "The fools! Everyone thinks I'm mad . . . I will show them!" And then later on: "At last I have proved that I can control leaches!" ■

Will Elder is such an amazing artist. There was a series of black-and-white reprints of Harvey Kurtzman's *Mad* comics that came out in the late fifties that I used to look at for hours. When I say, "look," that's because this was back when I was a little kid, before I could even read. I guess because I couldn't read and didn't have a clue as to what most of the stories were about, I'd make up my own narratives. I know the stories are supposed to be funny, but some of them were incredibly creepy and violent, like this Wonder Woman parody. You've got these two naked, bearded guys with machine guns pointed at a very voluptuous Wonder Woman. I guess they were supposed to have skin-tight outfits on, but because I was reading the story in black and white, I assumed they were naked. ∎

This is from a book called *Weird Women Coloring Book* that I published back in 1975. It's printed on the cheapest, crappiest newsprint paper I could find so it would emulate kids' coloring books. It's aged well; the paper's almost orange. ∎

Will Elder, "Woman Wonder!" *Mad* no. 10, interior panel, 1954 (E.C.). Copyright © 1954 E.C. Publications, Inc. All Rights Reserved. Used with Permission.

Charles Burns, *Weird Women Coloring Book,* interior page, 1975 (self-published). Copyright © 1975 by Charles Burns.

Charles Burns, *Mutantis*, single-panel cartoons, 1982. Copyright © 1982 by Charles Burns.

I did these back in the early eighties, when I was struggling to find ways of getting published. I remember hearing that the *Village Voice* was looking for a comic or some kind of art to fill a small section on their back page, so I tried coming up with a series of one-panel, gag-style comics. I guess the *Voice* wasn't all that impressed. Eventually they ran in *The Rocket*, a free monthly paper that came out of Seattle. ∎

While looking through my pile of old romance comics, I stumbled across not one but *three* bad "swipes" for this kissing couple. Stealing from the masters. ∎

Three comic panels depicting the same image, culled by the artist from undocumented romance comics, c. 1950s and (bottom) Burns's version.

Before I started working on *Black Hole,* I did a few stories that played around with the whole "teen plague" theme. I don't know why, but it was an idea that just got stuck in my head. Adolescence was such an intense, traumatic period in my life and I wanted to tell a story that would capture some of those feelings. ■

(Right) Charles Burns, original art for "Contagious," *Taboo* no. 1, splash page, 1988 (SpiderBaby Grafix). Copyright © 1988 by Charles Burns.

(Below) Charles Burns, original art for *Black Hole* no. 11, end-papers, 2003 (Fantagraphics). Copyright © 2003 by Charles Burns. Used by permission of Fantagraphics Books.

(Below, right) Charles Burns, original art for "Teen Plague," *Raw* 2, no. 1, splash page, 1989 (Penguin). Copyright © 1989 by Charles Burns.

This is the artwork for the end papers in *Black Hole* no. 11. When I started the series, my plan was to make an initial drawing, a detailed overhead view of the ground out in some woods, and then add on to it each issue; fill it up with layers of trash and debris. When I got to the next issue, that sort of felt like cheating. Even though it takes me forever to draw each pebble and twig, I make a new drawing each issue. ■

I just got a digital camera, so I've been motivated to start taking photos again. This one's my favorite: it's an unbelievably sad little pencil sharpener I stole from my daughter. ■

Charles Burns, original photo-graph, c. 2000. Copyright © 2000 by Charles Burns.

I painted this for a friend in the early eighties. It pre-dates my first Dog-Boy comic by a few months. ∎

Charles Burns, original Dog-Boy painting, early 1980s. Copyright © by Charles Burns.

Charles Burns, *The Cat Woman Returns*, detail of photo comic, late 1970s. Copyright © by Charles Burns.

This is from a comic I made in the late seventies called *The Cat Woman Returns*. I was looking at a lot of Mexican photo comics at the time and I thought I'd try one of my own. The story isn't all that great, but the whole process was beneficial in that it helped me step away from the way I'd always written comics. Because I was working with photos and had to set up each shot, it forced me to organize and structure the narrative in a way I'd never really done before. ∎

Entertainment Weekly hired me to do this illustration for their "year end" issue back in 1995. They had decided that Terry Zwigoff's *Crumb* was their pick for best movie of the year. Robert Crumb is probably the best cartoonist living on the planet and has always been a huge influence and source of inspiration, so I wanted to do the best illustration I possibly could as a tribute to him. I spent hours on this thing trying to squeeze in all of my favorite characters— can you see Bill Ding standing in line for the movie? Anyway, I finally finished it and sent it in only to find out that the editor had changed his mind and had decided some lame Oliver Stone movie was his favorite movie of the year. ■

Charles Burns, illustration of Robert Crumb, *Entertainment Weekly*, 1995, recolored by the artist for this publication. Copyright © 1995 by Charles Burns.

Most of the images from *Close Your Eyes* were drawn while I was waiting for my daughters to finish up their piano lessons, but I think this one was actually done during a recital; that's at least an hour's worth of crosshatching. ■

(Top) Charles Burns, *Close Your Eyes,* 2001 (Le Dernier Cri). Copyright © 2001 by Charles Burns.

(Bottom) Charles Burns, original art for *Close Your Eyes,* pp. 22–23, 2001 (Le Dernier Cri). Copyright © 2001 by Charles Burns.

This drawing was taken from an old 1950s crime comic. It was going to be used for one of those Zippo lighters, but the company, whoever makes Zippos, wouldn't accept the design. I guess it was the X on her forehead that put them off. ∎

Back in the early eighties, Marvel put out a book called the *Marvel Try-Out Book*. It was a big oversized thing that had penciled comic book pages printed in nonrepro blue on heavy-weight paper, so aspiring cartoonists could try their hand at inking them. I bought a cheap copy from a street vendor in New York and thought it would be fun to play around with. At first, I tried to ink it "straight" just to see if I could do it, but before I even got through one panel, I realized I was bored out of my mind and I'd never pull it off. Once I got Aunt May into black underwear I knew I was moving in the right direction. ∎

Charles Burns, original art for *Close Your Eyes*, pp. 94–95, 2001 (Le Dernier Cri). Copyright © 2001 by Charles Burns.

Charles Burns, original art for *Naked Snack*, interior page, stemming from *Marvel Try-Out Book*, early 1980s. Copyright © by Charles Burns.

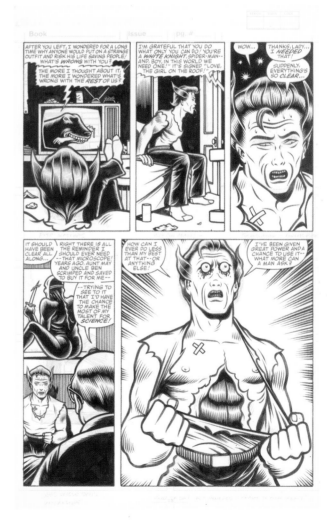

A selection from Charles
Burns's Japanese toy
collection.

I'm not a collector in the sense that I *have* to have these in order to complete
my collection of Japanese vinyl toys; I just enjoy looking at beautiful, cheaply
produced toys. ■

Charles Burns, original concept drawings for
Monster Teens figures, c. 2002. Copyright ©
by Charles Burns.

Last year I was contacted by Presspop in Japan to design a
set of toys for Sony Entertainment; it's the same company
that put out the figures by Jim Woodring and Pete Bagge.
The communication was a little bit difficult—I didn't have
a whole lot of guidance other than, "Teenage monsters
are good." I have pages and pages of designs that never
got used, especially the early ones. These are two of the
"rejects." ■

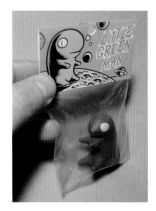

I sculpted an alien creature out of green clay when I was about seven or eight and called it "Little Green Man"—I even built a huge futuristic city out of cardboard for him to live in. This is a replica made out of Sculpey that I packaged up for myself and a couple of friends. ■

I designed this to look like the old Aurora monster model kits that I put together when I was a kid. Some friends of mine sculpted it and cast it in resin, but they were only able to make four or five of them before the molds broke apart. ■

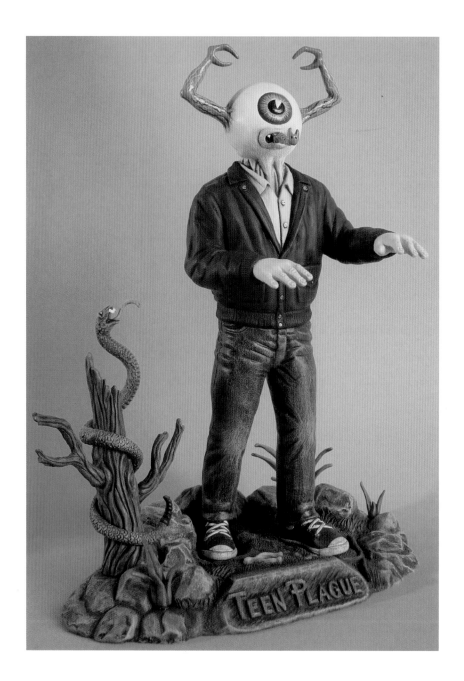

Charles Burns, *Little Green Man* figure, c. 2000. Copyright by Charles Burns.

Charles Burns, *Teen Plague* model kit, c. 1990s. Copyright © by Charles Burns.

Famous Monsters of Filmland Yearbook, 1965 (Warren). Copyright © 1965 by Warren Publishing Co.

(Above and right) Charles Burns, various stages of preliminary sketches for *Black Hole* no. 5, cover, 1998 (Fantagraphics). Copyright © 1998 by Charles Burns. Used by permission of Fantagraphics Books.

Most of my visual ideas start out as crude images I scrawl down in my notebooks—more like notations than drawings. When I get to the actual drawing stage, I start with very rough, gestural forms and then slowly refine them. I work on tracing paper so I'll cut parts out, reposition them, try out different compositions. When I'm happy with the basic structure, I'll flip it over and start a new, more refined drawing. If you stare at a drawing for a long, long time, you start to get the image engraved in your head and you don't notice all the clunky, distorted parts. By flipping it over you get a new, clear view of it. In the final stage I use a light box and do yet another more refined drawing on good paper, then I finally ink the thing up. ■

Charles Burns, various stages of preliminary sketches and the final artwork for *Black Hole* no. 5, cover, 1998 (Fantagraphics). Copyright © 1998 by Charles Burns. Used by permission of Fantagraphics Books.

Manny Stallman and John
Giunta, "Heartline," *Cham-
ber of Chills* no. 23, detail of
interior page, 1954 (Harvey).
Copyright © 1954 by Witches
Tales, Inc.

I re-inked this page to use on the back cover of the Fantagraphics edition of *Skin Deep*. I didn't
change anything—I didn't need to; the art and the story and the coloring are perfect. "I hear a
snap. It was my brain." ∎

Charles Burns, original art for *Skin Deep*, detail of back cover, 2001 (Fantagraphics). Copyright © 2001
by Charles Burns. Used by permission of Fantagraphics Books.

Charles Burns, paper theater,
c. 1990s. Copyright © by
Charles Burns.

This was for the *New York Times Sunday Magazine;* they were asking artists to do Christmas
window displays, three-dimensional pieces, so I came up with this. It's based on a classic Brit-
ish toy theater design, and I made a Christmas scene set up at the North Pole with Santa's
elves making toys. Even though it's a three-dimensional piece, it ended up looking pretty flat
when it was photographed. I was really interested in paper theaters at that point, so this was
an excuse for me to build one of my own. ■

Another badly Xeroxed book. Sometime around '82 I
started drawing little self-portraits in the front of my note-
books and this is just a collection of them. The drawings
aren't too good, but it's fun to watch me get old. ■

Charles Burns, *Plague Boy: 80 Self Portraits*, 2001
(self-published). Copyright © 2001 by Charles Burns.

Charles Burns, *Drawn from Memory: Some Disjointed Pencil
Drawings*, 2001 (self-published). Copyright © 2001 by Charles
Burns.

This is just a self-published thing I did that shows the early
stages of some of my *Black Hole* pencil drawings. When I put
this book together, I realized the most interesting drawings for
me were the first attempts; the rough, smeared images that can
sometimes almost look abstract. ■

"You got any free shit?" I print up about fifty of these before I go to conventions and give them away to anyone who wants one. ■

Charles Burns, three issues of *Free Shit*, late 1990s–2003 (self-published). Copyright © by Charles Burns.

Gary Panter is one of my favorite artists of all time. Here he took some men's magazine photos and drew clothes back onto the women [laughter]. ■

This is a slightly reworked drawing that I did for the cover of *Dope Comix* no. 5. I did this early on, right around the time I started doing stuff for *Raw*. Undergrounds were almost dead, but I guess a few titles like *Dope* sold well enough to struggle along. This was the last issue—the "All Marijuana" issue—so in the original, the guy's holding a joint. At some point, I got an offer to make a big silkscreen print of this, so I edited out the joint. Wouldn't you? ■

(Left) Gary Panter, untitled minicomic, undated (self-published). Copyright © by Gary Panter.

(Above) Charles Burns, reworked original art for *Dope Comix* no. 5, cover, 1984 (Kitchen Sink). Copyright © 1984 by Charles Burns.

At some point in the eighties I collected
a whole load of underground comics.
I had picked up all the obvious ones
when they originally came out, like all
the Crumb books and all the *Zaps*, but I
wanted to find some of the more obscure
titles that I'd seen in head shops but
wasn't willing to pay good money for.
Some of these are amazing: *Kukawy* by
John Thompson, *Insect Fear* with a cover
by Spain [Rodriguez], and, last but not
least, one of the most wigged out under-
ground series of all time, *Armageddon* by
Barney Steel. ∎

I tried to find some information online about Pierre La Police, but I couldn't come up with anything. All of his books are in French, so it's impossible for me to know what kind of a writer he is, but his artwork is outstanding—a kind of weird, mutant scratch-board look to it. This image is from a book called *The Gum*. ■

Pierre La Police, *The Gum*, detail of interior page, 1994 (Jean-Pierre Faur). Copyright © 1994 by Pierre La Police.

(Opposite)
(Top left) John Thompson, *Kukawy Comics* no. 1, 1969 (Print Mint). Copyright © 1969 by John Thompson.

(Bottom left) Spain Rodriguez, cover for *Insect Fear* no. 1, 1970 (Print Mint). Copyright © 1970 by Spain Rodriguez.

Barney Steel, *Armageddon* no. 3, 1974 (Last Gasp). Copyright © 2000 by Barney Steel.

Charles Burns, preliminary drawings for *Little Lit: Strange Stories for Strange Kids*, c. 2001 (HarperCollins). Copyright © by Charles Burns.

(Below) Chester Gould, original art for *Dick Tracy*, daily strip, June 3, 1959. Copyright © 1959 by Tribune Media Services. Reprinted with permission.

When I was working with Art [Spiegelman] and Françoise [Mouly] on the cover for *Little Lit*, I came up with what I thought was an appropriately spooky image. They looked at it and said, "Well, this book is for real little kids. Make the creature less scary." I worked on it and made it a bit cuter, and they said, "Well, no, it's still *really* creepy." So then I got out all my Japanese comics to try and figure out, "What *is* cute?" [laughter] I did a bunch of sketches and let them pick their favorite sweet, big-eyed creature. ∎

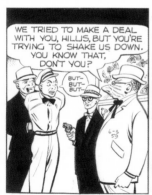

I've never been able to afford to collect original comic art, but I *had* to have an example of Chester Gould's *Dick Tracy*. ∎

I was living in Italy for a while and worked with a group of Italian artists called Valvoline that included Lorenzo Mattotti, Igort, Giorgio Carpinteri, and a number of other cartoonists. We would do collective pieces for some of the monthly magazines, and that's what this is from. You can see I was influenced by the way they were doing their color work, which was a very painterly approach. My color still looks flat for the most part, but I was trying out color markers and pens. ∎

Charles Burns, original art for *Dim Bulb*, comic strip, early 1980s. Copyright © by Charles Burns.

The Outer Limits was a weekly television show that I watched religiously when it first came out in the early sixties. Some of stories were actually pretty good, and a few were amazingly dark and eerie, especially the episodes directed by Gerd Oswald. Topps Chewing Gum put out a set of *Outer Limits* cards in 1964 that featured "colorized" pictures of the various monsters and aliens from the show. I guess there was some kind of copyright control on the televised stories, so the folks at Topps made up new, ridiculously infantile stories to go along with the photos. My favorite was a card with the title, "The Brainless Glob." ∎

The Outer Limits, three trading cards, 1964 (Topps Chewing Gum). Copyright © 1964 by The Topps Company, Inc.

b. 1959

5. Jaime Hernandez

Fiercely devoted to a smartly unrepressed view of the comic medium's far-reaching possibilities, brothers Jaime, Gilbert and Mario Hernandez's *Love and Rockets* single-handedly opened the door to new modes of thinking about comics geared toward adults, and as such represents the pivotal moment in the burgeoning early-1980s alternative movement. Expanding upon the straightforward storytelling structure and warm tones of the best kids', humor, and superhero comics, Jaime Hernandez has injected a previously unseen level of characterization and highly nuanced emotional insight into the serialized comic book format with his ongoing "Locas" stories, which he has continued to expand, deepen, and interweave for nearly twenty-five years. In the process he has created some of the most memorable and lasting characters in the history of the medium.

As much built on the classical midcentury American tradition of comic book storytelling as informed by the revolutionary taboo-breaking subject matter of the sixties underground artists, Hernandez's work encompasses many of the formal and narrative concerns of the two approaches: respectively, a mastery and cutting-edge implementation of a commercial mode of cartooning, and the depiction of marginalized, "underground" subcultures—for Hernandez, the Mexican-American culture of southern California and the early and gradually fading punk rock milieu. If Hernandez's virtuosity can be seen on one level as a revolutionary combination of these two avenues, diagramming the informing roots of his underlying sensibility falls painfully short of doing justice to the ultimate achievement. While elements of his work reference the form's past, always with an essential twist, the connection is merely a jumping-off point: any and all commercial and artistic genres—romance, science-fiction, superhero, "real-life" character types—are inherent backdrop elements, fictional in a sense, to be combined, manipulated, and transcended all at once, reconfigured within Hernandez's mastery of the language of comics to create an expansively poetic *inner* reality.

His groundbreaking "realistic" depiction of everyday lives, always keenly observed with a decided lack of pretension, is his most impressive accomplishment, and the

Jaime Hernandez, self-portrait, 2005. Copyright © 2005 by Jaime Hernandez.

Jaime Hernandez, "When I Was Little," *Comic Art* no. 1, single-page strip, 2002. Copyright © 2002 by Jaime Hernandez.

WHEN I WAS LITTLE...

XAIME 2002

WHEN I WAS LITTLE I USED TO WATCH A LOT OF T.V. AFTER SCHOOL. THE FLINTSTONES, MARINE BOY, WINCHELL-MAHONEY TIME, ETC... CHANNEL ELEVEN WAS THE PLACE TO BE. THE SAME OL' LINE UP EVERYDAY. OH, BOY!

SO NATURALLY I'D SEE THE SAME COMMERCIALS OVER AND OVER AGAIN, THREE OR FOUR TIMES A DAY. BUT IT WAS THE ADS FOR UPCOMING SHOWS THAT STUCK IN MY MIND AFTER ALL THESE YEARS.

LIKE THE ONE WHERE BISHOP FULTON J. SHEEN IS DOING HIS SERMON AND A GUY FROM THE AUDIENCE COUGHS. OR THOSE DAMN PRINCE STREET PLAYERS AND THEIR FAIRY TALE MUSICAL SPECIALS. "JACK AND THE BEANSTALK" COMES TO MIND.

HERE IT COMES...

OR THE ONE FOR THE CHRISTMAS SPECIAL WHERE A BUNCH OF OLD PEOPLE ARE WALKING IN TWO LINES SINGING "O COME ALL YE FAITHFUL" AND INCONSPIC-UOUSLY IN THE BACKGROUND STRIDES ACTOR ED PLATT.

LOOK, IT'S THE CHIEF!

OR THE LOCAL BEAUTY PAGEANT SHOWING LAST YEAR'S WINNER AND AS THE CAMERA PANS THE APPLAUDING AUDIENCE, SITTING IN THE FRONT ROW ARE TWO GORILLA SOLDIERS FROM "PLANET OF THE APES." AH, THAT WAS TELEVISION...

END

aspect most critically commented upon. However, it is how the artist treats such lives within the comic language that is revolutionary, and Hernandez intertwines his content and formal prowess in never less than surprising ways throughout stories that are ecumenical and specific simultaneously, populated by multifaceted (that is, realistic) women, replete with humor and passion. As such, the radical literary depth that Hernandez brings to comic storytelling, poignantly chronicling the human condition—"the secrets of life and death"—with unparalleled candor and affection while always avoiding didactic moralizing, has gone far in paving the way for myriad personal voices in the art form. In his hands, forays into outer space, folktales, and dreams always surprise and expand within his larger compassion for life's yearnings.

An important aspect of the most impressive comic book work over the past two decades has been an inventively experimental approach to narrative in an attempt to expand and deepen the efficacy of the language, and Hernandez movingly weds multilayered stories with radical fissures of time, place, and point of view. Conversations trigger entire histories, implied by the subtlest visual cues within his expansive integration of humanity: characters and locales are imaginatively rendered through telling minutiae, transcending mere realism through a snappy and increasingly pared-down shorthand style, which vigorously provides only the vital marks necessary to define characters. His stories incorporate an instant back-and-forth totality, alternating between direct spontaneity of execution and painstaking detail, profoundly evoking the mental and physical passage of time. While his clean approach (firmly grounded in a streamlined, no-frills punk aesthetic, as opposed to the ornate, homegrown styles favored by underground cartoonists) expertly allows the stories, rather than their delivery, to take precedence, it also provides the perfectly cool foil to the impassioned subject, and once drawn into these lives, his command of black-and-white weight, solidity, and perspective subtly exacerbates the iconic stillness of the language and its blatant distancing effects to isolate and heighten any action or situation.

Hernandez's comics embody the best qualities of the language, probing its singularity through a perfect balance of visual and textual information while triumphantly embracing the challenge of storytelling within the medium: to visually conjure the nonvisual—thoughts and memory—by using collectively remembered, traditional

techniques without being clichéd, entertaining with a constant underlying depth and sympathy. His overriding concern is a larger distillation based not in stark realism but in the fluid combination of true-to-life physical and internal landscapes, cartoon character types, and surprisingly capricious action, a realism as it exists within the reader's mind: where memories and friendships, all aspects of "real life" are fondly animated and solidified within comics' symbolic mist. ∎

Jaime Hernandez, cover for *Los Angeles City Beat*, December 16–22, 2004.
Copyright © 2004 by Jaime Hernandez.

When I think of the characters, I try to think of their whole lives. I honestly treat them as real people, which may seem silly when I'm doing it, but works in the long run. So I'll know there's a part of someone's life that I haven't gotten to and I want to fill that in, but I also know at certain points that I'm not yet ready. I have past pages that are false starts, which don't work for one reason or another, but now I can just redo them as I'm working; a lot of this comes from years of doing it and economizing. I find that I'm using a lot of tricks to get it out faster and hopefully whatever I miss, I'll get done later. Some stories—"Flies on the Ceiling" is one—are ten years in the making; it took that long to figure out what I was doing.

I'm just trying to put as much as I think is needed into my work. I want to give it humor so it isn't stale, and I want to give emotion, but also sometimes no emotion. As the story is coming out, I'm filling in the things it doesn't have yet. Sometimes

I can find two things to put into one, do things that keep me interested. And hopefully I'm thinking about the reader, too (without selling out or something). I guess I'm just trying to fill these people's lives, fill their personalities. Just keep giving them a drink—keep filling them up, because it's the characters' makeup, their personalities, that I want to last longer than anything. I guess that's the way I see people.

A character I'll create who will stick around—say, the Frogmouth—is someone that I've had in my head for years, and she gradually grew eyes and hair. It starts off with something that I wanted one of my characters to say. Then I'll figure out how to make her look different from the others: there are only so many eyes and noses that I draw for people. I think about that for a long time, and then often the first drawing I do of them is the perfect image. Though not always: with Ray, I wanted to create my male Maggie, who I could give a lot of my thoughts to, but I couldn't think of a way to make him look different. So I took a detour and thought about someone I used to know—I wanted to think about him and draw him as I remembered him, not by drawing from pictures, but from the image in my mind. The character Tony Chase was done in the

same way. I didn't look at photos, but pictured in my head a young Boris Karloff. And however he turns out—even if it doesn't look like the reference—is how he's going to look.

I've just recently found out that my wife doesn't think too much of the Frogmouth—I have to think of that sometimes. She's so much fun to do; if she wasn't dealing with other characters her dialogue would be totally unedited—it would be the first thing I wrote down. That's what I love about the character—she can say anything and it fits her crazy persona. I look back at my work and see individual stories mostly as part of a big tapestry. I remember that when I did the story "A Date with Hopey," I was really proud of it. That story was somewhat autobiographical, and now when I read it back, there are things that I've forgotten in my life, so I'll wonder, "What was I talking about there?" I remember doing pieces where I thought, "This is me, this is a perfect example," but then I'll read back and think, "Well, it could've been a little more . . ." [laughter] I don't want to go back and change things, but I do think back to how much looser the dialogue was. . . . Now, because of space and time, I have to make things fit perfectly. Hopefully it doesn't become just one big ballet, where it doesn't make sense to any human being. ■

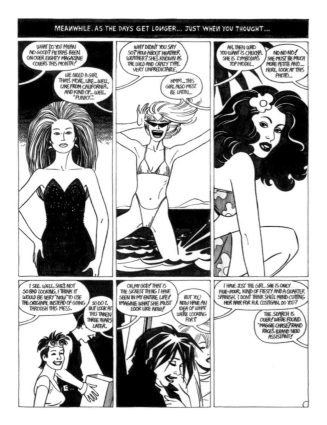

(Above) Jaime Hernandez, original art for *Love and Rockets* calendar, 1989 (Fantagraphics). Copyright © 1989 by Jaime Hernandez. Used by permission of Fantagraphics Books.

(Left) Jaime Hernandez, original art for "Meanwhile, as the Days Get Longer . . . Just When You Thought . . . ," unfinished story, c. 1989. Copyright © by Jaime Hernandez.

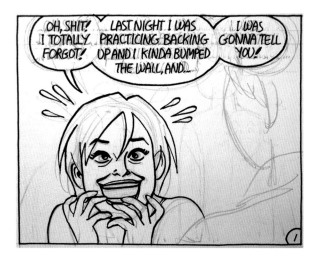

My process on this new issue is actually a bit different than usual because I wrote it right on the heels of the last issue and I was on a tear; so it's a lot more together than it would normally be. Since this one is a chapter in a longer story—"Day by Day with Hopey"—it's easier to come up with because I already know the pace for the storytelling, the particular formula, so I can sort of get it down right as the ideas come. Sometimes I'll write, say, Ray's narrative or Maggie's dialogue on a pad of paper, and I'll rewrite and rewrite it. Since I don't do it on a computer, I'm constantly rewriting and scratching out at that stage, instead of just correcting it on the keyboard. I prefer it this way because I've found that writing on a keyboard alters my writing style: I'm then more interested in spelling words correctly and placing them in the correct spot, when I prefer the characters to speak as they would in the situation. A keyboard tends to take over, and I'm following it rather than my actual thoughts.

When I draw the pages, I jump around from panel to panel, not finishing them in sequence. The writer Robert Fiore once asked me if the reason I jumped around was kind of like the process of writing a song, where maybe you're missing one beat; I thought that was a good way of putting it. When I know there's something I want to add to a sequence but I'm not sure what it is, I try to leave enough room—I'll know by the time I get to the end of the story. Occasionally I mess up and I'll be one panel short. I have no room and I'm driving myself crazy trying to figure out what to take out or how I can combine three panels into one. Sometimes it works, and sometimes I just have to let it go.

When *Love and Rockets* changed from magazine format, I had to get used to filling the space of the comic book format. I tricked myself into thinking it was new, so I'd have something new to think about, but it's really just a matter of altering the space. I remembered that when Dan Clowes went from magazine to comic size he complained that he didn't like the comic format as there wasn't enough space, and when I switched I found I had trouble with it, too. I find I prefer working in a frame like a movie screen, that's longer horizontally. It's sometimes frustrating—I was considering going to the magazine format for my art and then, when it's printed in the comic, filling another strip up on the top of the page like the old *Thimble Theatre*. But every time I start a new issue, I forget that was my plan [laughter]. The size does concern me in that I do go back and forth about how much to include in each panel. I'll have to force myself to show the figure and no backgrounds, to see how it works . . . but that's as far as my planning goes. ∎

Jaime Hernandez, unfinished art and finished panel for "Day by Day with Hopey: 'Thursday is Her's Day,'" *Love and Rockets* 2, no. 14, interior page, 2005 (Fantagraphics). Copyright © 2005 by Jaime Hernandez. Used by permission of Fantagraphics Books.

Jaime Hernandez, original art for "Wigwam Bam," *Love and Rockets* no. 33, interior page, 1990 (Fantagraphics). Copyright © 1990 by Jaime Hernandez. Used by permission of Fantagraphics Books.

I've been working on stories for some time that, even if they're part of a longer narrative, are self-contained. Some of my earlier long stories, such as "Wigwam Bam," drove readers crazy because they couldn't keep up. And in a way, I couldn't either—I was constantly going back and wondering if they knew what I was talking about: "Should I mention events again?" "Should I think about it as a full book and not worry about that, or should I think about my readers now?" In the end I was happy with the way it came out, but during the process I was a little worried about how it worked both ways and a little too concerned with how much information I should give. I don't like to worry about those things when I'm working on a story, so now I try to make it seem like they're all self-contained, even if each is part of a larger narrative: for example, the "Ray" stories—I take them one by one, but I also know that eventually they'll be collected in a big book and will hopefully all come together. ■

I try not to go back after the stories are collected and add things—the times I have thought about doing this, I can't remember what it was I wanted to elaborate on [laughter]. When I did "The Death of Speedy," I agonized for years about this one tiny little thing I wanted to add, which was a single panel. It was just when Maggie got her black eyes from being hit. All I wanted to do was mention after the fact that she had those black eyes for months. They didn't go away and it drove her crazy. Just this one tiny thing that I could never fit in when I collected the chapters . . . so eventually I said, "fuck it." ■

(Above) Jaime Hernandez, original art for "The Death of Speedy Ortiz (Part 2)," *Love and Rockets* no. 22, splash page, 1987 (Fantagraphics). Copyright © 1987 by Jaime Hernandez. Used by permission of Fantagraphics Books.

(Left) Jaime Hernandez, original art for "The Death of Speedy Ortiz," *Love and Rockets* no. 21, splash page, 1987 (Fantagraphics). Copyright © 1987 by Jaime Hernandez. Used by permission of Fantagraphics Books.

Jaime Hernandez, "Spring 1982," *Love and Rockets* no. 31, detail of interior page, 1989 (Fantagraphics). Copyright © 1989 by Jaime Hernandez. Used by permission of Fantagraphics Books.

"Spring 1982" was kind of . . . you don't call it cheating, but . . . I remember one time . . . I'll occasionally go back to Oxnard and hang out with my buddies, drink beer and "Talk about the old days!" One time we were hanging out in my friend's front yard drinking beer and across the street there was a bachelor party, which was just packed, you know. This guy came out, a white guy, who was obviously nervous in this Mexican neighborhood. You're either nervous and run away, or nervous and talk someone's ear off, you know? He came over: "Can I have one of those beers?" Obviously this guy was not of our world, and he told us this story about how he was there with the girls to collect the money. He sat there nervously telling us this story, and he was just rambling on and I could tell a lot of it was lies, trying to portray himself as a tough guy: "One time they chased me out of there with a shotgun, and I went back there with my Uzi, and I told them!" "Okay, that's a good story, but . . . " [laughter]. I kind of took the best parts of that and created the story for Doyle. I remember thinking that this was good material: "I'll steal that!" I would say the best parts from my work are stories that I've heard, things that I couldn't even begin to write. They're too amazing . . . and they're real.

And then there are elements, such as in "Home School" with the owl and the tree, that are taken from folklore or stories that my mom told us. There was a house down our street that had a big palm tree, and at night you'd sometimes see a white owl fly into it; that's where it lived. My mom told us that Mr. Maynez's mother was crippled because witches put a curse on her and she couldn't walk. It never even occurred to me that this wasn't real. I never even questioned it: "How can this be, mom? This doesn't make sense scientifically." It was just like, "Okay, that's life." Hearing these folk tales is just the most fun; I recently met a cartoonist who was from Oxnard who told me tons of stories. I was just amazed and really felt connected, and it inspired me to do my last "Maggie" story.

My biggest concern of the last five years, which I'm glad has now passed over, is that I was really worried that people didn't want to read stories about characters in their late thirties and early forties. And seeing my characters get old . . . I wasn't ready, because "real" time moves faster than in my comic world. I had to force myself and say, "Okay, I'm going to add wrinkles," but when I was in the middle of it I began to forget I was doing it, and it's there now. Maggie's old—and it's okay, the roof didn't cave in [laughter]. What I think about mostly with them getting older is whether or not the readers will find enough of interest in people of this age. I tried on occasion to create younger characters for younger readers, but they eventually became background characters. So I'm thinking now that people are universal, no matter how old, just as long as they're speaking—communicating. ■

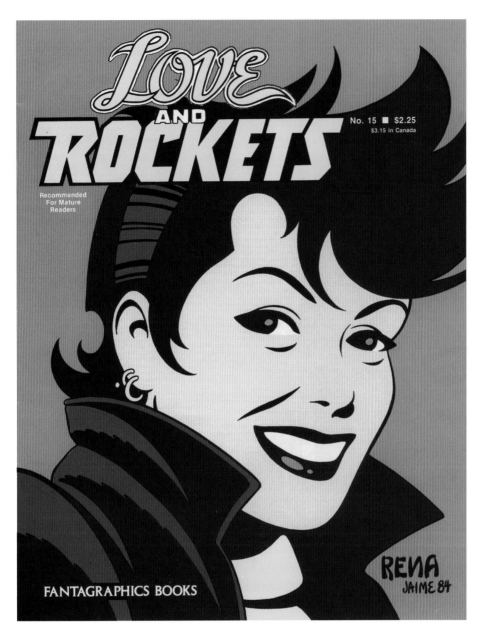

(Above) Jaime Hernandez, original art for *Love and Rockets* no. 15, cover, 1986 (Fantagraphics). Copyright © 1986 by Jaime Hernandez. Used by permission of Fantagraphics Books.

(Left) Jaime Hernandez, *Love and Rockets* no. 15, 1986 (Fantagraphics). Copyright © 1986 by Jaime Hernandez. Used by permission of Fantagraphics Books.

My influences for cover design are less particular artists and more of a time period. Comics in the old days had these wonderful cover images, and it had to do with nothing, nothing to do with selling the contents. Gilbert always had this idea that we should do covers that people would see from across the room: when someone walks in a comic store, they'll only see your comic. So we just kind of kept that in mind. For example, an old *Tarzan* comic cover would have a painting of Tarzan on a branch just looking over and seeing a leopard. That's all it was, but it's a beautiful image that really captivates me. Being the artist though, I look at my own covers and still think that they don't have the same effect as those I'm looking at or taking from. Maybe the reader does, but I still don't see it, don't see what I want to see. Maybe one day I'll get there and capture that feeling like an old issue of *Little Lulu,* an image of her just walking down the street that is so perfect . . .

Jesse Marsh, "Tarzan, King of the Jungle," *Dell Giant* no. 51, back cover, 1961 (Dell). Copyright © 1961 by Western Publishing.

(Left) Matt Baker, *Canteen Kate* no. 3, 1952 (St. John). Copyright © 1952 by St. John Publishing Co.

When I did this [*Love and Rockets* no. 15], there was a cover that I'd seen that sort of brought it all together—a Matt Baker cover for *Canteen Kate*. It was just a big image of her face laughing. I thought, "There it is, I would love to do something like that." But when I did mine, I thought, "Ummm . . . maybe there's something missing" [laughter] . . . but that's just because I'm the artist. I was also thinking of movie magazines: when we were young and drawing comics for ourselves, our mother brought out these drawings she had done as a teenager, where she had taken characters from forties comics—Doll Man, Black Terror, Captain Triumph—and made portraits of their faces. She drew these big heads on sheets of paper, and for us kids they looked like movie stars. "Who is this guy?!" you know. "Wow! Doll Man—he's like a doll!" They were just so amazing and had such a strong effect on us—a very detailed drawing obviously copied from a single panel and blown up. The one she did of Superman was from a cover that I traced back and found a copy of. Superman is looking through a magnifying glass, and I just had to figure out what it was about: "Why is Superman looking through a magnifying glass? This is amazing!" I just went crazy over it. It just made it so romantic, like images of your favorite movie stars. In my mind, it really romanticized the whole thing.

I've also always liked the camera aspect of our covers. Early on, I liked doing my characters not mugging for you, not looking at the camera, but as if someone took their picture while one was paying attention and one not, like a rock band or something. I always liked the candid aspect of it: they know the camera's there but don't care, you know? There was a time when the *Gerber Photo-Journal* [*Guide to Comic Books: Volumes One and Two*] books came out that Gilbert and I would be on the phone and we'd just go through page by page: "Look at that *Green Hornet* cover! What's wrong with his eyes?!" [laughter] For a while, whenever we wanted to do a cover, we'd look through those and even if we wouldn't come up with a specific idea, it inspired us greatly. ∎

I originally drew a photo for this cover that was supposed to appear in the book, but I wound up using it in my comic *Maggie and Hopey Color Fun*—so I had to bump it from here. As it happened, I thought replacing it was a great opportunity to include all of Maggie's different names. I don't blame readers for going crazy at all of her names; it's always driven me crazy! ∎

(Above) Jaime Hernandez, original art for *Love and Rockets Book 13: Chester Square,* cover, 1996 (Fantagraphics). Copyright © 1996 by Jaime Hernandez. Used by permission of Fantagraphics Books.

(Left) Jaime Hernandez, *Love and Rockets Book 13: Chester Square*, 1996 (Fantagraphics). Copyright © 1996 by Jaime Hernandez. Used by permission of Fantagraphics Books.

This original art is the more bulked up version—she was thinner initially, but I didn't like her that skinny so I bulked up her coat after the comic was printed. The whole idea came from thinking back to my young teenage days and remembering the old styles of how Mexican kids dressed. When I was in junior high, the girls wore these velvety blazers and stitched their gang-girl names on them. And they would wear these pink or light blue slacks—and I just thought it was great and a look that I hadn't seen reproduced, say, in a movie set in the period. ■

Jaime Hernandez, *Love and Rockets* 2, no. 5, 2002 (Fantagraphics). Copyright © 2002 by Jaime Hernandez. Used by permission of Fantagraphics Books.

(Above, left) Jaime Hernandez, original art for *Love and Rockets* 2, no. 5, cover, 2002 (Fantagraphics). Copyright © 2002 by Jaime Hernandez. Used by permission of Fantagraphics Books.

CLIMAX PRESENTS

BLACK FLAG

Advanced tickets available from Ticketron, Zed Vinyl Fetish, and Moby Disc.

THE REALITY
OF EVIL

FEAR
CIRCLE JERKS
CHINA WHITE

WEDNESDAY FEB. 11
at the STARDUST BALLROOM 5612 Sunset blvd $6
For more information call — 462-1111

(Left) Raymond Pettibon, Black
Flag flyer, c. 1979. Copyright ©
by Raymond Pettibon.

(Below, top) Gary Panter,
Germs flyer, 1979. Copyright ©
1979 by Gary Panter.

(Above, middle and bottom)
Jaime Hernandez, two punk
flyers, 1982–1983. Copyright ©
by Jaime Hernandez.

When I first saw Raymond Pettibon's punk flyers, I immediately thought, "Wow, comics and punk rock—I knew there was a connection!" That inspired me a lot, because if you see the back cover of Black Flag's first single, I sort of ripped off the lineup for the first cover of *Love and Rockets*—yes, ripped off! I was getting his flyers off the street, when people would be handing them out at punk shows. I remember them being numbered early on, and I wanted to get all of them. I loved the playful comic book aspect of them—I always knew comics, rock 'n' roll, and junk culture just all kind of went together. That's why the first issue of *Love and Rockets* is just bombarded with everything. ∎

(Right) Raymond Pettibon, back cover for Black Flag, *Nervous Breakdown* EP, 1978 (SST). Copyright © 1978 by Raymond Pettibon.

(Bottom left) Jaime Hernandez, punk flyer, 1982–1983. Copyright © by Jaime Hernandez.

(Bottom right) Jaime Hernandez, original art for "So, When Was It Really?" *The Comics Journal Special Edition* 2004, single-page strip, 2004 (Fantagraphics). Copyright © 2004 by Jaime Hernandez. Used by permission of Fantagraphics Books.

(Opposite, top left) Jaime Hernandez, *Love and Rockets* no. 1, 1982 (Fantagraphics). Copyright © 1982 by Jaime Hernandez. Used by permission of Fantagraphics Books.

(Opposite, bottom) Jaime Hernandez, original art for "Worms," strip, 1982. Copyright © 1982 by Jaime Hernandez.

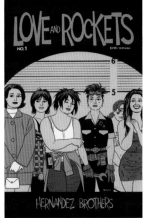

(Top) Jaime Hernandez, *Love and Rockets* 2, no. 1, 2001 (Fantagraphics). Copyright © 2001 by Jaime Hernandez. Used by permission of Fantagraphics Books.

(Above) Jaime Hernandez, tour sticker for the Damachers, a band from Hernandez's comics, undated. Copyright © by Jaime Hernandez.

Jaime Hernandez, *Love and Rockets* no. 24, 1987 (Fantagraphics). Copyright © 1987 by Jaime Hernandez. Used by permission of Fantagraphics Books.

(Opposite, left) Jaime Hernandez, *Whoa, Nellie!* no. 2, 1996 (Fantagraphics). Copyright © 1996 by Jaime Hernandez. Used by permission of Fantagraphics Books.

(Opposite, top to bottom) Jaime Hernandez, "Angel Altergott" pin-up, *Whoa, Nellie!* no. 2, inside front cover, 1996 (Fantagraphics). Copyright © 1996 by Jaime Hernandez. Used by permission of Fantagraphics Books.

Wrestling Revue, February 1965.

Jaime Hernandez, original album cover art for Lung Leg, *Maid to Minx*, 1997 (Vesuvius). Copyright © 1997 by Jaime Hernandez. Collection of Glenn Bray.

This was one of those images where I started off with a foot and in a half-hour it turned into the final image—it just sort of spilled out. By the time I was done, I said, "Hey, pretty good." Usually they're planned out, but this one sort of poured out; images that are unplanned like this are often the best ones. As far as the color, I was thinking of concert lights, and I think I rushed it because of a deadline: let's make it all red. I personally delivered it to the colorist, who was a friend of mine, and said, "Make it all an orangish-red, with the logo and bottom text banner white." He went and put a grey screen on it and made the entire cover flat red . . . I remember calling and asking, "What the hell is goin' on here?" I guess he just heard "Make it all red." I was a little pissed, but it turned out fine. ■

Originally, *Whoa Nellie!* was going to be done like a wrestling magazine, with photos and captions, and so the pin-ups came from this idea. But they're all that remained of the idea. At first I thought, "That'd be great, do it like a wrestling magazine with big block titles," because the old ones had these great layouts—"Bloodbath in Cincinnati," or something. I was going to do it this way, but then I realized I would have to write articles—and I wasn't going there! That's when it turned into a story. ■

Growing up with six kids in a house, there was always the issue of space, so a lot of things were thrown away. We would keep the comics we made for a while, but then there would be a big clean-out. So, the oldest stuff that I have is from the early seventies, which I don't consider my most imaginative stuff, because I was a teenager and influenced by things around me. When I was a kid, my imagination went nuts: I didn't understand the way the world worked, so I made it up. As I got older, of course, I wanted to draw like Jack Kirby, and made many failed attempts. But as a kid, I drew as I drew, which was the best stuff, but they're all gone . . . they're all just memories. However, I'm lucky to have four brothers and a sister who constantly talk about what we did in the past, especially Gilbert.

When we talk that way, I realize how Gilbert just went through so many phases with his comics. He for some reason had it more together than I did—I had no structure, I didn't know how to create a series of stories . . . it wasn't until *Love and Rockets* that my work got streamlined. But he would create entire series of different genres; he would just go for it, issue after issue of penciled, folded-over comics—create an entire series then move on to something else. I've always thought it was just amazing how he did that. About once a month I'll be sitting at the drawing board and I'll remember a series he did back then—it's just crazy.

The thing about Gilbert that amazes me most is his ideas—he's just constantly working on three things at once. I can barely handle one. He's always been like that since he was a kid; he's always had that energy toward producing his art. If you ask him, he'll say, "Oh, that old stuff was terrible," but he was just on speed the whole time, you know? His imagination is incredible, he's constantly coming up with a million ideas for projects, and he's always been able to do it. He's doing a graphic novel right now, and while he's telling me about it, I'm thinking, "You actually had an idea for something completely outside everything else you're working on?" He can come up with ideas for whole separate things—mine come few and far between. ∎

Jaime Hernandez, original art for "A Life in Comics," *Comics Journal* no. 200, single-page strip, 1997. Copyright © 1997 by Jaime Hernandez. Used by permission of Fantagraphics Books.

Gilbert Hernandez, "A Trick of the Unconscious," *Love and Rockets* no. 44, interior page, 1994 (Fantagraphics). Copyright © 1994 by Gilbert Hernandez. Used by permission of Fantagraphics Books.

Bob Bolling, *Little Archie Giant* no. 20, 1961 (Archie). Copyright © 1961 by Archie Comic Publications, Inc.

Bob Bolling is the reason I write the way I write. He had something that we have borrowed from him, which is a very bad word: sentimentality [laughter]. His stories are very sentimental, but he knows when to back off; he knows exactly what to put in and what to take out—and when. I like his adventure stories, there's this one about a carjacking, but I really prefer the stories that are . . . like one about a weird frog from outer space who comes to earth, tries to study, meets Little Archie, and they go to a costume ball. Someone always learns something

in the end. I've talked on many occasions about Bolling's story "The Long Walk," which is about Betty loving Archie, but he doesn't like her, and he runs her through the mill but in the end he thinks she's the coolest because of all the trouble she's been through. It's just the way Bolling tells these stories; I'm not embarrassed to read them—he had just the right touch. Also, it's obvious from his art that he wasn't a polished A-style illustrator, but he really evoked moods by putting in long afternoon shadows and things like that. As a kid, I could just feel myself outside when I was reading them—being by myself when the stillness of the afternoon is spookier than the dark of the night, you know? He would draw lone silhouettes off in the distance, and they seemed so lonely it made me want to cry.

There's a story where a new kid, Dewey Lippersnipper, comes to visit and all the girls love him because he's perfect in every way. Archie just can't compete with him until finally he blows a bubble and the new kid sees this and says, "I've always wanted to blow a bubble, but don't know how—could you teach me?" And Little Archie says "Sure," full of himself. The first bubble Dewey blows is really cool and everyone becomes friends, but then at the end Archie gets a letter from Dewey saying, "I've been practicing and I'm going to come back to visit and we'll have a contest." Little Archie then confesses to the reader that he's been bluffing, that this was the first bubble he's ever blown. In the last panel he's walking into his house and there's a shadow on him and he's saying something like, "I bet grown-ups don't have these problems," and it's just so perfectly put. We've been trying to write stories like that ever since, trying to convey those feelings that he put into those stories. For years we couldn't convince people about this stuff. ■

I've always been more of a fan of the kids in, say, *To Kill a Mockingbird,* who reflect on things and talk about events going on that they don't understand. I'm much more interested in that than some kid Spielberg comes up with, who wants to blow up things and is just so obnoxious. It makes me wonder how other kids have grown up. When I do my comics, I just try to think of being playful and my memory of being a kid. ■

(Opposite, top) Bob Bolling, "Buzzin' Cousin," *Little Archie Giant* no. 20, detail of interior page, 1961 (Archie). Copyright © 1961 by Archie Comic Publications, Inc.

(Opposite, bottom) Bob Bolling, "The Long Walk," *Little Archie Giant* no. 20, splash page, 1961 (Archie). Copyright © 1961 by Archie Comic Publications, Inc.

(Right) Jaime Hernandez, "Home School," *Penny Century* no. 3, splash page, 1998 (Fantagraphics). Copyright © 1998 by Jaime Hernandez. Used by permission of Fantagraphics Books.

(Below) Jaime Hernandez, "6 Degrees of Ray D. Ation," *Maggie and Hopey Color Fun,* detail of interior page, 1997 (Fantagraphics). Copyright © 1997 by Jaime Hernandez. Used by permission of Fantagraphics Books.

Harry Lucey basically drew this neighborhood as the idea of one: a tree off to the side, a house, a street. But as a kid, I always wondered whose house this was. He could create these backgrounds in a way that made me feel like someone actually lived there, which adds to the whole feeling, the whole picture. The thing I love most about him is the body language and expressions—it's where I got all my arms flailing and stuff like that. He and a couple of others had the ability to really bring characters to life that very few other cartoonists have had.

I think my characterization is a mixture of my own thing and older artists like Lucey or Dan DeCarlo. It sounds really silly and it's hard to convince people that I like the Archie characters: I think Archie is a cool guy, and Jughead Jones is one of the most complex characters ever in comics. But who are you going to convince, you know? These two cartoonists in particular were good storytellers and could bring out personality so well. "How could you like Betty and Veronica? All they're ever doing is chasing Archie." But that's not all they're doing—yes, the stories are very simple, but I followed these characters because they were my pals whom I could get that warmth from. ■

Harry Lucey, "Over-Joyed," *Archie* no. 123, splash-page, 1961 (Archie). Copyright © 1961 by Archie Comic Publications, Inc.

(Opposite, left) Owen Fitzgerald, "Dennis the Little Angel?" *Dennis the Menace Giant Christmas Issue* no. 11, interior page, 1962 (Fawcett). Copyright © 2005, used by permission of Hank Ketcham Enterprises, Inc.

(Opposite, right) Owen Fitzgerald, "Wishbone Thinking," *Dennis the Menace Giant Christmas Issue* no. 10, interior page, 1961 (Fawcett). Copyright © 2005, used by permission of Hank Ketcham Enterprises, Inc.

Owen Fitzgerald, a comic book ghost for Hank Ketcham, was a fabulous body-language artist. This page is just absolutely amazing, and within these insignificant panels are contained things that I've never seen anywhere in comics. This couple going back to their car: they're obviously leaving a nativity pageant to go home; they're all bundled up and you can tell it's cold outside. Just by their lean, the way they're walking and talking like people would when leaving—this simple thing. But there are very few artists to this day who will concentrate on that little thing that brings it all to life. You know, when I hear "So-and-so's characters are so alive"—well I've never seen them take a bath. I don't need to see them *in* the bath, but once in a while show me that you're the guy who lives next door.

There's a particular story where Dennis wants to go to the North Pole because that's where Santa lives. His parents are telling him he can't go, and besides, it's bedtime. There's part of a page where Dennis's mother is preparing him for bed, giving him a bath, putting his pajamas on, putting him under the covers while she's explaining what the North Pole is like: it's got a lot of ice, snow. She's telling him in this warm, mom way, and as she's doing it he's getting sleepier and sleepier. I was just thinking, you can't find that in comics—and these are throwaway comics that people scoff at: "That's not real art!" Well, to me it's better art than anything, because that's what I look for. I look for the stuff that makes us . . . I don't know, who we are, how we live, you know? And that stuff helps the character become bigger than life to me. I'm not saying that other types of comics aren't as good, this is just the particular way I prefer to see them done, more than something else that I might also like. At the same time, I like the Thing from the *Fantastic Four.* But do you ever see a story like that with him? No [laughter]. It's a whole different thing—this is the stuff I prefer to follow, and what I think creates characters. ∎

Ghost Stories no. 1, 1962 (Dell).
Copyright © 1962 by Western
Publishing.

This is a comic that I never went near as a kid, because it didn't look like Archie or Marvel. But my brothers swore that this was the craziest, spookiest comic they ever read. I didn't see it until I was in my late teens, which proves its power, because I could see it then. The unknown artist just captured this darkness . . . "The Werewolf Wasp" is John Stanley writing at his wackiest. He knew what to give you and what not to give you: this story ends with the Werewolf Wasp saving this kid, and in the last panel he's running away, saying "I've got to get help! Those boys may all be alive!" That's much creepier to me than your standard horror story where you find out what awful thing happens. Just him running away, and that's the end—whew, shivers! When we heard that it was John Stanley, we kind of threw our arms up and said, "Of course!" ∎

Kirby comes in waves with me—right now he's not that big in terms of me going back and looking at his work, but next year he will be: I'll come back to it and be amazed. He was one of those guys who had the power, which everyone knows about, but he also had a sense of humor—a sense of fun—and subtlety that a lot of people don't catch in his work. One of the biggest things that I like about him, and something I don't hear about too much, is that it makes me laugh. I think a panel where one swing of Thor's hammer sends twenty guys flying is hilarious. It's so powerful, but at the same time I'm just cracking up—out of joy. ∎

Jack Kirby, *Sgt. Fury and His Howling Commandos* no. 3, September 1963 (Marvel). Copyright © 2005 Marvel Characters, Inc. Used with permission.

A scratchy guy [Alex Toth] that I also wouldn't go near as a kid, though Mario and later Gilbert were both awed by him. They discovered him in hot-rod magazines like *Car-Toons*, and liked the guy who drew in that certain way without knowing who he was. He's another guy who I got into when I was much older—I was really closed off to that kind of technique as a kid, but later my appreciation just blossomed and I realized how amazing he is.

I recently heard that Toth moved to the West Coast not only because of animation work but also because he liked a lot of the guys like [Jesse] Marsh who were living out here. As opposed to New York, L.A. is a place where you have to work harder to have your city: it's a hidden, mysterious place if you don't know it. Coming here you work harder. I've read that certain artists and writers like to come out here because of that: "It made me work harder at my craft . . ." While a lot of people like that, a lot don't. ■

Alex Toth, "The Clown-Around Caper," *Hot Rod Cartoons* no. 16, splash page, 1967 (Peterson). Copyright © 1967 by Alex Toth.

Roy Crane, *Wash Tubbs*, daily strip, April 1, 1941. Distributed by Newspaper Enterprise Association. Used by permission of United Media.

I like Roy Crane a lot. He's someone I discovered as an adult, so it's more of a technical appreciation. I think he puts just the right amount that you need in his comics, and that's his biggest strength. I don't even read the strips; I just look at them. ■

(Above) Jaime Hernandez, illustration for Alison Moyet poster, c. mid-1990s. Copyright © by Jaime Hernandez.

(Left) Jaime Hernandez, illustrations for the Criterion Collection's DVD release of Pietro Germi's *Divorce Italian Style,* 2005. Cover design: Eric Skillman. Reprinted courtesy of the Criterion Collection. Illustrations copyright © 2005 by Jaime Hernandez.

(Below) Jaime Hernandez, original art for illustration, *The New Yorker,* October 18–25, 1999. Copyright © 1999 by Jaime Hernandez.

I don't go looking for illustration work, people come to me, so I'm pretty lucky. Partly because of the editorial aspect, it's all just to pay bills. A lot of the work strips me down to just a guy who puts lines on paper and it really busts up my ego [laughter]. At the same time, I feel like if given the chance to do what I want, I could really give them something good. I'd say most of the work I've been hired for, I get a call, "We'd love for you to do something," and when I agree, then they just pick me apart, take my arms off, take my legs off, and a lot of times it results in something I'm not even happy with, I'm not proud of. But it also helped me learn really fast how most of the industry works, and I really feel for a lot of the

Jaime Hernandez, album cover for the Coyote Men, *Call of the Coyote Man!* EP, 1998 (Estrus). Copyright © 1998 by Jaime Hernandez.

artists now. I used to just think, "Oh, what a hack, ha, ha"; now I know the process and think, "Oh, you poor guy."

This [*Divorce Italian Style*] was actually one of the easier jobs I've had, meaning they asked me to do it, I did, and they said, "Oh, this is great." A lot of times I'm hired because the person in charge actually likes my work, so they will trust my artistic judgment. ∎

I have a sketchbook that I just finished, which took five years [laughter]. There was a time when I was sketching a lot . . . I like doing them because I try to draw every way other than how I draw my comic. I sometimes get frustrated sketching because it just doesn't come—I'm not the type that can take a sketchbook out and draw a tree, you know? It's no reflection on people who do that, but it seems very silly to me. It's just not my art form. But I sometimes wonder, "Why not? I'm an artist aren't I? I should be going out there and drawing my heart out." But it just seems so . . . I guess in a way, pretentious. I try to force myself to keep a sketchbook, because my comics are all the art I do—all that same thing. It's almost product, and I'm sure I have other ways of expressing myself. I just don't do it . . . though I know I could.

In doing a sketchbook and using different tools—pencil, brush, or whatever—I've found out something very frustrating about art, which helps other artists but drives me nuts: the medium alters my art. That's something I never thought about too much; millions of artists switch around every day, but to me it was a revelation: "Oh, wow, I have to draw this way be-cause of this brush." It's really frustrating because it shows how I've gotten set in a particular way. So this whole sketchbook was a learning process that forced me to rethink things, and at first it was maddening. I would love to learn to paint, but that's of course a whole other world. I'd love to do it, but I'm a pretty impatient person—drawing for me is so instant and it'll take me ten years to become the painter I want to be. Maybe that's why I've been holding off for so long—"No, I want it now!"

A lot of this is just forcing myself to draw—even if it's figuring out a new hairstyle for Maggie. "Just draw!" It sounds so silly, coming from an artist. It brings out all this stuff that I don't know about myself: I've found that all of my faces start in the same point . . . and that if I don't sketch them out first, my drawings lean toward one side since I'm left-handed (right-handers' slant the opposite direction). So I have to flip them over to check them. When using a brush, I don't pencil anything first, so it's just a matter of where my hand takes me, which is why some of these turn out odd. Seeing guys like Alex Raymond, Al Williamson, and Frank Frazetta—they have so many lines on a face, yet the face isn't overworked. I go crazy try-ing to figure out how they do it. Sometimes I think in my work I'm making up for the lack of something else. I work extra hard on the characters' being, personality, and stance, because of the lack of rendering in something like the shading of hair. That's not a big interest for me, although I'm a big fan of many artists who do it. ∎

Jaime Hernandez, four pages of sketchbook drawings, created between October 10, 2000, and February 7, 2005. Copyright © 2005 by Jaime Hernandez.

THURSTY NEWELL

ARTIE TIMMONS
NEW YORK
1959

I think I was watching a documentary on jazz and decided to make up my own jazz greats. "What kind of names do they have? Thursty Newell—that sounds right!" And I'll work out the appearances of new characters—for example, this one: the Angel of Tarzana. Since the Frogmouth is so unlikable, I wanted to create a character that was very agreeable, who wasn't a pain in the ass and constantly fighting [laughter]. She may fail because of that—my characters are constantly bashing up against each other. I wanted young blood . . . young blood with an old soul. I was so excited to do the first two-page story with her, because it had a totally different feel: it's all action. I got away with being able to do my super-heroes, but putting them in this safe, realistic environment—having my cake and eating it too! Whereas the action in *Whoa, Nellie!* resembles composed, still photographs—that's what remained from the wrestling magazine format I had in mind—here I wanted action: bam, bam, bam. ∎

Jaime Hernandez, three pages of sketchbook drawings, created between October 10, 2000, and February 7, 2005. Copyright © 2005 by Jaime Hernandez.

A lot of my early fanzine work, before *Love and Rockets*, was influenced by *Heavy Metal* magazine. I was discovering all the European guys. Their stuff really breathed and sometimes didn't go anywhere—I thought that was art [laughter]. Some of it is, but some you look back on and say, "Well, nice try . . . " We did work for fanzines because we wanted to do comics but had no idea where we could: we thought, "At least we'll be printed." We were that naïve. I just had no idea of where to go, but I didn't know if I could handle working for The Man. When we did our first issue of *Love and Rockets*, we put a copy together and stapled it, and kind of propped it up against the couch and stared at it. Then came the question, "Now what?" ∎

Jaime Hernandez, original art for early superhero illustration, 1981. Copyright © 1981 by Jaime Hernandez. Collection of Eric Reynolds.

Love and Rockets no. 1, 1981 (self-published). Copyright © 1981 by Gilbert, Jaime, and Mario Hernandez.

b. 1961

6. Daniel Clowes

Full appreciation of the microscopically scrupulous portraits within Daniel Clowes's structurally layered comics requires a gradual deciphering of interweaving narrative clues and symbolic tropes. After contributing illustrations and stories, both individually and collaboratively, to a handful of fanzines and small publications, Clowes made his initial mark in the alternative comics world with his idiosyncratic celebration of mid-century American junk culture, *Lloyd Llewellyn* (the name itself an homage to superhero wackiness), which first appeared in 1985. The most immediate aspect of his early comics is the slippery vacillation between visceral hilarity and surprisingly empathic insight into character; as Chris Ware has stated, "Somehow, he's able to blend satire and sympathy, two sensibilities which are generally mutually exclusive." Clowes's vision has always incorporated a biting critique, whether in an indictment (or commendation—or both) of prematurely embittered youth or in deflation of current fashion in high culture, but the leap in breadth to his ongoing comic *Eightball* in 1989, with its inaugural "orgy of spite, vengeance, hopelessness, despair and sexual perversion," came as nothing less than a shock.

The title, a fluid vessel for all manner and length of work—much of it pioneering and all the product of an artist at the absolute peak of his craft—has been the eminent art comic since its inception. While experimenting with various storytelling conventions and genres, both within the comic field and in related marginalized forms (pulp writing and illustration, B-movies), Clowes's short stories and sustained graphic novels became increasingly ambitious both in terms of complex intelligence and accruing thematic ambiguity, building toward a staggering literary sophistication unseen in the medium. A master at the short novella format, Clowes is the form's most assiduous delineator of complex psychology with a command of characterization and dialogue that manifests a dizzying cross-examination of all levels of creativity and artifice. His work comprises densely compressed and intertwined keys, both textual and visual, which braid together in a perfect, tightly wound balance. Rife with structural anomalies begging to be

Daniel Clowes, self-portrait, 2005. Copyright © 2005 by Daniel Clowes.

Daniel Clowes, "The Death Ray," *Eightball* no. 23, interior page, 2004 (Fantagraphics). Copyright © 2004 by Daniel Clowes. Used by permission of Fantagraphics Books.

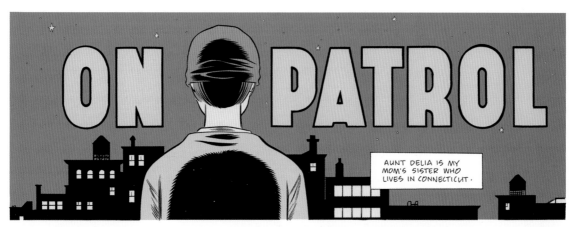

ON PATROL

AUNT DELIA IS MY MOM'S SISTER WHO LIVES IN CONNECTICUT.

AFTER DAD DIED I WAS SUPPOSED TO GO LIVE WITH HER, BUT LUCKILY I WAS ABLE TO SCAM THE CHILD PSYCHOLOGIST INTO LETTING ME STAY AT HOME WITH PAPPY.

ANYWAY, SHE SAID THE PACKAGE WAS IN THE MAIL... YEAH, AND I WON'T COME IN YOUR MOUTH (THAT'S AN OLD GEORGE CARLIN JOKE, I THINK).

GO DAN YC

I LIKED AUNT DELIA OKAY, EXCEPT SHE ALWAYS KIND OF MADE ME FEEL LIKE A PATHETIC TURD. SHE REALLY DID NOT GET ME AT ALL.

ET HERE!

STILL, I HAVE TO SAY I THINK I COME FROM A PRETTY GREAT FAMILY. I MEAN, JUST THINK ABOUT WHAT MY DAD DID FOR ME. WHAT DAD HAS EVER DONE ANYTHING LIKE THAT BEFORE?

THAT DOESN'T BELONG TO YOU!

CRAS

ICK!

SHIT

AND PAPPY, TOO... HE WAS ALWAYS GREAT TO ME... I JUST WISH...

WHAT YOU'VE DONE!

I'VE BEEN THINKING A LOT LATELY ABOUT HOW MUCH STUFF WE TAKE FOR GRANTED. WE'RE SO LUCKY TO LIVE IN THE MODERN WORLD. I MEAN, IF YOU WERE BORN IN UNCIVILIZED TIMES, YOU'D SPEND ALL DAY LOOKING FOR GRUBS AND THEN YOU'D DIE IN PAIN AT AGE TWENTY.

REALLY, WE SHOULD ALL BE SO THANKFUL FOR OUR ANCESTORS IN THE HUMAN RACE.

THAT'S WHY I FEEL I HAVE TO DO MY PART, HOWEVER SMALL, TO HELP OUT HUMANITY, OR AT LEAST THE GOOD, DECENT MEMBERS OF SOCIETY.

22.

IT'S NOT EASY, THOUGH... AND TO BE HONEST, A LOT OF THE TIME IT FEELS KIND OF LIKE HOMEWORK.

BUT SOMEBODY HAS TO IMPOSE SOME KIND OF STRUCTURE ON THE WORLD, I GUESS. OTHERWISE EVERYTHING WOULD JUST FALL APART, WOULDN'T IT?

decoded and spiked with the subconscious warmth for the formative period of child-hood when one was first smitten by comics' jolt, the gestalt is significantly greater than the tabulation of individual elements can convey. The possibilities of the comic language have been significantly expanded through such a holistic immersion, seen to full effect in the visual and textual sign–laden *David Boring* (which, among a great many other things, explores the translation of stereotypically cinematic conventions into comics). Metaphorical meaning reveals itself slowly in Clowes's comics, puzzled together through the inherent unreality of the language's texture.

Clowes's masterful *Ice Haven* (2005) exemplifies this larger approach to narrative, in that the story is actually soldered to the point that all aspects—from the conceptual conceit, which structures the narrative around various elements of midcentury news-paper strips, to seemingly insignificant background detail—are inseparable, a true totality whereby meaning is generated from fragments, snippets, and casual asides. Clowes's wintry artwork epitomizes the stilted flatness, or static "dead" quality found in midcentury superhero comics, growing gradually cooler and more neutral with a vanish-ing of individual style, to become conceptual cipher, another character in the narrative. His sober stories reflect this mood, drawing their intimate sonority from the precise integration and juxtaposition of all characteristics of the medium.

Expanding his vision (and his inquiry into the structural properties of other art forms) to film, Clowes, along with director Terry Zwigoff, adapted his serialized comic *Ghost World* into a 2001 feature movie, and he wrote the screenplay for the 2006 Zwigoff-directed *Art School Confidential,* also based on his comic of the same name. Clowes's contemplative rhythm, focusing on spiritual emptiness, searching, and re-newal, rewards meditation on the vast potential of the form and its power to inexhaust-ibly expand in scope and internal life, to reverberate with multiple layers of meaning. ■

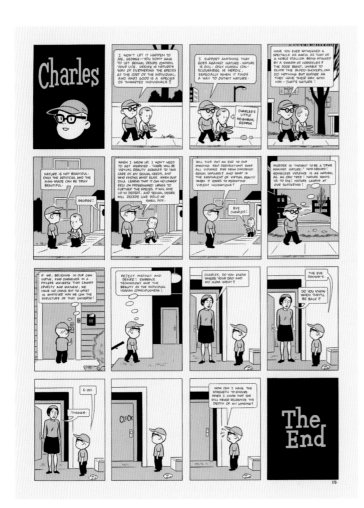

Daniel Clowes, "Ice Haven," *Eightball* no. 22, interior page from the original comic book format, 2001 (Fantagraphics). Copyright © 2001 by Daniel Clowes. Used by permission of Fantagraphics Books.

After I finished the comic version of *Ice Haven,* it hit me that something was slightly off about the format. They were very much like Sunday newspaper strips, and to put them into more of a comic book format seemed not exactly right. I had done all the pages at such a large size that the original art had to have a hinge in the middle so I could reach the top corner when I was drawing, so I worked on them as half pages, and I realized when I saw the final comic with the full-size assembled pages that they seemed not quite right.

The whole thing was somewhat inspired by Sunday newspaper comic sections from the late fifties and early sixties, by which time most of the strips had begun running as half pages rather than the gigantic full pages of the twenties and thirties. There was something really great about that crazy mixture of styles: *Steve Roper and Mike Nomad* and *Henry* and the latest version of *Mutt and Jeff* all on the same page—and somehow, because they're printed in the same colors and drawn with the same basic tools, there's a kind of internal cohesion to the whole thing. I thought it would be great to do a story using all these different kinds of styles and approaches and put them into a larger all-encompassing narrative structure.

The story works better for me in the book format. It seems denser. Flipping through the book, as opposed to the comic, it feels substantial in its own way. Until you put it next to something like *Jimmy Corrigan* [laughter]. There are probably eight or nine new pages as well as new title pages and endpapers, both of which have some semblance of narrative value. But in general it was sort of worked out as it was, and I didn't want to just throw in extra material that would derail the whole thing for the sake of adding stuff. The book looks very much like it's for kids, the cover is really multicolored and cheerful, so I anticipate being thrown in jail at some point. ∎

The Mad Reader, 2002 reissue (E.C.). Copyright © E.C. Publications, Inc. All Rights Reserved. Used with Permission.

I must've been five or six when I first saw *The Mad Reader*—it just seemed like a whole new world. Even as a kid that young, I could tell that these were of a different order than what I was seeing elsewhere. I'm sure I didn't read them—either I couldn't read yet or I felt like I couldn't yet grasp what was going on—it was purely a visual experience; such a fully realized, dense world. I really wanted to just kind of hang out with the guys that drew them more than anything. I used to imagine moving to New York and going to the *Mad* magazine offices and all those guys would be there, and I'd be welcomed into their little world [laughter]. ■

John Forte and Curt Swan were two artists whose work I liked very much as a kid. Forte was one of the guys whose comics images really stuck with me, and when I see them now I still get some kind of visceral feeling, though I'm not even sure what that feeling is. He drew the "Legion of Superheroes," which for some reason I had many issues of when I was a kid. He'd always draw every single member of the Legion in every single panel: there would be like fifteen guys in every panel, standing there talking. Even as a kid I knew that he was putting way too much work into it, that there was something really crazy and obsessive about it. The way he drew facial expressions: the characters were always sort of grimacing angrily, but you can't tell if they're laughing or shouting. There's something disturbing about his artwork, but I can't quite put my finger on it, which is why it's still sort of compelling.

Whereas Curt Swan to me is sort of the perfect comic book artist: he has almost no style at all. He's the closest there's ever been to somebody drawing with no inflection whatsoever; it's almost like a schematic drawing. With Forte, everybody seems tense and there's a stiffness beyond anything you've ever seen—he makes Wally Wood seem totally fluid [laughter]. I've seen old horror stories he did and they're not quite as interesting, because his work seems to lend itself more toward that kind of world—it looks kind of like low-grade Al Feldstein. But there's something unbeatable about those tense, irritable superheroes. ∎

(Left) John Forte, "Tales of the Legion of Super-Heroes," *Adventure Comics* no. 325, splash page detail, 1964 (DC Comics). Copyright © 1964 by DC Comics. All Rights Reserved. Used with Permission.

(Above) Curt Swan, *Adventure Comics* no. 302, 1962 (DC Comics). Copyright © 1962 by DC Comics. All Rights Reserved. Used with Permission.

[Drew] Friedman is definitely in the realm of [Basil] Wolverton, where there's just a certain intrinsic rightness about the grotesquerie of his artwork. Wolverton's characters are mostly all imaginary, but there's something very truthful about the grotesquerie. Other people try to do that stuff and it's never effective at all. With Wolverton there's a real push and pull going on, where he has a true revulsion at the physicality of the human face, but then he's also sort of generous about it, as though saying, "We're all repulsive and it's fine, let's laugh, and it's funny and not that bad." Friedman has that too, although with him it's weighted more heavily toward the revulsion department [laughter]. But it's so carefully worked out to express that, and he never cheats, never relies on a shortcut or gimmick. It's very easy to make someone grotesque using the same two or three tricks over and over, but he never does that—he finds what is inherently and individually repugnant about each person he draws [laughter]. His imagery is so strong that at this point my mental image of many big-time celebrities (such as Britney Spears and Tom Cruise) is closer to the Friedman version than to the real thing. ■

I remember my approach to these was sort of to discourage people. The whole practice of drawing pictures for fans at comic conventions involves this weird ritual—who knows how it started—in which you're supposed to do this perfect rendering of one of your characters, often the same stupid thing over and over and over, for pretty much anyone who asks, which is usually in my case somebody who has no idea who I am. I would see artists slaving over these drawings just to please their fans . . . There's something so sad and desperate about it. And you're sort of obligated to do it, or you're thought of as a real asshole, which I guess I am. So I thought I'd do drawings to make fans think, "Well, he put a lot of work into it, but it's so hideous I don't even want it" [laughter]. I think that was my initial impetus, just to keep myself from going crazy. ■

To TODD, Best, Daniel G. Clowes '01

As this story begins, there is a "voice-over" that I was planning to carry through the entire narrative, but I wound up cutting most of it. It just seemed to be too much, and if you do it on the first page you're kind of stuck for the rest of the story. As I recall, it didn't really say anything, it was just an attempt to establish the particular kind of language that I was going to use—it didn't have any narrative information. Of course now I go back and wonder why I didn't also cut it out in the other few spots where it remains. At the time I was working by the seat of my pants, I had no idea where the story was going to go. In the instances I left it in, I suppose I was thinking I might want to get back to using narration later in the story, and I guess I thought it would be weird to have it abruptly start in the middle without any precedent so I left a bit of it in. But then I got so hooked into doing it all visually that I never did find the need to get back to it.

I kind of like it now. I like those comics back then that everybody was doing in installments, where you can see their style change with each new issue. This story changes so drastically by the end in terms of the overall look, but that's kind of what the story is about in a certain way—there's something great about that. I often think I should go back and redraw the entire story, but I could never capture the weird quality that it has. It has almost a John Forte quality to it . . . there's something about it—I really felt that story as I was doing it and I could never get back into it now. ∎

(Opposite, above) Drew Friedman, original art for Britney Spears illustration, 2004. Copyright © 2004 by Drew Friedman. Collection of Glenn Bray.

(Opposite, below)
Daniel Clowes, original convention sketch, 1991. Copyright © 1991 by Daniel Clowes.

(Above)
Daniel Clowes, original art for "Like a Velvet Glove Cast in Iron," *Eightball* no. 1, splash page, 1989 (Fantagraphics). Copyright © 1989 by Daniel Clowes. Used by permission of Fantagraphics Books.

There are a number of old book-jacket artists that I really like—Gerald Gregg, Leo Manso, George Salter—all the more "design-y" guys. But the one I'm really obsessed with is Alvin Lustig. I wish someone would do a book on his work; I've been trying to collect all of the New Directions paperbacks he did, but they're hard to track down. I can't even put my finger on what it is about his work, but he's just the best. The combination of the images in relation to the title in relation to the typography is pretty much unmatched. ■

(Right) Alvin Lustig, dust-jacket design for the book *The Man Who Died*, by D. H. Lawrence, c. 1945 (New Directions). Copyright © the estate of Alvin Lustig/New Directions.

(Below) Spine lettering for various paperback book covers, early 1960s.

[Richard] Powers was primarily a sci-fi paperback artist. If he did anything else, I've never seen it. He did some really interesting fake-abstract kind of stuff—one of the few guys in that field with a distinctive style and a sense of humor. My favorite aspect of his work is his crazy lettering, especially the spine lettering he did for a series of Ballantine covers in the early sixties. Actually, it's quite possible that he didn't do this lettering himself, but whoever did is a genius. ■

I have always collected records more for the cover art than for the music. It's just like movie posters—the ones with the best graphics never match the movies that you really like. You always wind up with posters for Burt Lancaster movies you've never seen. I like the ones where you can tell it's a really bad house band that would print their own LP to sell in the restaurant where they played and nowhere else. I have many dozens of those and some have great covers—it's the devil-may-care, haphazard quality that appeals to me. Nowadays, everybody has Photoshop, and every grandmother can make a competent-looking Christmas card, but

Two unidentified record covers from Clowes's collection.

back then people had no idea what they were doing and there were some really interesting, unpredictable results. Really bad drawings, photographs that are so blurry you can't tell what's going on, insane unreadable typography—all the stuff that makes life worth living. ∎

Two unidentified record covers from Clowes's collection.

That cover image was a very important icon of my childhood. My brother and I had that issue of *Screen Thrills*—the most beat-up copy in the world. Finally, something happened to the cover: I think he tore it off or something, but it was removed from my existence at some point. Then, a few years later, I started buying *Famous Monsters of Filmland,* and you'd see the ads for it in the back. I would always stare at that little ad; it had such strength; I was haunted by that face . . . it took me a long time to find another copy. I finally bought one when I was around seventeen or eighteen. It's just the greatest image: a combination of intense joy and horror. The weird thing is that the actual magazine is all about old thirties and forties movie serials that no crewcut kid in the fifties or sixties would have been that interested in. He would have been much more interested in James Bond, or *Psycho,* or whatever was coming out at the time.

There's something about that cut-in-half image with the type around it: it's one of those great designs. Every time I think of a new cover that's the first sketch I do, and then I remember, "Oh yeah, I've already done that seventy-five times." ∎

(Left) Basil Gogos, original cover painting for *Screen Thrills* no. 1, 1962 (Central). Copyright © 1962 by Basil Gogos.

(Above) Daniel Clowes, *Lloyd Llewellyn Special* no. 1, 1988 (Fantagraphics). Copyright © 1988 by Daniel Clowes. Used by permission of Fantagraphics Books.

(Above) John Jacobs and Ken Landgraf, *Dr. Peculiar* no. 1, 1983 (Madison). Copyright © 1983 by John Jacobs and Ken Landgraf.

(Right and opposite) John Jacobs and Ken Landgraf, *Dr. Peculiar* no. 1, splash page and interior page, 1983 (Madison). Copyright © 1983 by John Jacobs and Ken Landgraf.

I sent away for these comics because of a crazy-looking ad in the *Comics Buyer's Guide* in around 1985. John Jacobs was this nutty Christian writer and occasional artist, who hired this equally nutty New York artist named Ken Landgraf to act as the Jack Kirby to his Stan Lee. Landgraf's work is so oddly derivative that it looks more like a collage than a standard comic page. *Dr. Peculiar* no. 1 is possibly my single favorite comic of all time. It's true art. You'll have this really slick Wally Wood–ish stuff, then a passage that looks like Mark Beyer, then an actual pasted-on face clipped from a Bob Oksner comic. The great conceit of this series is that every city has its own superhero. Did you know that Baltimore is protected by the Purple Unicorn? [laughter] ∎

ZATHUTAS LOVES SLITHURGO

There's this overt Christian content, and a conscious attempt to be morally instructive, but it's just chock full of the most twisted unconscious sexual content. You can't believe that it's not intentional. These creatures are the most repulsive, bizarre characters ever created. This one is like a living manifestation of the author's sexual neurosis. Dr. Peculiar has this secret identity. Here he's asking his girlfriend: "C'mon Louise, when are we going to get married?" "I told you Jeff, I need more time." Then she's thinking, "I wish you were more like Dr. Peculiar," and then he says, "I've asked her to marry me more than two hundred times. I've got to ask God for guidance in this situation." Later, this weird group of Christians is singing to him.

Here's a funny thing: Landgraf always uses this weird zipatone pattern, and once someone who knew him told me, "That's Elvis's head." Look at the soundtrack album for the movie *This Is Elvis*, and on the cover there's a really grainy halftone photo of Elvis's face. He actually Xeroxed that and cut it out and used it for zipatone. After a while, you can make out which part of Elvis he's using. "Oh look, there's his sideburns." ∎

(Opposite, top) Daniel Clowes, Slithurgo-inspired Valentine's Day painting for the artist's wife, 1999. Copyright © 1999 by Daniel Clowes.

(Opposite, bottom) John Jacobs and Ken Landgraf, *Dr. Peculiar* no. 1, interior page featuring the horrific Slithurgo, 1983 (Madison). Copyright © 1983 by John Jacobs and Ken Landgraf.

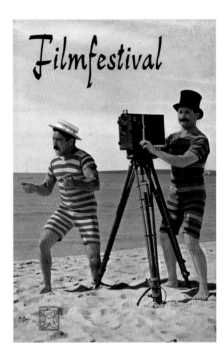

I'll give myself away here. My own swipe file. I won't ever really use this cover idea—I just wanted to get it out of my system, so I drew it in my sketchbook. ■

Daniel Clowes, sketchbook page, 2002. Copyright © 2002 by Daniel Clowes.

Filmfestival, 1961.

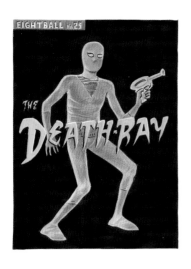

(Left) Daniel Clowes, preliminary sketches for "The Death Ray," 2003. Copyright © 2003 by Daniel Clowes.

(Below) Daniel Clowes, *The Death Ray*, letterpress print, edition of ninety-five, 2004 (Buenaventura). Copyright © 2004 by Daniel Clowes.

I actually did the single-image, all-black cover first, but it had a different layout—the typography went diagonally across his chest, and it just didn't quite work. My second choice was the newspaper image, so I did that and was fairly happy with it, but then I kept thinking I had to go back to that iconic image, which was so much stronger. Ultimately, I figured out how to make the first image work by getting rid of the type. I actually did a bunch of artwork for that comic that I didn't use; I did several pages that I wound up completely trashing or redrawing. ∎

These are some great Roy Crane *Captain Easy* Sunday pages. His drawing is so cool, and I love the way he tells a story. He sets a very detailed scene, and then leaves the rest of it up to your imagination. And the stories are filled with such weird, fetishistic stuff, like spanking, and these disturbing, masculine women . . . ■

Roy Crane, *Captain Easy*, Sunday strip, June 8, 1941. Distributed by Newspaper Enterprise Association. Used by permission of United Media.

Otto Messmer, *Felix*, Sunday strip, February 12, 1933. Copyright © by King Features Syndicate. Used by permission.

Terry Zwigoff turned me on to these. I was never that interested in the character, but he had a bunch of old Sunday pages, including an amazing original [Otto] Messmer, and I just kept looking at them every time I'd go over there. They have such a great comic presence, you know—just the way the characters dance around on the page. Simple, but really inventive and perfect and charming. Really smart stuff. To me, these look the best in these old, decayed Sunday pages. You can't beat that look. The way the paper ages makes all the colors work together, even if they didn't originally—like a watercolor with a yellow underpainting. I've often wanted to do my comics on newsprint, but I don't like the way it looks when it's new. I don't want to have to wait twenty-five years for it to look good; I want some printer to find a stock of aged newsprint. ∎

Barnaby ran in a lot of the smarter papers: it was in *PM,* the New York leftist daily in the forties, and it was in the *Chicago Sun-Times.* That's how I came to know about it, because my parents were always talking about it, twenty years after the fact. My mom bought me the Dover reprint when I was seven or eight. I think, at this point, I have every single Crockett Johnson *Barnaby* strip in every form. He redrew them for the books. He was completely out of his mind because, with his drawing style, it hardly looks different. You know, you look at it panel by panel and it doesn't do much, but when you read the stories it really comes alive. Not only is it absolutely hilarious, but it has this really strong, unexpected emotional quality. ■

Crockett Johnson, *Barnaby,* daily strips, March 2, March 4, 1946. Copyright © by the estate of Ruth Krauss. Used by permission.

(Top) Jack Bilbo, *Out of My Mind: Strange Stories,* 1946 (Modern Art Gallery, Ltd., London). Copyright © 1946 by the estate of Jack Bilbo.

Jack Bilbo, "The Strange Story of the Suicide Machine," *Out of My Mind: Strange Stories,* interior page, 1946 (Modern Art Gallery, Ltd., London). Copyright © 1946 by the estate of Jack Bilbo.

(Right) Daniel Clowes, Bilbo-inspired watercolor and gouache painting, 1997. Copyright © 1997 by Daniel Clowes. Collection of Glenn Bray.

Jack Bilbo was a crazy, aggressively bad artist whose work has a very compelling, childlike, X-factor quality. My friend Glenn Bray gave me some very rare books, and asked for a small piece of artwork in return. I knew he was a Bilbo fan, so I did this color "homage." Later, when we were looking for artwork to put on Seymour's living room wall in *Ghost World,* Glenn lent us both this painting and a great one by Bob Armstrong, saving the production a lot of money in usage fees. ∎

You couldn't figure out how to do this. You couldn't just sit down and map out how to make this kind of page work. It just has to pop out of your head—it's pure inspiration. He [Jaime Hernandez]'s got something in his brain that normal people don't have. Alex Toth has it, and a few other people, where everything they draw comes out absolutely perfect. He's just a perfect artist. You don't really even need to look at the original, in a way. It may as well be a Photostat, you know, it looks so perfect: "Did he scam me by just putting some ink-blobs on a stat?" ■

(Above) Jaime Hernandez, original art for "Jerusalem Crickets," *Love and Rockets* no. 21, splash page, 1987 (Fantagraphics). Copyright © 1987 by Jaime Hernandez. Used by permission of Fantagraphics Books.

(Left) Garrett Price, *Skull Valley*, Sunday strip, 1936. Copyright © 1936 by Chicago Tribune–NY News Syndicate, Inc.

I've been trying to find these old strips by a guy named Garrett Price, who was a *New Yorker* illustrator. He did this comic strip called *White Boy*, that later became *Skull Valley*. It's a Western, and he used a very eccentric art style; it's all about patterns and colors and textures, rather than realistic drawings of horses, or whatever. He's actually a really good artist, though some of these are kind of rushed and sloppy. It's an interesting area, between amateurish and accomplished. These are not the best strips, which is why I could get them, I think. These are from the thirties, like '35, '36. I really like how the lettering doesn't quite fit. I think he was kind of a sophisticated New York guy trying to do something for kids while still keeping himself engaged as an artist, so it's got this oddness to it. ■

I found these years and years ago, when I was in high school. What are they? Who are the Hippies? ∎

"The Hippies" buttons, undated.

S-Comics, homemade comic, c. late 1960s.

These were done by an older kid in my elementary school. I'm not sure how I got them, but if I stole them I think the statute of limitations has passed by now. Somehow, he captured perfectly the wacky excitement of those early-sixties superhero comics, better than the comics themselves, really. ∎

A long time ago, Chester Brown did a plug for *Eightball* in *Yummy Fur* and he redrew the cover to issue no. 1. He doesn't sell his originals, so it's very hard to get anything. He sent this to me, and I've always treasured it. It points out the weirdness of my own style to me. I wouldn't notice it when looking at my own cover, but to see it through his style, it's like, "What was I thinking?" ■

Chester Brown, original art for *Eightball* advertisement in *Yummy Fur* no. 17, 1989 (Vortex). Copyright © 1989 by Chester Brown.

Otto Soglow, *The Little King*, Sunday strip, May 21, 1939. Copyright © by King Features Syndicate. Used by permission.

Otto Soglow is a guy nobody ever talks about. I just love his stuff. Some of these are literally laugh-out-loud funny. I'm totally in awe of his simplicity, though the construction of the jokes is often very complicated and ambitious. ■

A guy I know bought this story from the original auction; very cheap, I think. A lot of the old E.C. collector guys hated [Bernard] Krigstein. Luckily, my friend got sick of it, and I was able to swoop in and liberate it from him. I look at this all the time; it's pretty unbelievable. You can tell he did it very fast. He was just sort of goofing around and it's really a pretty idiotic story. The worst drawing is the pay-off panel—it's like he didn't even care. The guy's got the goofiest face—it's hard to imagine anyone getting too scared by this. To me, it's just fun to read the word *pirhuana* over and over [laughter]. I don't even know when it's supposed to be set. Is it modern day? The main character is some South American overlord, but he lives in a modernistic Krigstein apartment. I think Krigstein was just trying to keep his interest in this nonsense. Where did the guy get all his Eames furniture? ■

Bernard Krigstein, original art for "The Bath," *Tales from the Crypt* no. 42, two interior panels, 1954 (E.C.).
Copyright © by William M. Gaines, Agent, Inc.

Isn't this incredible? He [Archer Prewitt] did this with a brush at about 10 percent bigger than printed size. It's just astounding to me: he's an amazing artist. Especially coming from Chicago, as I do, this captures so perfectly the atmosphere of a horrible, rat-infested Chicago alley. ∎

Archer Prewitt, original art for *Sof'Boy* no. 2, cover, 1998 (Drawn and Quarterly). Copyright © 1998 by Archer Prewitt. Used by permission of Drawn and Quarterly.

Steve Ditko, original art for "Blood of the Werewolf," *Creepy* no. 12, detail of interior page, 1966 (Warren). Copyright © 1966 by Warren Publishing Co.

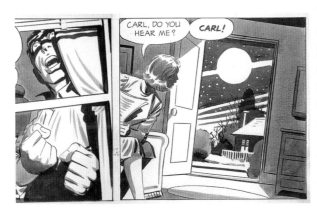

This is from *Creepy*, or is it *Eerie*? I forget. I got this years and years ago. I went to a comic convention with the idea of buying, you know, *Superman* no. 93 or something, and then I saw this and thought: "You mean I can buy this for the same amount of money?" It was no contest. It's got every [Steve] Ditko cliché: the open hands and determined fists, and the weird Dutch angle in the last panel.

I like that his wife is just, like, sitting in the dark, reading. Then there's the great line, "Hair on my Palms! Another of the Signs!" I didn't even know what that meant when I first bought it, and all of my friends used to tease me. The wife looks like a man with a wig on, as do all of Ditko's women [laughter]. ∎

Daniel Clowes, title sequence lettering for the film *Art School Confidential,* directed by Terry Zwigoff, 2006. Copyright © 2006 by Daniel Clowes.

To me, the most useful experience in working in "the film industry" has been watching and learning the editing process. You can write whatever you want and try to film whatever you want, but the whole thing really happens in that editing room. How do you edit comics? If you do them in a certain way, the standard way, it's basically impossible. That's what led me to this approach of breaking up my stories into segments that all have a beginning and end on one, two, three pages. This makes it much easier to shift things around, to rearrange parts of the story sequence. It's something that I'm really interested in trying to figure out, but there are pluses and minuses to every approach. For instance, I think if you did all your panels exactly the same size and left a certain amount of "breathing room" throughout the story, you could make fairly extensive after-the-fact changes, but you'd sacrifice a lot by doing that.

As far as movies, you have to have the stuff to begin with—I think a lot of people think that a good editor can make a good movie out of any footage. The studios seem to feel that way and tend to hire the same people over and over to try and salvage horrible movies with their cutting-room heroics. It's not like you can just make anything work—we have to throw away great scenes all the time just because we can't quite make them work. It's a very mysterious process: you put together a cut of the film and at the first viewing it always seems just terrible, then you work on it for two weeks and you can't imagine what else you could do with it; then six months later, you're still working on it and making significant changes every day.

It's very odd, but you kind of know when it's there. I had no experience, but yet I somehow had this sense along with everyone else as to when *Ghost World* was finally a movie rather than a collection of scenes. Now I can see in movies—usually lower-budget Sundance kind of things—I can see where they didn't have time to work something out. And now I notice all the continuity errors—it's really jarring—two people eating at a dinner table and when they cut to the reverse shot the woman's arm is suddenly lower. I never noticed stuff like that before and now it's like, "Ouch!"

But in a way I now have an appreciation for every single film, at least on a certain technical level. I hear people sort of dismissively complain about movies, "Oh, that was awful," and yes, they are usually quite terrible, but it's almost always the fault of the script or the basic premise. The way the films are made is an amazing thing to behold, even when they're terrible and tasteless, especially when compared with the way comics are made. I just saw the movie *Phone Booth,* which was just the most tastelessly made film. Everything was so overdone and show off–y, and yet I couldn't help but be amazed to think of how much work went into it; so many craftsmen working so hard to do these things, making these minute artistic choices throughout about the tiniest, most inconsequential things. It's hard not to be impressed and even sort of touched by it. ∎

b. 1962

Seth has proven himself the dean of deceptively austere emotional resonance, master-
fully manipulating every element, no matter how seemingly insignificant, of the comic
book's content and format. Each word, pause, and organic brushstroke is rendered cru-
cial to narrative scale and progression, a distillation of the overall luminosity of his vi-
sion. Seth is the form's grand miniaturist, and his languid pacing has reinvented the art
of cartoon time: his movingly crafted comics derive maximum (but never overwrought)
sublimity with minimal superficial action, representing the height of introspection in
the medium. Through beautifully expansive formal touches, and always glowingly under-
painted with the hues of loss and longing, his stories, particularly *It's a Good Life, If You
Don't Weaken,* channel seasonal transitions, narratively as well as metaphorically, refer-
encing a rich but forlorn history of thwarted artistic ambition and disillusionment within
the commercial comic industry.

The artist's ongoing *Palookaville* has been a staple of alternative comics since the
early 1990s. Gorgeously snapped and bathed in translucence, each issue is a com-
pressed microcosm of his larger aesthetic, conveying infinite weight and harkening back
to the slick professionalism of the *New Yorker* gag-cartoon heyday, while interweaving
and scrambling the broader cultural signification of that style and its softly echoing
historical textures. Seth's warm register is diffused throughout, exemplified by his pro-
tagonists' constant grasping for the surrogate lives buried in past ephemera, be it post-
cards, crumbling books, or yellowed comic pages. Implicitly, the overall psychological
glow of comics and the spirits of their creators are a slowly unfurling subtext, deeply in-
ternalized narratives that dominate characters' thoughts. As in his masterpiece to date,
Clyde Fans (currently in progress), the themes of loss and redemption whisper through
all of Seth's comics, a lassitude regarding the necessary rhythms of commerce, symbol-
ized by recurring cityscapes, fleeting vistas seen from the majestic angles envisioned by
the dreamer, both the socially ill-equipped introvert and the materialistic striver.

The sheer variety, consistent level of artistic craft, and conceptual intelligence of

Seth, self-portrait, c. 2002. Copyright © by Seth.

Seth, "190 Dublin Street," single-page strip, 2005. Copyright © 2005 by Seth.

7. Seth

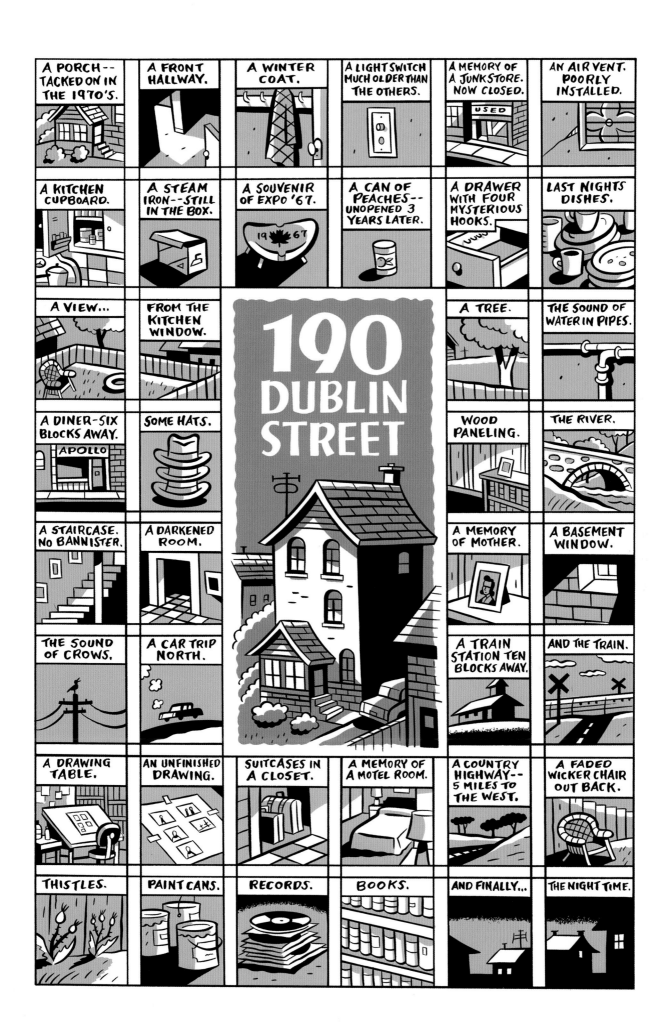

his comics and wide-ranging design, illustration, and personal projects punctuate a coherent yet open-endedly sympathetic worldview. Seemingly empty formal spaces are not only activated but also charged by a laconic brush flourish or minor touch of color or shadow; the ephemeral is transformed into sculptural solidity, a psychological and physical landscape. Seth's is a constantly expanding vision, spilling over into his research as one of comics' most articulate historians, specifically of his native Canada's underdocumented history.

The meditative environment of his comics bears witness to the perfect integration of form and content wherein every aspect shimmers with the artist's precisely realized aesthetic sensibility; subtle relationships slowly deepen, thematic variations gracefully reveal themselves, and interrelated spiritual connections abound. Seth's overflowing stories, when unpacked, showcase comics' residual warmth not found in any other medium. ■

Seth, "155 Ashwood Street," first page of uncompleted strip, c. 2004. Copyright © by Seth.

This is a page from a graphic novel I was planning to serialize through the magazine *Toro* here in Toronto. It was titled "155 Ashwood Street"—I planned it to run two pages an issue, about ten issues a year. Each of these pages was designed to be cut in half when I republish, so I figured in about two years, roughly, I'd have enough material to finish the story and publish it as a book. I was planning to call the book *The Amazing Henry Foot*. I was promised a completely free hand when I agreed to the project, but within two installments the editor started to interfere—basically trying to edit me. They wanted a tight breakdown of exactly where the story was going (which I tried to fulfill, even though I never work that way) and then they tried to get into micromanaging the writing. That's when I had to quit. It only made it to three installments. It's too bad; if it had carried on I would be half done with the book now. It was a very introspective piece, not much different than what I'm doing in *Clyde Fans*, I suppose. It was about a book designer in his late forties who's just had a serious breakup from a long-term relationship and was going through a period of reevaluating his life in the small town that he's moved to where he doesn't really know anybody. It's certainly based to a large degree on actual experience, but I didn't really want to deal with autobiography in a direct sense, and it gives me the freedom to change details. What will become of it . . . I don't know. I may come back to it later; I may just end up drawing the book out in my sketchbook over the next couple of years. ■

A couple of years ago—one and a half or maybe two years ago—I put this book together. And what it is—well, I had opened up a suitcase where I kept all these teenage comic books that I had drawn as a kid and a teen, which I had been carrying around for twenty years or so, and for some inexplicable reason I got inspired and wanted to gather them together into a book. It turned into this crazy time-wasting project where I ended up writing about fifty pages of autobiographical text to go along with the comic strips. When I started the project—at first I was simply writing a little introductory note to explain what these comics were—but as I began going over each comic and trying to describe what it was about and what I was ripping off at the time, etc., it turned into this bigger thing where I wound up writing endlessly about my childhood and teen years. The book is broken up into chapters, one comic per chapter. Generally, they are complete comic stories, unless of course pages were lost, or as you can see in some of them, I just ran out of steam and the story ends in the middle of a page. Everything is just an emulation of whatever I was reading at the moment. It's an entire Marvel-style universe of heroes and villains: Cosmic Comics.

I've got more of these childhood comics, too—there was a later period than this. There were actually several periods of these comics, and this book covers from about grades eight through eleven. There was a period before this—the best stuff really—but those were all lost long ago. Then I've got a period after these, which is stuff that I'd be more hesitant for anyone to see because it's got to the point where I was doing . . . well, childhood drawings are kind of charming, then there are terrible teenage drawings. That awful period when the drawing struggles to get better—it loses the charm of childhood but has none of the polish of adult work. Just awful drawings. Those stories are much more embarrassing, too.

The painting [*Employees of the Cosmic Comics Company circa 1975 to 1977*], which I did recently, is of most of the different characters from these teenage superhero comics. I've actually kind of reconnected with these characters in a weird way now; I've been thinking that I'd like to do some drawings based on them. At the end of the book I did a new three- or four-page strip, in my sketchbook style, with one of the main characters, and I think I may do another ten- or twenty-page strip using that character, just for my own pleasure. His name was the Bobcat, and he was my main character and was actually sort of supposed to be Spider-Man, although why I chose a bobcat I don't know. This book was a fun project to do—I poured hundreds of hours into it, for no logical reason, since it's nothing that will ever see print. It was a great pleasure. It's funny, this was just some junk that I was carrying around for years, but only when I actually began doing something with it did it become sort of meaningful to me again. ■

Here's another thing, which is kind of in the same vein. It's a silly project done for no reason at all. Lately I've been doing more and more stuff where there's really no reason why I'm doing it. Again, it's not for publication . . . I think I'm becoming increasingly interested in simply doing things for myself as opposed to having any logical purpose for it. This probably comes from doing so much work for the mainstream publication media and finding it so dissatisfying that I lavish the kind of attention—that I should put into these other things—into my private projects. Even my comic, which is personal expression, is still clearly work. So this stuff gets done out of the desire to have fun with art.

(Opposite, left) Seth, *The History of the Cosmic Comics Company*, hand-bound book of the artist's drawings, c. 2002. Copyright © 2002 by Seth.

(Opposite, right) Seth, *Employees of the Cosmic Comics Company circa 1975 to 1977*, watercolor painting, 2003. Copyright © 2003 by Seth.

Seth, *Funny Book Info Guide* (redesigned *Overstreet Comic Book Price Guide*), original drawing and hand-painted front cover, 2004. Copyright © 2004 by Seth.

For some reason I was flipping through my *Comic Book Price Guide,* and it's such a hideous book that I decided to redesign it entirely. The guts are the same, although I did give it new endpapers. You'll see that on the front you've got all the superheroes, and you flip it over and on the back are all the actual comic book collectors. The Sad Truth. It's playing with that very basic comic book dichotomy of the fantasy identification figure, and then here's the reality of the poor schlub who's actually reading about him (in this case, the "Barn-Owl" comic book) [laughter]. It's a cheap gag. I knew that the *Price Guide* people would never be hiring me to design a cover, so . . . ■

Seth, *Funny Book Info Guide* (redesigned *Overstreet Comic Book Price Guide*), hand-painted back cover, 2004. Copyright © 2004 by Seth.

These buildings came about when I started planning a big story, for after *Clyde Fans*, based on this imaginary town of Dominion, Ontario, which is actually where Simon is in part 2 of *Clyde Fans*. I had an idea for a series of stories, and I thought I'd like to begin doing some work on envisioning a backstory about the history of the town itself: where everything takes place. When I started, I thought that I'd work out some of the businesses, get a feel for the history . . . then, for some reason, as I was working it out, I began building a couple of models of them, and it got a bit out of hand and became a project in itself. I've got about thirty buildings now, and am working toward a minimum of fifty. Although I can't imagine stopping there. It may turn out to be a lifelong occupation. They're all cobbled together from mixed-up sources. I might take the basic shape of something I've seen and add on a tower from some other building, etc.

This book is where I've been doing the notes for the project. It starts out pretty rough, but as I worked along, adding new information with each business, it became more and more complicated and more fully realized. As I worked out each business—at first I had no understanding of what it was I was doing, just coming up with a building: for example, the vaudeville house. Then I'd come up with some of the acts that had appeared there, who had owned it, its history, how it later became a burlesque house—things of this sort. Each business was

Seth, five views of model buildings stemming from "Dominion, Ontario" graphic novel project, c. 2000–2004. Copyright © by Seth.

Seth, sketchbook pages related to "Dominion, Ontario" graphic novel project, c. 2003. Copyright © by Seth.

conceptualized separately, but as time has gone on, I've found them connecting to each other. This guy for example, Silas Ott, of the Ott Typewriter building, was just somebody I came up with for that particular building, but later on I figured out that he was involved in the backing of the television station, and before I knew it, the characters at the television station were involved in other businesses, and I began to understand how things interconnected and how the history of the city worked a little bit more. For example, I designed a sculpture for a park and then began working out who sculpted it; that connected to the local bookstore. On one page you can see some of the different musicians from the town; I worked them out while figuring out the local TV shows . . . from these shows came a character named Clinton Hall, who had a radio program called *The Hall of Records,* and he later shows up involved with the town collectors and the record store that later is part of the "Kamph-Saunders block." This Chinese laundry later becomes the fish and chips shop. It gets more and more realized as you go along.

This is turning into a whole book by itself, before the story that I had planned even starts. I've decided to tell the story of the whole town before I start in with the narrative, so that could be a couple of hundred pages by itself. What's fun about it is that you're the omnipotent god who is putting it all together, but on the other hand, you can also be the observer who says: "Why were things done in this way? What is the story of this place, or what's around that corner? What are the architectural motifs of this northern town? What is its soundscape?" It's endless. It becomes more fun to do as it gets more and more complex. The only thing I regret is that I used an old ledger book for my notes, since there are lines on all the pages behind everything. I didn't plan it to be something that I would put this much effort into when I started—the early pages are quite rough.

Making the buildings has turned into a project of its own, and I actually enjoy making them, and I'm probably going to keep doing them even if the story never pans out. It might take me years to even approach the story, and I have a feeling there may be a graphic novel in between *Clyde Fans* and this. Something will come of it though. ■

(This page and following page, top) Seth, original sketchbook painting and Polaroid reference photograph, 2003. Copyright © 2003 by Seth.

The main sketchbook that I'm working in now is all strips. After *Vernacular Drawings* came out, for some reason, I switched over exclusively to strips; but I do have another separate sketchbook that is just single images. When the second sketchbook volume is published in the next year or so, it'll probably be a mixture of the two. This strip sketchbook contains a story called "The Great Northern Brotherhood of Canadian Cartoonists." In it, I'm creating a whimsical history of Canada's cartooning history—comics about Mounties and trappers and the like. I also have a whole section of that story detailing some fake comic books, that I think are funny, based around Eskimos in outer space [laughter]. These sketchbook strips have freed me to do stuff that I would never do in *Palookaville*. If it had crossed my mind that the next story in my comic book would be an imaginary history of cartooning, I wouldn't have done it, because it seems like an idea that's just a lark. In the sketchbook I can fool around with autobiographical strips . . . or humorous ideas. Stuff I'd never put in the comic because I consider the comic to be real backbreaking labor and I wouldn't think this material was worthy to waste my time on. This has actually opened the door to a lot of work, because with this style I can churn out a page in no time: the drawing is completely free and fun. It's also allowed me to see that when I get older I can still do strip work—because while I know that I can't keep the brush control as I get older and older, I can look at this looser style and feel "It's good enough." I can do this without feeling too bad when I'm an old man.

MOTHER

AUG 7 2003

Seth, original sketchbook painting of the artist's mother, 2003. Copyright © 2003 by Seth.

The other book is a much more traditional sketchbook, where I'm working along doing actual drawings, much like in the previous *Vernacular* book. A lot of buildings, which I can't stop drawing . . . and I've been doing a lot of portraits of my mother lately, too. I've become obsessively involved with my mother now that she's going into such a severe decline, and a lot of my work seems to be connected with her at the moment. Actually, I suppose, what's going on right now in *Palookaville,* for the next issue or two, is connected to that, having to do with Simon and his mother. I did a strip about her that just appeared in a newspaper recently also. This sketchbook jumps around, there are blank pages occasionally where I'll begin planning a drawing and lose interest—for example, I was going to illustrate some limericks and lost interest, but I'll come back to them later. The blank pages get filled in eventually. I find my desire to tell stories has really hurt my straight sketchbook. The gaps between pages of simple drawings grows longer and longer.

I've been very interested in the last few years in landscapes and buildings, so I've been drawing them a good deal—a lot of this has to do with Thoreau MacDonald. I seem less interested in drawing the figure than I used to be. In fact, my whole approach that I was using in *Vernacular Drawings* has no interest to me now at all. In there, I was simply drawing from books and printed matter—whatever image struck me. I don't have any desire to do that anymore; it seems I only want to pursue a couple of themes when I draw: landscape, buildings, or my mother, and that's about it. The source material now is mostly just my own photographs. It used to be I'd draw from any book—I'd pull out a book of Diane Arbus photographs and draw from them. That seems completely screwy to me now—how can you be drawing from someone else's art?

I carry a camera with me all the time, and I'm always snapping shots of buildings, looking for anything that strikes my eye architecturally. I have huge amounts of photographs that I glue into books. It's a simple matter of them becoming the source material of drawings in my sketchbooks; I don't really feel tied to the specific realities necessarily—I'll change color, etc. Most of the time what I'm going for is mood more than anything (although what mood that is I'm not entirely sure); it's not so much a deep interest in architecture per se, as it is in the feeling you associate with buildings. Most of the time that I'm drawing in my sketchbook, I'm just trying to achieve an effect that has some sort of emotional resonance, more than any attempt to capture architectural accuracy, or record a specific period or anything of that sort. I think on some level drawing buildings and landscapes in my sketchbook is part of a collecting urge. I've got such a strong desire to collect and possess things and you cannot possess buildings or places . . . but by drawing them in the sketchbook, I somehow feel that I've added them to my own pile. The backgrounds in *Palookaville* are very much cobbled together from these photographs. Although over the many years of doing this, you start to build up a mental reservoir, so you can begin to put together street scenes without doing much reference at all.

I've been more interested lately in capturing Guelph [Ontario] itself in my sketchbook, doing something more local. You develop a sense when you live somewhere, become connected to it. My whole process of working in a sketchbook has moved very much from the general to the specific. When I first started working in them years ago, initially I was very inspired by Crumb—just as any cartoonist working in a sketchbook—and I had this wide-ranging interest in drawing anything from the past. But as time has moved along, year by year, I find I'm less likely to spend time drawing a page full of flappers or some such thing, and more and more likely to draw something from just down the street. ∎

Two landscape illustrations by Thoreau Mac-Donald. Copyright © by the estate of Thoreau MacDonald.

Thoreau MacDonald was not a cartoonist, but he's one of the main artists that I'm interested in at the moment, and have been for a couple of years. He was a book designer in Canada and the son of a famous painter, J. E. H. MacDonald. His books were a thing of beauty with his hand-rendered type and black-and-white illustrations; I love everything about his work. He worked for different publishers (though mostly Ryerson Press) and also self-published chap-books of his own illustrations—one every ten years maybe—and it's all beautiful pen-and-ink work; a bit like a Canadian Rockwell Kent. His early work has a similar approach and real Kent feel to it. But later it takes off in a simpler direction of its own. Less streamlined than Kent. Personally, I feel the great depth of feeling in MacDonald's work leaves Rockwell Kent looking pretty cold and sterile in comparison. MacDonald had a deep love of the natural world and his drawings are almost entirely about the beauty of landscape and nature, and display just an amazing graphic ability. These little drawings are so beautifully put together.

Thoreau was a modest, reserved man, too—he wasn't much interested in art, just in life,

producing a limited amount of work, just what was required from him in a humble sort of way. He took after his namesake, a thoughtful man who loved nature. A couple of his diaries have been published, which are very interesting: the work is a remarkable example of virtuoso pen-and-ink drawing, displaying a real command and understanding of the environment—you can just feel it. He spent most of his life just north of Toronto in a little town called Thornhill. The drawings are beautifully understated, as is his use of type. He's been a big influence on me—when you see the book I did with my father [*Bannock, Beans, and Black Tea*], it's very clear. ■

A selection of books illustrated by Thoreau MacDonald: *The Mackenzie (Rivers of America)*, 1949 (Rinehart); *Birds and Animals*, 2nd Series, 1973 (Thornhill); *Talks with a Hunter*, undated (Woodchuck); *Woods and Fields*, 1951 (Ryerson). Copyright © by the estate of Thoreau MacDonald.

This doesn't relate to cartooning much, except peripherally. These are all fake trophies—fake awards; another one of these projects that I've just started in the last few years. They're all constructed from a variety of trophies and statues that I've put together and reconfigured and had new engravings done for them. They are all awarded to me, and are mostly self-deprecating. They generally follow a Canadiana theme—gags, in a way, that are generally pretty negative. Nonsense humor. A few of them relate to that long strip I've been doing in my sketchbook (currently up to about forty or fifty pages in length but not finished as of this moment): the imaginary history of Canadian cartooning. A handful of the trophies are connected to the actual organization in the story. So this very tall one here is the Journeyman Award, which is awarded each decade to an outstanding cartoonist. I've managed to win it for the last ten years. Chester [Brown] won it the ten before. The Jasper Award is given yearly, to the cartoonist of the year; this loving cup goes to "Unrecognized Genius." Some of them are more grandiose, but most are just the opposite [laughter]. I want to assemble about thirty or thirty-five and then stop making them. The wonder of eBay—I needed a metal moose for one of these trophies; I just had to look around eBay and found one right away, whereas, before eBay, it would have taken me ten years to find all the elements to make these things.

The sketchbook strip that these are based on has been a lot of fun. I'm really interested in Canadian cartooning, but in a way it's been a very limited field. There were only a handful of guys who did anything of any real interest, so it was kind of natural to start making up an entirely fake version. I'm researching a book right now (titled *The Gang of Seven*) with journalist Brad Mackay that will attempt to document the seven important [newspaper and magazine] Canadian cartoonists of the past. There were other guys who worked in comic books in the forties, and there was some interesting work there, and there is a tradition of editorial cartooning here, but that's all somewhat out of my realm of interests. I've included some of these guys in my fake history too, such as Doug Wright, but for the most part, I'm just making that stuff up out of whole cloth. ∎

Seth, fake trophies relating to "The Great Northern Brotherhood of Canadian Cartoonists," c. 2000–2004. Copyright © by Seth.

TREPANIER WAS A MORE COMPLICATED CHARACTER—AMBIVALENT ABOUT HIS WORK, MISANTHROPIC, SECRETIVE... DEEPLY LONELY.

REAUME PRODUCED EIGHT VOLUMES ABOUT HIM OVER THE NEXT 15 YEARS. EACH ONE A UNIQUE CREATION WITH IT'S OWN DISTINCTIVE ATMOSPHERE.

VOLUME THREE—"FIRES OF MIDSUMMER" DESCRIBED THE HARROWING TALE OF TREPANIER'S FIGHT FOR SURVIVAL AGAINST A RAPIDLY APPROACHING FOREST FIRE.

ONE POWERFUL SCENE DEPICTS TREPANIER FURIOUSLY PADDLING—THE FIRE RAGING ON BOTH SIDES OF THE RIVER. THE SOUND OF THE BLAZE IS LIKE A HURRICANE IN HIS EARS.

IN VOLUME FOUR—"THE ICE WALK", THE MOOD IS ENTIRELY INTROSPECTIVE. ALL 200 PAGES ARE EMPLOYED TO TELL OF AN EIGHT HOUR PERIOD WHERE TREPANIER TRACKS AND KILLS A WOUNDED BLACK BEAR ON A COLD SNOWY NIGHT.

THE REAL GEM OF THE SERIES IS VOLUME SEVEN—"GHOST VALLEY." HIS MASTERPIECE.

UNUSUALLY LONG FOR A NICKELBACK (350 PAGES), IT IS THE STORY OF TREPANIER'S LOST WANDERINGS IN A REMOTE MOUNTAIN VALLEY. MONTHS PASS AND HE REMAINS HOPELESSLY LOST.

THE READER IS IMMERSED IN THE CAREFUL DETAILS OF HIS DAY TO DAY SURVIVAL... HIS BITTER LONELINESS. THROUGHOUT THIS DARK TALE HE IS HAUNTED BY MEMORY.

TOWARD THE END OF THE BOOK, EMACIATED, NEAR DEATH, TREPANIER ATTEMPTS TO CLIMB ONE OF THE GREAT MOUNTAINS TO, PERHAPS, GAIN A VANTAGE POINT.

Lost in Space
Aimee Mann

This mock-up is something I did last year. I really hate the early work I've done, and that story in *Palookaville* no. 2 and no. 3 had elements of it that I still think are all right, but I really hate the thing in its entirety. For a long time I'd thought how I would like to fix the story, so I decided to rework it. I spent a few months tearing it apart, throwing out everything that was wrong, rebreaking it down, and trying to pace it as it should have been told. I restructured the whole story with the foolish idea of perhaps redrawing it at some point in the future, which will probably never happen. It's double the length now and considerably better. All the pacing in it was wrong—the first part is less torn apart because I was happier with the flow—I was really taking my time telling the story in *Palookaville* no. 2. Then in *Palooka* no. 3, I just wrapped it up and it was a mess. Ultimately it's work that I'm very ashamed of. Afterward I decided to bind the mock-up together into a rough book; I played around with what kind of endpapers I could add and thought I might open it up with a series of individual drawings of the characters. Then once I'd bound it together with the fake covers, I decided I liked the cover design, so later ripped it off for the *Bannock* book.

I've actually started now to rework again that material into another story based around a restaurant, but removing myself as the main character and also excising any of that "coming of age" content. I like the idea of all these characters interacting in this specific environment, and

(Opposite) Seth, "The Great Northern Brotherhood of Canadian Cartoonists," original sketchbook strip, c. 2000–2004. Copyright © by Seth.

Seth, mock-up book cover and preliminary interior page for proposed "Short Order" graphic novel, c. 2003. Copyright © by Seth.

then having lives that are separate outside of it—so I'm kind of thinking that could be a future story. That's another good thing about those sketchbook strips—I'm coming up with stories all the time, but I don't work very fast, so it's not likely that I'll be doing twenty graphic novels in my life. I've got to focus on the few that I think are worthy of spending ten years apiece on, and try to use the more throwaway ideas in something else. ∎

Seth, original watercolor for proposed "Short Order" graphic novel, c. 2003. Copyright © by Seth.

John Gallant and Seth, *Bannock, Beans, and Black Tea,* 2004 (Drawn and Quarterly). Copyright © 2004 by John Gallant and Seth. Used by permission of Drawn and Quarterly.

Seth, original art for illustration, c. 2000–2003. Copyright © by Seth.

(Opposite) Seth, original watercolor painting for the cover of the French *Palookaville* collection, c. 2004. Copyright © by Seth.

I lik
ing more
to classif
great fun
as an arti
was work
and came
a bad art
designed
Crumb, i
years to g
that I use
a very dif
lustration
walking t
"keep on
an air of a
a totally d
was a *Ne*
out exactl
give much

This is the new cover to the French edition of some early *Palookaville* stuff. ∎

Seth, three mock-ups: *Clyde Fans Book One*, 2004;
Vernacular Drawings, 2001; Stuart McLean, *Vinyl
Cafe Diaries*, 2004. Copyright © 2004, 2001, 2004
by Seth.

These mock-ups basically were made to demonstrate how the books are structured as a guide
for the publisher (and the production people). I'm involved in every detail of the final design
of my books, so these are just things to be sent along to make absolutely sure everything is in
the correct order. I don't include every element of the design in the mock book—they're not
meant to be tight guides, which I also do, but just to make sure that the publisher doesn't get
anything mixed up. As much as you write things down, this is much easier and more concrete
to compare every page and see it existing as a physical object. ∎

These are the covers from the [Charles] Schulz reprint proposal that I presented to Jeannie
Schulz. Basically, Gary [Groth] went through all the dealings, and then after they'd got things
fairly concrete, where it looked like it was going to happen, they brought me down so I could
talk to Jeannie and show her what I wanted to do with the book. I went there with a small talk
planned, basically to tell her that I felt Schulz's work was so wonderfully sophisticated and that
it had been, I felt, undersold in the last thirty years—pushed as kids' books, really Pop-y, and
that I wanted to try to put together a package of some sort that had some quality of under-
statement to it. So here is the production art that I brought down to sell the idea. These fake
covers I put together are pretty rough, really. I outlined how the books would fit together and
what the design system was . . . originally, I was planning on each book collecting one year
of the strip and I wanted to do fifty covers with Charlie Brown's face on every cover. His face
would have been taken from the specific year and then you could chart his changes over fifty
years. Basically, everybody but me felt that was too much, that we should vary the characters,
which is what will happen. This original idea was to demonstrate how much variety there really
was just in the Charlie Brown face itself. Conceptually I like it, but I didn't really expect them
to go for that. So, we'll have twenty-five books with all the characters appearing once on the
covers—one face per book, two years per book, although Charlie Brown, Snoopy, and Lucy,
maybe Linus too, will reappear; Charlie Brown will definitely be on the first and the last books.

Joe Matt, original *Peanuts*-
inspired art, 2001. Copyright
© 2001 by Joe Matt.

(Top left) Seth, mock-up cover design for *The Complete Peanuts*, 2003 (Fantagraphics). Copyright © 2003 by Seth. Used by permission of Fantagraphics Books.

Seth, three cover design proposals for *The Complete Peanuts*, 2003 (Fantagraphics). Copyright © 2003 by Seth. Used by permission of Fantagraphics Books.

Not all the characters can get the cover—but everyone will make the spine. I'll start the early volumes with the minor characters, like Shermy. Each cover-featured character will dominate that specific volume's design.

In many ways, the design has stayed almost exactly the same as I originally conceived it. The endpapers for each are completely assembled from Schulz's background imagery, which I've reworked. I'm keeping the same endpapers for each decade, so it'll change once we hit the sixties, and what's interesting is that by the time we hit the nineties, there are almost no backgrounds; it'll become very minimalist, with just a bit of grass, or some detail to build around. When you open the book, I want the reader to move into Schulz's work in a quiet way, so they start with the environment—then you cross a double-page splash of just grass that will lead you into the book. The grass will be updated every ten years as well, which no one will even notice but me. That will lead into a series of spreads that go throughout the book before you enter into the strips. Each book will feature one of the iconic places—twenty-five iconic backgrounds I can work with, Snoopy's doghouse, for example.

It's a pretty straightforward design system, in that with each volume I don't have a huge amount of elements to change, just certain spreads. I have to replace elements here and there

with new imagery from that volume's years, of course. Things slowly evolve over the whole series, but in a very subtle way, which from book to book really isn't noticeable, but by the time you get to the last book the changes in the strip and the characters will be very clear. This spread, showing Schroeder's living room, is taken from various sources and it will give you some indication of how much I am playing around with his art. If you look carefully, you will see that it's almost entirely pieced together from a variety of sources. In a sense, I feel like I'm drawing with Schulz's hand by taking horizons from different backgrounds, taking trees, a house, a road from separate drawings to be able to create this scene and then drop color over it. What I want to try to do with each book (if there's the space) is create at least one spread that pulls forward the background of the strip (although it might be more difficult in the later volumes). And then possibly I might have spreads that show the joyfulness of the characters—like the one in the first volume with the running figures.

In the design, what I'm going for—I hope to create a package around the work that shows it in a slightly different context than it's been presented in for years. I don't want the reader to think much about it at all, but when they come to it, I hope they're led in and out of Schulz's work in a way that puts them in the right mood to read it again as the subtle work that it is, not as the product that has been pushed for so many years by merchandising and TV specials. But we'll see. Jeannie Schulz was very receptive and easygoing about things. I was somewhat prepared that if there was any sort of conflict and I felt myself being pulled down the road having to do the same old boring *Peanuts* books that everyone's done, I would probably back out of the project. I was happy that she was so open, and what's great about Jeannie Schulz is that you could really see when talking with her that she thought of Charles Schulz as a genius. You know, when someone's been married for thirty years (or however long it was), it would be very easy to imagine the widow feeling the exact opposite: sick to death of that irritating husband who spent all his time in the studio complaining about being a sad multimillionaire. But she didn't have that quality at all. ∎

Seth, original rough collage mock-up for double-page spread, *The Complete Peanuts,* 2005 (Fantagraphics). Copyright © 2003 by Seth. Used by permission of Fantagraphics Books.

John Stanley, "Val and Judy: Beginner's Luck," *Thirteen (Going on Eighteen)* no. 22, interior page, 1967 (Dell). Copyright © 1967 by Western Publishing.

It's hard to encapsulate just how highly I hold John Stanley's work. He's one of the handful of old commercial comic book artists who worked within the very confining parameters of writing and drawing licensed characters. For years he worked on *Marge's Little Lulu*—a book he did not create. Still, over those years he breathed life into the character, who was essentially a one-note cartoon brat when he first came to her, and crafted an extremely rich cartoon universe for her to live in. The same is true of her sidekick Tubby, who later had his own comic book too. The most amazing thing about these books is the incredible fertility of his imagination. He came up with a series of stock situations for the books—examples being Lulu's imaginary stories or Tubby's detective tales—and then wrung endless variations out of them. The situations never became tired. It's hard to imagine but he kept those books fresh for hundreds of issues. Remarkable. The quiet everyday humor of these comics is truly something beautiful. Reading these comics over dozens of issues the characters come to life and you grow to feel deeply for them—even though on the surface they are such broadly etched creations. It is a rare thing to bring these lines on paper to life.

Late in his career he created a handful of new books: *Kookie, Dunc and Loo,* and my favorite of all his works, *Thirteen (Going on Eighteen)*. The teenage girls in this comic, Val and Judy, are so alive to me that I often think of doing stories about them myself in my sketchbooks. I think it comes from the desire to have them "live" a little bit more. I mean, there were so few issues of this comic—under thirty issues! Much like for Lulu, he created a series of stock situations for the girls, like Judy's Saturday night dates with Wilbur, or Val's "dream dates," that he spun his variations off of. The shame of it is that he really seemed to be hitting his stride with the characters when the comic book was canceled. I don't know much about the man himself—but he sure could write a funny and intelligent comic book. He knew how to pace a story and he knew how to set up a gag. His drawing was beautiful—economical in its design. Like Harvey Kurtzman, he was one of those masters of simple, true cartooning; not a line out of place or wasted. I really admire his use of negative space. I suppose that most of Stanley's work could be written off as "girls' comics," but those old books really speak to me. I've learned an awful lot by just reading them over and over again for pleasure. A master. ∎

Doug Wright, *Nipper*, three
weekly strips, late 1950s. Copy-
right © by the estate of Doug
Wright.

Doug Wright, original art for
Nipper, detail of weekly single-
panel strip, late 1950s. Copyright
© by the estate of Doug Wright.

Doug Wright was a cartoonist who worked from about 1948 to around '80. His best-known
work was the strip *Nipper*, and an interesting fact that I just found out is that the very day the
last *Nipper* strip appeared is when he had his stroke that put him out of commission; he died
a few years later. This example of his work demonstrates that he had a great amount of render-
ing ability. His strips don't generally involve quite this much detail. This is one of the single-
panel strips. He varied between four-panels and occasionally single images.

His strip started off in a quite simple style—simple figures, not much detail in the early
stuff. As it goes on it becomes progressively more complex, and in the sixties his work begins
to really flower. It's always pantomime, and what's great about Wright is this was always a
family strip, but completely unsentimentalized—the opposite of *The Family Circus*. He never
played up any of the cutesiness of childhood. The strips were remarkably slice-of-life. The two

Car '64

6. "Oh, Harry cooks on the weekends!"

boys in the strip are mostly depicted as kind of petty, with constant infighting. It's remarkable how long he did this strip based on just the small details of family life; it is really pretty charming stuff, and at the peak of the strip he really began to pack in the detail: in one picture, you'll go from foreground to middle ground, to an incredible background vista going way back, up a long street, seven or eight houses, hills, etc. All in service of a very simple gag, but really evoking a sense of place and time. Obviously, his love was in the detail. It's interesting because in the figures, he was not interested in detail. He kept them extremely stylized and set them against his richly realized backgrounds—which is in many ways similar to what is being done in manga today. He also did a good number of magazine covers, which are beautifully evocative, and just amazing compositionally and in his choice of color.

I realized recently, there's nothing in the world that brings back to life, for me, that period of the late sixties and early seventies as much as this strip. When I look at it, the details of everything, down to the split-level houses, the clothes that people were wearing, even the screen doors, or the kind of toys the kids have—he was really fascinated with actually being accurate. In the same way that the E.C. artists would get excited about drawing the right kind of equipment for the army, he really poured his attention into the mundane details of everyday life: if he depicted a variety store, for instance, he made sure that he went out, looked at the reference, and drew it exactly right. He was great and one of my earliest interests—he and Schulz.

We—myself, Brad Mackay, and Chris Oliveros—have been in touch with his widow and his sons recently for a book project, and they have a huge collection of his work. The family has donated most of its collection to the archives in Canada; Wright kept everything, and they were showing me sketchbooks, which is unusual to find with old cartoonists, that were full of local details, vehicles, trips he had taken to the Caribbean, books full of characters—all great stuff. He loved to draw automobiles and was a master—an example of yet another midcentury artist who loved drawing machinery. I have about seven scrapbooks myself full of tear sheets of his work that I've managed to track down, but it's been a tough slog. It's difficult to find, because unlike the usual American collector market, there's no market for this stuff, so it all had to be tracked down through finding the magazines in junk stores. ∎

(Opposite) Doug Wright, cover for "Entertainments," *Montreal Star*, December 28, 1962. Copyright © by the estate of Doug Wright.

Doug Wright, detail of a series of single-panel cartoons, early 1960s. Copyright © by the estate of Doug Wright.

Jimmy Frise, illustration for "Apples Lead to Trouble" by Gregory Clark, *Toronto Star Weekly*, September 12, 1942. Copyright © by the estate of Jimmy Frise.

Jimmy Frise, *Juniper Junction*, Sunday strip, 1948. Copyright © by the estate of Jimmy Frise.

Jimmy Frise was mostly famous for two things: his early fame came from being connected with the writer Greg Clark. The two of them did a feature every week for the *Star Weekly*, back in the twenties, thirties, and forties. The thirties would have probably been the big period for this, but Clark worked with Frise right up until the time of his death in 1948 of a heart attack. Basically, Clark was a humorist, very middle-of-the-road sort of thing. He wrote a popular kind of funny column—a Dave Barry type. The stories were the exaggerated adventures of Clark and Frise. It's very typical of Canadian pop culture of the time, very woodsy, lots of fishing and hunting, and each week in this feature, Frise would do a large main illustration. At the same time, he was doing a comic strip in the same magazine, but the Clark feature brought a lot of attention to him personally because they were the main characters of the thing. It's a perfect kind of comic pairing in the drawings: you've got the short little round figure matched up with the tall gangly character. I've read a good deal of it, and it's all kind of charming, but the stories are mostly forgettable. This fellow Greg Clark went on to become something of a Canadian institution in the fifties and sixties in the same way as Andy Rooney— kind of an old curmudgeonly humorist. He and Jimmy went on for a number of years, even switching papers to the *Montreal Standard* at one point.

You know, it's beautiful to look at these just to see the quality of color reproduction that they had; beautiful, too, to see how they formatted the inset illustration, dropping it organically into the article, which would have been a big hassle in those days. The hand-rendered type is quite nice as well. You can see he had a style that was very indicative of the period, real twenties and thirties cartooning: he's got a great love of the figure, nice scratchy pen line, and his compositional skills were really great, too. Frise was an interesting character—a typical newspaper cartoonist, who apparently liked to gamble a lot and would do these drawings at the last minute while they were waiting down in the engraving room to put the paper to bed.

Frise's strip also appeared once a week, and what's very interesting about a lot of his stuff, and Canadian cartooning in general, is you can clearly see, in the work, Canada moving from rural to urban as you go through the century: his work is very much based on small-town, rural existence. As you move into the fifties, you start to see in

the cartoonists of the period the switch over from rural to suburban. In the sixties, you start to see actual urban work. It's rather interesting to see that movement; there's not a clear period in the early part of the century where you find Canadian artists who are trying to be sophisticated, for lack of a better word. It's all very folksy. In some manner, this falls into the *Gasoline Alley* type of characters, very slice-of-life—but perhaps lacking the poignancy that *Gasoline Alley* has. The original strip was titled *Birdseye Center,* and when he switched over to the *Standard* it became *Juniper Junction,* another example of a cartoonist being allowed to take the characters but not the name. Most of the work appeared in black and white, weekly, and he would also vary between the full panel and sequential. It was mostly gag-oriented, very much based on character types—very charming in a similar way as somebody like J. R. Williams, Clare Briggs, or H. T. Webster, which seemed to have been a popular school during that period—fondly looking back at a time that couldn't have been more than twenty years earlier. I think this is a strong element of this period because Canada was changing over into an urban environment rather quickly, but there was a lot of nostalgia for farm life and the country. I think you can even see this in the American strips of the period, too. The whole idea of the bucolic small town has always been a much-loved myth here in North America. It's interesting, as once Frise died, Doug Wright took over the strip. Wright changed the focus of the strip almost immediately: because of his interest in cars, it becomes almost entirely centered around the local town garage. That midcentury love of machines took the strip right into the modern age. ■

Jimmy Frise, *Birdseye Center,* single-panel cartoon, August 20, 1932. Copyright © by the estate of Jimmy Frise.

(Right and opposite) Peter Whalley, covers for three issues of *Maclean's:* August 16, 1958; September 27, 1958; April 11, 1959. Copyright © by Peter Whalley.

CRISIS
in the
Mediterranean

An on-the-spot report by
BLAIR FRASER

COVER BY PETER WHALLEY

How to learn French (or English) and have fun
BACHELOR GIRLS: THE CLASS CANADIANS HATE

MACLEAN'S
AUGUST 16 1958 CANADA'S NATIONAL MAGAZINE 15 CENTS

One of the fifties and sixties cartoonists that is of interest to me is Peter Whalley. He's a kind of gag cartoonist, I suppose—more of a satirist actually. In this, we're definitely moving into a fifties kind of sophistication; more harshly satirical. In many ways he could've been a *New Yorker* cartoonist. He has that kind of modern looseness in the sensibility of his work. Whalley had a very playful attitude toward art, somewhere in that school of Steig or Steinberg. It's certainly not quite up to that level of visual artistic exploration, but there's quite a lot of freewheeling cartooning and a real streak of antiestablishment thinking in it. Much of his work is purely commercial, but he was very political too. This is certainly all within the framework of commercial art; sometimes he's just trying to make charming images—this cover is a nice contrast between the past and present childhood.

He did a lot of work that fell into the format of a strip, satirical in nature; or a lot of gags

formatted together on a page, skewering whatever the particular subject was that week. This satirization of Canada was widespread to a degree, particularly during this period when Canada, as an idea, was really coming into being. In the sixties, we got our own flag and were separating fully from Britain, and it was also a time when there was a lot of pumped-up interest in ourselves—Expo '67, a peak year, when Canada was really trying to put forward the idea that it was a great place. Whalley seemed perfectly timed at that moment to be making fun of all that self-righteous interest. There's always been a tradition in Canada of looking down our noses at the Americans, this conflicted superiority; it almost demands that someone take the air out of that smugness. There haven't been that many humorists in Canada who have really aimed at that, so he was interestingly off in his own corner. Most of our humorists prefer to flatter the Canadian self-image.

I just came across some very early self-published books by him from the early sixties; he had quite a history of self-publishing in addition to working through the mainstream publishing media, which is rather interesting. The books are sequential narratives done in a linocut style, titled "Portraits of Near Greatness." I have three of these booklets. In each one, he takes on a character and skewers their stuffed-shirt pretensions: corrupt politicians; the hockey player who makes a big career for himself as a thug and becomes a star in the Hall of Fame, eventually winding up as a drunken bum; the actor who does poorly in Canada, goes to Britain and gets a bit of paltry training there, then comes back as a celebrity and is fawned on by the Canadian media, who will pay attention to anyone who has received even minor attention elsewhere. All very Canadiana themes. They're almost like little [Frans] Masereel pieces, but meant

native talent

Peter Whalley, artwork for *An Uninhibited History of Canada* by Eric Nicol, interior page and cover, early 1960s (Harpell's). Copyright © by Peter Whalley.

to be satirical. He really liked to go after stuffed-shirt Canada. Here's an early book done in collaboration with another humorist named Eric Nicol: *An Uninhibited History of Canada,* published in the early sixties. There seems to be a tradition in Canadian publishing of cartoonists linking up with prose humorists. In the first part of the book, Whalley illustrates the humor of the other guy, then in the back he's got complete free rein to do his own parodies. Basically, he's going after the pathetic quality of Canadian culture that's representing itself as . . . how do I put this: pride in the second-rate, and that famous sense of insecurity that Canadians have about their own culture. Courting attention from America yet scoffing at them at the same time. He goes about it in a smart-alecky way, which is very funny. When this book was reprinted, say ten years later or so, he entirely redrew the back half of the book, his half, which tells me a lot about him. He had a completely off-the-cuff quality to his drawing; he wasn't concerned with draftsmanship per se, which is pretty typical of what came out of fifties gag cartooning, I suppose.

Later on he published several weird projects—he took a nineteenth-century book on

housewives and how to take proper care of the home and drew little pictures to make fun
of the original writing. An odd project: just mocking the subject, which seems remarkably
contemporary and postmodern. His later work in the seventies attacks the most well-loved
Canadian painters, and he really goes after the government—it definitely has this antiestab-
lishment quality running through it. The most interesting book, titled *Phap*, near the end of
his most focused period, strikes me as almost an underground comic: very scatological, and
seems quite out of keeping with the times. Very gross; I can't help but feel he was looking at
underground publishing at this point. It's rampantly uncommercial, certainly not operating as
a portfolio to get him any commercial jobs. I find it interesting that he'd been working at this
point for over twenty years and there's still a strong creative desire to express something, like
a real artist, not just a commercial hack. I'm sure he viewed himself as a satirist, although I
don't have any personal information because I haven't gone to talk with him yet; there's a feel-
ing of disgust with civilization in general. At this point, as you can see in his work, there's no
interest in the bucolic past of Canada; very political, very sociological. And no concern either
with typical cartooning aesthetics—he was just trying to get something down on paper. ■

(Above) Peter Whalley, drawing from the series of booklets "Por-
traits of Near Greatness," early 1960s (self-published). Copyright ©
by Peter Whalley.

(Left) Peter Whalley, *Peter Whalley's Almanac*, single-panel cartoon,
c. early 1960s. Copyright © by Peter Whalley.

Earlier I mentioned that the sketchbooks have become a place for me to work on stories that I wouldn't consider worthwhile to labor over for my comic book. Well—this is a perfect example of that. When the idea of "the world's greatest comic book collector" occurred to me, it certainly didn't seem to be something worth much effort. Nevertheless, when I started drawing it out in my sketchbook, I found myself completely wrapped up in it, and over the next six months I drew over a hundred pages of him. Strangely, at the end, I had a book; a book that would never have come about if I didn't have another outlet for my throwaway ideas. Looking over the *Wimbledon Green* material now, I have come to see that these throwaway ideas can be richer soil than you think at the time. I'm more open to any stupid idea that pops into my head now. It remains to be seen how well *that* approach will work out in the future. ∎

Seth, *Wimbledon Green,* mock-up cover, endpapers, and finished interior page, 2005 (Drawn and Quarterly).
Copyright © 2005 by Seth. Used by permission of Drawn and Quarterly.

The FOUNDING MEMBERS OF THE COVERLOOSE CLUB

WAXY COOMBS CHIP CORNERS ASHCAN KEMP R. SADDLESTITCH
DADDY DOATS
PULPY WISE "CUTS" COUPON NELSON BINDLE DOC ASTRO

THE BRAINCHILD OF PREMIER COLLECTOR "CUTS" COUPON.

A BROTHERHOOD TO ADVANCE THE NOBLE ART OF COMIC BOOK COLLECTING.

MAX MOUSE

FOUNDED (WITH THE AID OF PULPY WISE, DADDY DOATS AND NELSON BINDLE) IN 1969.

THE REMAINING MEMBERS WERE HANDPICKED (BY "CUTS") FROM THE YOUNGER RANKS OF FANDOM.

THE CLUBHOUSE IS LOCATED AT 1616 MILNER STREET.

COVERLOOSE

UPON "CUTS" PASSING SADDLESTITCH ASSUMED THE PRESIDENCY-- THEN CHIP CORNERS.

CUTS COUPON C

THE CURRENT PRESIDENT IS "VERY FINE" FINDLEY. MEMBERSHIP IS 38.

MEETINGS-- EVERY THURSDAY. 8 TO 10.

AUGUST

b. 1967

8. Chris Ware

To a greater degree than any contemporary cartoonist, Chris Ware has achieved art-world and literary commendation for his formally inventive, rhythmically dense, and emotionally wrenching comics. And deservedly so: for more than a decade, his *Acme Novelty Library* (begun in 1993) has been the most obvious example of the graceful marriage of experimentation and richly eloquent voice in the medium. Ware's narrative complexity and the quiet humility of recurring motifs and themes work in perfect concert with staggering architectonic filigree to warmly intensify the tenor of all his stories.

Much of Ware's collected work, such as his magnum opus, the multiple-award-winning graphic novel *Jimmy Corrigan, the Smartest Kid on Earth* (2000), began as serialized, single-page strips in Chicago weekly newspapers. Corrigan, a nod to the rich history of bald boy comic protagonists, functions as something of a blank slate on whom other characters pin their emotional weakness, insecurity, and cruelty, a single symbol of Ware's deeply ingrained, multiple methods of conveying psychological insight. Notable from the start of his career, parallel stories run simultaneously in text and imagery, strangely alternating a childhood remembrance, for example, with panels from an archaic 1940s superhero yarn. Assumptions about "reading" the form are short-circuited as the acts of remembering both the physical events of one's own life and those experienced vicariously through popular media are conflated. Exploring the latent psychopathology of the collector (Ware's Rusty Brown) by uncovering the overwhelming emotional impact and inherently heartbreaking displacement of cartoon surrogates in the formative years of childhood—and taking the brightly colored comic strip as personification of adult grief, loss, and regret—his comics are profoundly expansive in their humanity.

So, though audaciously innovative, Ware is far from a mere formalist. His psychologically analytical "pictographs," achieved through the scrutinous manipulation of time, space, color, weight, density, impact of text, design, and typography, always serve to crystallize shades of emotional transition and uncertainty. In the contemporary

Chris Ware, self-portrait, 2002. Copyright © 2002 by Chris Ware.

Chris Ware, *Rusty Brown*, weekly strip, 2003. Copyright © 2003 by Chris Ware.

rusty brown

climate of rampant shortcuts, technological and otherwise, Ware's level of integrated craft for a reproductive medium seems practically Sisyphean, continually mining the poignancy of every formal and narrative device to sustain a both palpably devotional and self-deprecating tone. Such an innovative approach builds upon the fanciful visual experiments of both well-known and nearly forgotten pioneers from the golden age of newspaper cartooning. Such history is an ever-present informing lineament as Ware reconfigures the spatial in art and the temporality of literature within comics' peculiar rhythmic balance to explore entirely new possibilities for the language. Readers, along with Ware's characters, are constantly in a state of reorienting themselves within the organization of the page, distribution of panels, and visual/textual codes: Ware doesn't tell a story, he brilliantly shows it, internally and externally, boldly mapping emotions through ordered space and radical, juxtaposing shifts in time. The baroque layouts foreground labyrinthine procedures for processing information, mirroring the ways memory and consciousness slip and calcify, a mastery of every element that also abounds within the panels themselves. Psychological inwardness is heightened by Ware's rendering of defining contours, circling back upon themselves in beautifully fluid brushstrokes and compressed within the heavy panel border's frame.

Firmly devoted to the form's history, Ware has also edited an issue of *McSweeney's Quarterly Concern* devoted to comics, and is widely visible (and extremely influential) as a graphic designer. Ultimately, his is nothing short of an intrepid reinvention of the form: by opening up an entirely new lexicon for visual and typographic elements, language, and construction of time, his harmonious visual poetry has completely splintered any preconceptions of comics' capabilities. ■

These are two pages of what I optimistically call "stories," which originally appeared weekly. I vacillate between doing strips that are the flattest, most simple emotional approach I can muster, and then doing angry strips to relieve the tension of being so pretentious. In some cases, the two approaches come together, but I hope in at least a somewhat natural way.

This one [*Rusty Brown*] includes some of my first use of "almost-real" perspective in years, which I usually try to avoid, as it doesn't really work too well in comics because it confuses the composition and the reader's eye, but I had no real choice with this sequence.

As far as my so-called "process" goes, it totally depends on the individual page. Occasionally I write down fragments of words that seem to capture a feeling I'm going for, other times I'll visualize the events as if they actually happened to me, and then I simply try to reproduce that "false memory" on the page; the latter approach is what usually turns out the best. Inevitably, however, whenever I actually start drawing, all my plans are immediately out the window; new characters appear and some objects start to seem more important than others—it's all a very strange process.

Chris Ware, original art for *Rusty Brown*, weekly strip, 2003. Copyright © 2003 by Chris Ware.

I'll make notes about ideas that sound fancy or clever, which almost always guarantees those ideas will not be used. Very rarely do I have an advance concept of how I want to organize anything. I make notes for each particular chapter, draw the strip, color it, and I paste a black-and-white Xerox into a book to keep track of everything. Then I start to change and correct, which goes on for years. Worst of all, I can't ever tell if what I do is any good, mostly because the strip never turns out the way I want it to. Some stories slam on their brakes and make a right turn when I least expect them to, while others just sit there and crawl forward, ploddingly. ■

Chris Ware, original art
for *Building Stories*, weekly
strip, 2003. Copyright ©
2003 by Chris Ware.

I'm also working on a story about an apartment building concurrently with the Rusty Brown storyline; I switch off whenever I get bored with one or the other. *Building Stories* allows me to be slightly more pretentious, however, which is good, because I'm prone toward absorbing canted ways of presenting dialogue and movement, having internalized the false delivery of actors in motion pictures and television as a kid, and it always comes back to bite me. *Rusty Brown,* however, is where I'm sort of letting some of this out, as awful an idea as that may be. ∎

Found photograph of house
in Omaha, Nebraska, and
Chris Ware's drawing of the
house as used in his *Rusty
Brown* strip, 2000. Copyright
© 2000 by Chris Ware.

I found this photo of Rusty Brown's actual house in a frame I bought in a junk
store a few years ago here in Chicago; it was slipped underneath another non-
descript picture. On the back, it reads "Our new home: 5132 Charles Street,
Omaha"—which, incidentally, was also one block away from where I grew up,
on 52nd Street. I'm pretty sure this photo was taken in the thirties or forties,
right about when the house was originally built. I took new reference photos
of the house when I visited Omaha in 2002, though little had changed about
it other than the garage. ■

(Right) Chris Ware, *Rusty Brown*, weekly strip, 2002. Copyright © 2002 by Chris Ware.

(Below) Chris Ware, cover mock-up for *The Acme Novelty Library* no. 16, 2005 (Acme Novelty Library). Copyright © 2005 by Chris Ware.

(Bottom) Chris Ware, Rusty Brown lunchbox, 2001 (Dark Horse). Copyright © 2001 by Chris Ware.

Every child pictured on this lunchbox is real, all being kids I went to school with in Omaha and grew up with; that's me behind the apple and paper bag. ∎

I keep a sketchbook, which I haven't drawn in as much recently because I also keep a regular daily comic strip diary, but nobody will ever see most of it because it's way too embarrassing. Lately it's turned more into a sort of "illustrated text," though, because comics are such an inefficient way to speedily record information, though it was my ambition when I started the diary to try and figure out a way around this problem . . . obviously, however, I haven't. ■

Chris Ware, sketchbook page, 1994. Copyright © 1994 by Chris Ware.

Bobby Make-Believe was Frank King's last regular strip before *Gasoline Alley,* a sort of *Little Nemo* imitation with a little more of a midwestern "rough and tumble" flavor. King is one of my favorite artists, and, as the years have progressed, has become pretty much my favorite nonliving cartoonist, along with [George] Herriman and [Charles] Schulz; if the quality of art is measurable by the degree of affection one feels for it, as Stanley Kubrick has suggested, then at least as far as I'm concerned, *Gasoline Alley* is a masterpiece. I've been collecting the strip since 1988, though now, by coediting the *Walt and Skeezix* series with Jeet Heer and Chris Oliveros, I don't have to seek it out on eBay anymore. Taken as a body of work, *Gasoline Alley* is not only a fifty-year-long comic strip novel that captures and distills the ineffable passage of time through the regular touch of an artist's pen to paper, it was also a semiautobiographical re-creation of King's life, and it grew just as wonderfully haphazardly.

This, however, is extremely disturbing: it's one of King's last Christmas cards, and frightening in that it's clear he'd lost his ability to draw. In fact, there's little indication here that he ever knew how to draw. It's very strange and sad to me. I only found out recently from his granddaughter Drewanna Schutte that he died of Alzheimer's, which explains it, I guess. ∎

(Above) Frank King, original art for *Bobby Make-Believe,* detail of Sunday strip, c. 1915–1919. Copyright © the estate of Frank King.

(Left) Frank King, Christmas card, 1966. Copyright © the estate of Frank King.

Photograph of Frank King at work, c. 1925 (note the Walt and Skeezix oilcloth dolls in the background). Copyright © the estate of Frank King. Collection of Drewanna King Schutte.

Frank King, sketchbook page, 1920s. Copyright © the estate of Frank King.

King admonished young artists to keep pocket notebooks, and to draw constantly, advice which he apparently followed himself, as this example from his notebooks of the 1920s demonstrates. The book came from the estate of his letterer of many decades, Jack Foxx, who also lived in Florida when King resided there. Drewanna has shown me many more examples of King's notebooks since I acquired this, including his diaries, planners for the strip, and sketches. His may be the most thoroughly documented life of an early-twentieth-century cartoonist, and I hope with the *Walt and Skeezix* series to demonstrate that he took his work very seriously, and that I think emotionally it meant the world to him.

On our last fact-finding mission to Drewanna's house, Jeet and I discovered a letter to King from Charles Schulz, dated October 19, 1962, which begins:

Dear Frank,

The more I read your strip, the more I am convinced that you are the best comic strip artist working today. You seem to be the only one who really understands the medium. Each daily episode amazes me, and you continually build up interest with little stories that are completely beyond the scope of any cartoonist or writer working in any other medium . . . ■

Chris Ware, preliminary and final cover designs for *Walt and Skeezix, 1921 and 1922*, 2005 (Drawn and Quarterly). Copyright © 2005 by Chris Ware. Used by permission of Drawn and Quarterly.

We had to change the title of the *Gasoline Alley* series when the Tribune Media legal department threatened to take us to court over copyright issues; as it turned out, however, the *Tribune* let all of their copyrights lapse decades ago, so they were simply trying to scare us. However, to be sure we didn't violate the copyright of the strip title, we switched it to *Walt and Skeezix*, which really was how King himself thought of the strip and frequently referred to it in interviews. Actually, I'm happy it worked out this way, though I did have to letter everything twice to accommodate it. I tried to make it look as much like King's typography as I could (as opposed to the *Krazy and Ignatz* books with Fantagraphics, where I'm applying a different design sense to every cover), because I want this series as much as possible to appear as if it was of King's own devising; I think this sensibility applies more readily to King's work than to Herriman's. Besides, I'd never presume to pass off a mark of my hand as one of George Herriman's. I think King, however, who used countless assistants, wouldn't mind in the least; his concern was for readability and story, I believe. ∎

Chris Ware, cover design for *Krazy and Ignatz, 1931–1932*, 2004 (Fantagraphics). Copyright © 2004 by Chris Ware. Used by permission of Fantagraphics Books.

Chris Ware, cover design for *Krazy and Ignatz, 1935–1936*, 2005 (Fantagraphics). Copyright © 2005 by Chris Ware. Used by permission of Fantagraphics Books.

Cliff Sterrett, original art for *Polly and Her Pals,* detail of Sunday strip, September 16, 1945. Copyright © King Features Syndicate. Used by permission.

Cliff Sterrett's comics were some of the first to ever really "knock me out" when I was in school; seeing the colors and composition, I thought, "Well, this is what I want to do with my life." Though I drew comics throughout art school, I regularly vacillated between the story-driven and the art-driven, always trying to put the two together, and Sterrett is a good example, I think, of how to do it in the simplest and most effective way. I can't imagine cartooning being any more "solid" than this. The hands, faces, gestures—everything is perfect, and the whole page works as a dynamic, electric design. ■

Some of these Herriman dailies actually ran in color in the *Kansas City Post* in 1913; I presume that it was colored by the local art department and not a nationally directed sort of initiative, though I of course could be wrong. These also might have appeared in a Sunday section, so they were colored to "match." ■

George Herriman, *The Dingbat Family,* daily strip, 1913. Copyright © by the estate of George Herriman.

Japanese cartoonist Suihô Tagawa is—along with George Herriman, Frank King, and Charles Schulz—my fourth-favorite cartoonist who's no longer alive. The first time I saw one of his books it was just like one of those dreams where you wake up thinking, "I was looking at the absolute greatest comic ever but . . . "—and then it starts to dissolve from your memory, and before you know it, it's gone. The packaging of these books, the layouts, the drawings . . . everything about them is just incredible and beautiful. Originally produced in the 1930s, they were rereleased in the 1970s in facsimile format, which I first saw at Richard McGuire's house in New York in 1995, who'd in turn first seen them at Mark Newgarden's. I spent years searching for them, but they're virtually impossible to find in the United States; these copies were all very graciously sent to me by Yuji Yamada at Presspop. To me, this is the course comics should've taken before they got sidetracked and transformed by the language of cinema in the 1930s. As near as I can tell, the Japanese understanding of art is almost a sort of simultaneous reading and seeing, where ours is purely seeing—a very Western idea. Unfortunately, Tagawa's work is not as highly regarded now in Japan, the Tezuka Astro Boy aesthetic, which springs from a more cinematic mode of presentation, having taken precedence. ∎

Suihô Tagawa, spread from *Norakuro* series, c. 1930s. Copyright © by the estate of Suihô Tagawa.

I found these little Japanese water-transfer images at a flea market here in Chicago, strangely enough—you can see the Tagawa characters mixed in with distorted Max Fleischer characters, like Betty Boop and Koko the Clown, which shows how popular Tagawa was in Japan at the time. Strange. ■

Shigeru Sugiura was, I'm told, Tagawa's assistant, who later went on to do his own stuff; his work is more baroque, but also much stranger and, it seems, more "personal," though one can start to see some of the more modern movie influence creeping into his later work. I still find it all stunning. There are even experimental examples where two simultaneous stories are transpiring on the same page. I think Sugiura is beginning to develop a following here in the U.S., and younger cartoonists are translating and reprinting his work, which is great, because now I can finally actually read it. ■

Shigeru Sugiura, interior page, c. 1950s. Copyright © by Shigeru Sugiura.

Sheet of Japanese transfers, c. 1930.

Wat deed Jan? 't was wonderlijk om te zien
want met een zaagje, en z'n hand als machien . . .

Zaagde hij snel vijf, zes bomen om
· en Jan, hij lachte zich krom. . . .

Because I've had the amazingly good fortune to somehow fleece a number of Dutch people into flying me to Europe a few times, I've also amassed a fairly large collection of Dutch and Belgian comics. Whenever I go to a comics "festival" in the Netherlands, I usually find one or two boxes of cheap old stuff that nobody wants, and usually there's something in it that's extremely weird. This particular book is a masterpiece of self-taught cartooning, some sort of early superhero, obviously; the odd thing is, it looks like it's from 1909, but it's really from 1945. For some reason, the Dutch seem to have had a serious cultural problem with the whole idea of having a narrative advance purely visually—it had to have text running along the bottom; an arcane holdover from centuries before. They were definitely not at the advanced visual level of the Japanese, for example. ■

Dutch comic book, 1945.

Marc Smeets, sketchbook drawing, c. 1990. Copyright © by the estate of Marc Smeets.

Ron Regé, original art for *Skibber Bee Bye*, interior page, 2000 (Highwater). Copyright © 2000 by Ron Regé.

One of the greatest Netherlandic/Belgian region cartoonists (along with Joost Swarte and Ever Meulen, obviously) was Marc Smeets, who isn't really well known here—or even there, for that matter—but he did hundreds and hundreds of these odd sketchbook drawings that look like some sort of dreamy Hergé-like palimpsests. Near as I can tell, he seemed to try and set up some sort of humorous juxtaposition between meaningless everyday events happening in the same physical locales, but hundreds of years apart. My Dutch friends tell me they're all nonsensical, but I don't believe them. ∎

Without a doubt Ron Regé is the most amazing cartoonist of the "younger" generation. I just recently moved Winsor McCay and Cliff Sterrett in together in my flat file so that Ron could have a whole floor to himself. He's the only artist in there to have his own drawer who's under a hundred years old and who's not dead. ∎

Kim Deitch is easily one of the greatest cartoonists in the world, and in the history of the medium. I first saw his work in *Raw* and *Weirdo,* and I find his stuff more inspiring than pretty much anything else around—the amazing world he's created just keeps growing and growing. There have been times when I've thought I should just quit cartooning altogether, but his stuff, and especially the fact that he continues to do it, has kept me going. (Art Spiegelman's told me Kim's work has had a similar effect on him.) His originals clearly show that he's one of the finest craftsmen alive. I'm surprised when I hear very occasionally that some cartoonists don't "get" his work. Thus his work acts as sort of a litmus test for me—I've never met a cartoonist I respect who doesn't love his work. ■

The work of Swiss educator and writer Rodolphe Töpffer (credited as the inventor of the comic strip) is revolutionary for the sheer energy and apparent movement of his characters, which practically seem to walk of their own volition . . . and which is what basically sets pure comics apart from the illustrated text they can very easily become. Plus his stuff is still even funny; this Anglicized version of his 1839 underground hit *Histoire de M. Vieux Bois* features a poor scrawny sap love-struck by a woman the size of an outhouse . . . how could you go wrong with that? ■

(Above) Kim Deitch, *No Business Like Show Business,* interior page, 1988 (3-D Zone). Copyright © 1988 by Kim Deitch.

(Left) Rodolphe Töpffer, *The Adventures of Mr. Obadiah Oldbuck,* first American publication as a bound supplement to the magazine *Brother Jonathan,* interior page, 1842 (Wilson). Collection of Robert Beerbohm

I grew up down the street from an *Omaha World-Herald* cartoonist named Hank Barrow, who was sort of the school of Walt Kelly—and, I'd hazard to opine, almost better than Kelly. He was a wonderful, loose artist with a salty sense of humor. I used to walk over to his house and annoy him by asking him to draw superheroes, and he'd always do something that would deliberately thwart my original idea, like making visual puns on the names of the characters. Once I remember asking him to draw the character Isis from that Saturday morning show because I found her sexually exciting, so he drew a goofy-looking ice cube wearing a skirt just to bug me. He had this devious smile, and a handlebar moustache, and his house always smelled like stale cigarettes. When I'd go trick-or-treating, my mom would take along an empty Scotch glass and when we got to their door, he filled it . . . these newspaper people (my mom was also a reporter and editor) had their own way of life, I guess. This was a sketch he did for me when I was in a downtown art show when I was nine, which thrilled me. It hung on my wall for years. (I'd just broken my "drawing arm" in a bike accident.) ∎

Hank Barrow, original drawing, 1976. Copyright © by the estate of Hank Barrow.

(Opposite) "La Hute," original cartoon, 1945.

My grandfather was a newspaper editor at the *Omaha World-Herald,* and this drawing was done by a fellow in the art department named "La Hute" about an irascible guy in the composing room who was always screaming at them to get things into him by deadline. They all obviously hated his guts. It hung in my grandparents' basement all through my childhood, and it was years before I ever knew what it really was; actually, it used to scare me. I almost can't see it now, anyway—the shapes and colors are such a part of my childhood memory, like the back of my hand. ∎

My grandfather also wanted to be a cartoonist when he was a kid. Apparently, when he went off to college in 1916, he told his dad that he was going to study mathematics, but instead enrolled in art classes and got involved in "the sporting life"—which included football, dirty songs, pranks, ragtime, drinking—not to mention cartooning. He got thrown out of college for stealing stationery from the dean's office and writing a fake letter to all the fraternities telling them to show up at the stadium one Sunday morning for mandatory VD testing. He could still draw old men in starched collars when I was a little kid in the 1970s. He was friends, in a business sort of way, with Milton Caniff, Walt Kelly, Bill Holman, and Hank Ketcham; my mom even remembers getting to talk to Milton Caniff on the phone when she was a little girl. ∎

Original drawing by Chris Ware's grandfather, Fred Ware, c. 1913. Copyright © by Chris Ware.

Original drawing by Chris Ware's grandfather, Fred Ware, 1973. Copyright © by Chris Ware.

(Opposite) Bill Holman, original Smokey Stover drawing, undated. Copyright © by the estate of Bill Holman.

Richard McGuire, *What's Wrong with This Book,* 1997 (Viking). Copyright © 1997 by Richard McGuire.

I think Richard McGuire is one of the best artists in the world. Everything he's ever done is truly groundbreaking in the real sense of the word—in that it expands the possibilities for expressing himself, and by extension, other people's possibilities. I've more flagrantly ripped him off than pretty much any other artist, and it's a testament to his greatness as a human being that he still lets me call him a friend; I'm in awe of him. ■

Chris Ware, paper model of the artist's studio, 1989. Copyright © 1989 by Chris Ware.

I made this paper model to give to my grandmother in 1989 when she was getting increasingly weak and unlikely to travel anywhere in the nursing home where she was incarcerated. She frequently asked me about my apartment, and she had always loved dollhouses—though she never had one—so I thought I'd sort of make one for her. A pretty squalid dump of a dollhouse, though—a horrible 1950s apartment in Austin, Texas. It smelled like rotten meat when I moved into it; my friend John Keen helped me steal a refrigerator from an empty unit in the same building and trade it out to get rid of the smell. The rent was $195 a month, or maybe even cheaper. I think you can see a "miniature" of the *World-Herald* cartoon in the left corner, and where I spilled ink all over the carpeting. ■

Jessica Yu is a Los Angeles filmmaker who asked me to contribute to her documentary about Henry Darger; needless to say, I jumped at the chance. Most incredibly, though, she also invited me to visit his apartment when she was photographing it shortly before it was dismantled; I remember it smelling really waxy, like old crayons. His work is a constant inspiration to me for its utter "immersion factor," not to mention his unparalleled compositional skill. I really think he was affected not only by the colors, scale, and content of early Sunday comics, but also their overall effect on the eyes, if they're regarded simply as an "image," as opposed to a read series of pictures. For example, if you look at a Darger painting side by side with an early Sunday page like *Little Nemo*, the composition and patterning are somewhat similar. I'm almost sure he must've seen *The Kin-der Kids* by [Lyonel] Feininger when it was in the *Tribune;* he even mentions reading the Chicago papers when he was in Lincoln, Illinois, though I guess my dumb hypothesis will never ultimately be provable. Probably just wishful thinking on my part. ■

Chris Ware, original title sequence lettering for the documentary *In the Realms of the Unreal,* directed by Jessica Yu, 2004. Copyright © 2004 by Chris Ware.

Henry Darger, "At Jennie Richee. Going out of shelter. Tree is struck by lightning," from his book *In the Realms of the Unreal,* undated. Copyright © 2006 Estate of Henry Darger/Artists Rights Society (ARS), New York.

Henry Darger, "At Jennie Richee. Are rescued by Evans and his soldiers after desperate fight," from his book *In the Realms of the Unreal,* undated. Copyright © 2006 Estate of Henry Darger/Artists Rights Society (ARS), New York.

Winsor McCay, *Little Nemo in Slumberland*, Sunday strip, August 12, 1906. Copyright © by the estate of Winsor McCay.

(Opposite) Lyonel Feininger, *The Kin-der Kids*, Sunday strip, 1906. Copyright © by the estate of Lyonel Feininger.

The Kin-der Kids
Visit A Football Match, And Piemouth Enjoys himself.

Copyright 1906 by Tribune Company, Chicago, Illinois.

This, I believe, is an autobiographical comic written by a woman who was a stripper in Montreal, though I can't really read much of it, since it's in French. But it has such an urgency, naturalness, and is so idiosyncratically laid out, that it's in many ways one of the "purest" examples of comics I've ever seen. As far as cartooning goes, it's fairly sophisticated and surprising in its panel layouts and its flexibility of storytelling. Unfortunately, it was inexplicably redrawn in a slick style and then published by Kitchen Sink Press a number of years ago, but its original form contains some of my favorite pages from a comic book. I guess most people want to see something that's drawn "realistically," which in comics is a misnomer—the awkward little pictures of her dancing for her mustachioed creep boyfriends, yelling at them, crying, just wouldn't work if drawn "well," and they're more heartfelt and real than an accurate rendering of the flesh that stretches across the skull and bones would be. You "feel" them, the same way you feel *Peanuts*. I wish someone would put out a translated edition of the original. In a way, it's sort of like Jeff Brown's stuff. ■

I first met Jeff [Brown] in 2001 when he was attending the [Chicago] Art Institute, and we've since become friends. His work best demonstrates what the core "engine" of comics is, as well as having the added bonus of also being some of the most straightforward and revealing writing published in newer comics. His stuff has a real human warmth to it, comes of personal necessity, and often makes me completely reconsider my approach to everything I do. ■

Sylvie Rancourt, *Melody, The True Story of a Nude Dancer,* interior page, 1987 (S. Rancourt). Copyright © 1987 by Sylvie Rancourt.

(Right) Jeffrey Brown, *Clumsy,* interior page, 2002 (Jeffrey Brown). Copyright © 2002 by Jeffrey Brown.

David Heatley, "Portrait of My Dad," *McSweeney's Quarterly Concern* no. 13, splash page, 2004. Copyright © 2004 by David Heatley.

I also really admire David Heatley's work; he seems to alone have the guts and the emotional maturity to deal with subjects my generation barely knows how to touch . . . and the amazing thing is that he does it in a way that's frequently "funny," but always in a heartfelt and sympathetic way. His confidence with the language of comics is accomplished and personally idiosyncratic, and, most importantly, demonstrates a serious humanist disposition, which is unusual to the discipline but necessary for the creation of stories that are true and impossible to dismiss. He's also really smart, and clearly has a "vision" of what he wants his comics to become, which I sometimes wonder if other cartoonists don't really think about all that much. ∎

Joost Swarte, cover for *Raw*
no. 2, 1980 (Raw). Copyright
© 1980 by Joost Swarte.

Of all things that have affected me, I think I can cite Art [Spiegelman] and Françoise [Mouly]'s *Raw* as the most all-encompassing;
pretty much everything I've ever done artistically I can in some way attribute to them—simply by their example they've made
me try harder when I thought I couldn't, and they were never anything but encouraging and supportive to me. In fact, and
though it sounds schmaltzy to confess, they've practically become "family" in my mind. Art and I talk on the phone frequently,
lamenting the effort and frustration that cartooning never seems to tire of dishing out; there have been times when I was ready
to give it up and he's "talked me down" or offered such kind words about my stuff that he's literally inspired me into work
again. Françoise and I also talk often because of her ongoing invitations to me to contribute to *The New Yorker*. (I should men-
tion here that Joost Swarte's amazing cover of *Raw* no. 2—which I ripped off with my very first self-published comic—taught
me practically everything I know about coloring using printing tints, and it was only years later that I found out Françoise had
colored the whole thing herself; to this day I still make use not only of that basic palette, but also the sensibility of the scheme,
with the bright colors being picked out against a more subdued background.) Anyway, that's why I dedicated *McSweeney's*
no. 13 to them. ∎

The jacket to *McSweeney's* is my "metaphysical defense" of comics. ∎

Chris Ware, cover design for *McSweeney's Quarterly Concern* no. 13, 2004. Copyright © 2004 by Chris Ware.

I redesigned the constella-
tions in *The Acme Novelty
Library* no. 7, but because of
the sloppy way I presented
it, I don't think it was terribly
clear that it was indeed the
actual night sky, so for the
new Pantheon *Acme* col-
lection I did it a little more
carefully with a glow-in-the-
dark layer, which of course
doesn't really work so well,
but I guess it doesn't really
matter, though, because it's
more the idea of "seeing
what you want to see" that's
important. ■

Chris Ware, two versions of constellations, c. 2005. Copyright © by Chris Ware.

When I was in graduate school from 1991 to 1993, my capacity for self-pity was limitless, and I poured a lot of it into stupid little one-of-a-kind handmade comics and books like this one, which is about one inch wide. I didn't have a published weekly strip for my first semester there, or a girlfriend, and for this reason I was convinced that I was the most miserable soul on Earth, even though I'd brought it all on myself. ■

Chris Ware, *Quimby the Mouse,* handmade accordion mini-comic, 1991. Copyright © 1991 by Chris Ware.

Robert Crumb, "A Short History of America," color serigraph (strip originally published in an altered format in *CoEvolution Quarterly* no. 23, 1979), edition of 250, 1990s (Wildwood). Copyright © by Robert Crumb.

I'm obviously prone to hyperbole, but "A Short History of America" has got to be one of the greatest comic strips ever drawn; I find myself thinking about it, looking at it, and stealing from it probably more than any other single page. Even if this was all that Robert Crumb ever drew, that'd be enough, though we all know his oeuvre is quite a bit more humbling than that. I've said it before, but if my house was on fire and I had a chance to pick books to throw out the window, his sketchbook facsimiles would be the first to land on the grass. He's the greatest artist in the world. ■

b. 1967

9. Ivan Brunetti

Ivan Brunetti reinvigorates past formats and types of comics—the classic gag panel, for instance—exposing their inner workings as multileveled vehicles for greater or lesser shades of veiled expression. Harkening back to sublimated personal voices found within commercially rigid format and subject matter dictates, Brunetti's vision is crystallized and strengthened through such layerings, personal and historical subtexts pouring out kaleidoscopically.

The artist's early work was preoccupied with autobiographical eviscerations of the turpitude of modern life, broad anomie seen through the bleakest, though shockingly humorous, nihilistic lens. His overall subject was the (literal, in some panels) vomiting of humanity's bile, often on the level of a screed, rancorous venom unseen in the medium outside of a handful of the more extreme underground cartoonists. In all of Brunetti's work, primarily published in his serialized comic *Schizo* (1995 to present), visceral pain and existential hopelessness, while the constant, are slowly transcended through humor: the inevitability of perpetual brutality is exaggerated to the point of paradoxical alleviation. The cathartic sustenance provided by the physical, communicative act of doodling, even the most violent images, affirms the capacity of art—and life—for gentle beauty.

Brunetti's subject matter continues in good measure to be the analytic examination of emotional turmoil through the pathos of the gag, always through the psychological infusion of formal structure. In rich single-page-strip aphorisms, his style has recently flayed down to a minimalist calligraphic line, its beautiful spareness an ascetic rejection of self-indulgence and decadence. While his work remains rigidly ordered, dealing with similar themes of spiritual truncation and social malaise, the cramped claustrophobia of his early comics—a pinpoint reflection of their subject, the nausea-inducing midlevel office cubicle world—has given way to undeniably graceful brushwork. Suffused with an internal light and muted palette, the harsh black-and-white onslaught of the past work is leavened while its emotional force is actually intensified.

Ivan Brunetti, self-portrait, c. 2001. Copyright © by Ivan Brunetti.

Ivan Brunetti, "Shakyamuni," *Schizo* no. 4, single-page strip, 2006 (Fantagraphics). Copyright © 2006 by Ivan Brunetti. Used by permission of Fantagraphics Books.

Brunetti's single-page comic biographies represent the artist's most fully realized work to date, quirkily resonating on numerous levels and revealing as autobiography (in the selection of lives depicted as well as in specific approach and treatment) and inquiry into the formal properties and mechanisms of comic construction. Strips on the lives of such revolutionary cultural figures as Søren Kierkegaard, Erik Satie, and Piet Mondrian instructively demonstrate an affinity with rigorous formalist methodologies, while humorously deflating "high art" via the translation of revered modernists into stereotypically flattened cartoon characters, ironically presented with a complex depth historically thought well beyond the comics format.

In Brunetti's work, increasingly symbolic shapes, colors, and structures have transformed visceral rage, comically distilled and anthropomorphized for ever more placidly powerful effect. The grace of the hand in the humble act of cartooning itself provides commentary, evincing a push-pull of conceptually loaded contours and design, whereby the abyss is ordered. In addition to creating one of the most respected contemporary bodies of work in the medium, Brunetti has emerged as one of the most thoughtful and critical voices on comics' history, plastic qualities, and great potential. ∎

VAL LEWTON•

FEAR OF BEING TOUCHED

"WHY DO I Bother" running gag

MARK ROBSON → 7th victim

pornographic secretary
(Books) / chastised

MAKING the 7th victim - psycho children

short interviews (EXPOSITION) [3-4?]
family, FRIENDS, critics

Freddie Bartholomew story ??

gets the B-picture deal

CRITIQUES of CAT PEOPLE
(LAUGHS)

7 tiers

LAST DRAFT=
HIS

[marginal notes:] Anna Karenina / ① Gone w/ the wind / ② / Don't people see your film... / title of zombie / Betrayal

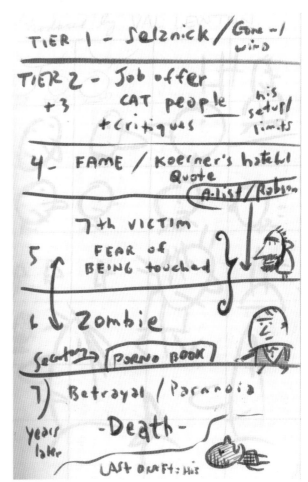

TIER 1 - Selznick / Gone w/ wind

TIER 2 - Job offer
+3 CAT people his setup / limits
 + critiques

4 - FAME / Koerner's hotel / Quote
 A-list / Robson

7th VICTIM

5 FEAR of BEING touched

6 Zombie

Secretary → [PORNO BOOK]

7) Betrayal / Paranoia

years later -Death-

LAST DRAFT = HIS

In producing a strip, I start with a ton of thumbnails and notes on scrap paper for different sequences. For this particular strip I have all my notes, but I used to destroy all notes and sketches after every strip was finished . . . I would throw away the newsprint underdrawing, all my thumbnails, all my notes. I didn't want anyone to know anything about me after I died. I think Chris Ware convinced me not to do that anymore and I wish I hadn't in the past, as I'd be very interested to go back and find out what I was thinking at a certain time, how I was coming up with ideas.

Basically, I do a thumbnail of the strip first, to see how it flows. In the case of this one, it's a biography, so to start I make a list of my favorite anecdotes about the person that I think tell something about them. I like to sketch in the borders of their lives; I don't need to tell the reader everything about their lives—there's not enough room to do that in *twenty-eight* panels. I might make a text list, then from there I'll work up a really rough thumbnail and keep changing things around, moving sequences, revising and rewriting certain sequences. I'll also make notes in the books that I'm reading for research, though a lot of this goes on in my mind, so there's no physical record of it: I tend to play out the strip in my head all the time, and it comes alive as I'm working on it. I always have it memorized by the time I start inking it since I've gone over it so many times, particularly with a biography. I tend to write sequences

(This page and following eleven pages) Ivan Brunetti, notes, text lists, doodles, thumbnail drawings, character designs; color sketches; underdrawing; revisions; inked, finished original artwork; and final single-page strip for "Produced by Val Lewton," *Schizo* no. 4, 2006 (Fantagraphics). Copyright © 2006 by Ivan Brunetti. Used by permission of Fantagraphics Books.

out as thumbnails and then put those together so they flow. When I think about a biography, I'm trying to picture someone's life as a series of six or seven short sequences.

I want to take the bare minimum information needed to have that person's life make sense to the reader. I also want to strike a balance where those who already know a good deal about the person's life will find details that they can appreciate, but also where those who know nothing about the person's life will be interested enough to explore further—ultimately, I want to do comic strips that can be appreciated by both of those readers as well as everyone in between. It's been a good unconscious exercise for me because it makes me do that for other types of strips as well, for example, an autobiography; every strip has to work in both ways. So the approach that I've been trying to take with the biographies has helped me a great deal with writing in general—this sketching in the borders of someone's life and letting the reader fill in a lot on their own, picking certain moments or sequences that tell a lot about them but

that also tell the reader a lot about me, because if I'm focusing on these things they are obviously important to me; so you can read these and figure out a lot about the author as well.

With each biography I've also tried to take either an actual signature or something printed, type from a movie poster in this example, and use that as an artifact, a little way for someone familiar with the subject to relate to the strip. This particular strip is a biography of Val Lewton, a movie producer and writer who did these psychological horror movies in the 1940s, *I Walked with a Zombie* and *Cat People*, directed by Jacques Tourneur. Lewton was nominally only the producer, but they are in large part his movies—he wrote the story and worked on every draft of the screenplay, and, as in every movie he worked on, he wrote the final draft. Tourneur was the best director he worked with, one who really brought Lewton's vision to life. The screenplays are incredibly detailed and Tourneur had a strong visual sensibility that matched the ideas. *I Walked with a Zombie* is a great movie, though a really odd film called *The Seventh Victim*, the first one that Tourneur didn't work on, is

probably my favorite. At the time RKO thought, "These movies are doing really well, so if we separate the team we could make twice as much money" [laughter].

I'll also do a color sketch with markers to roughly lay out the palette in my mind. Originally I envisioned this strip having muted tones, maybe a slate blue and a dull pink, or maybe a few different dull blues—there are a few panels that are actually scenes from his movies, which will be black and white, so I don't want the rest of the artwork to stand apart too much from that. I think now I want yellow to be the dominant color (I've been dying to steal that from the "Fair Japan" brochure, as you can see). I might change my mind by the time I do the final color on the computer, but I've been using a marker to get an idea of the rough color shapes, so the page has a unified sense as a whole. I've been using limited palettes for my strips, because I'm not a good colorist and I don't really understand color. My eyes are pretty bad and it's hard for me to see tonal variation; I tend to see things as pretty flat, since I have zero depth perception—I think I see the world as a cartoon already. With the strips I've been doing, I've been limiting myself to a few colors per page in order to learn about color, to learn how to distribute it throughout the page so it looks pleasing as a whole, both on the micro level (within the panel) and the macro level.

I tend to use the same few colors on every strip—the same colors I've painted my apartment, which are the same colors I've been attracted to since I was a kid, when I saw books

that had posters of animated cartoons from the 1930s. I always prefer warm tones to cool tones, and I always associate these warm colors with animated cartoons from the 1930s; they are what I was drawn to as a kid. It's interesting that you spend your whole life seeking things out but don't really realize it. Hopefully, I'll eventually be able to use a much more extended palette, but even still, it's important to always think of the page in its most simplified terms. This really helps to organize it visually—I always want my pages to have a visceral impact, as well as a subliminal impact, an organization that pleasingly leads the viewer through the strip in a certain way. I want the page as a whole to draw the viewer into a particular world—so that it works both as a page, which is like the external world, and as panels that you climb inside of and read and experience as they come alive in their own language (which is like the internal world). You basically have line and color to work with, and color includes the empty space, which I try to be very conscious of as well. Within the panels, word balloons are another whole ball of wax, because you have to decide how much you want those to stand apart from the coloring—it can get confusing as to whether they are their own space within the panels or if they have to exist on top of it. I don't know if there's a right or wrong way to do it, but it's something you have to be conscious of as the tone of the strip can be altered greatly by how they are approached and changed around.

Most of the best ideas I have come from doodling, or playing around with markers—creating ideas from making mistakes. Many ideas come from making mistakes, but all of my ideas have come from doodles—I think you have to have a strong gestural root to cartooning. Dan Clowes has mentioned that part of the genesis for *David Boring* was an image he had of someone with a bullet in his head, and he worked outward from there. Maybe it's true of any art form; that there has to be a real core of something visceral that compelled one to do it, which the artist can't fully explain. When I'm doodling, I'm not thinking about anything, it's pretty much automatic drawing, but I've often come up with character designs this way—if you try to think of how to design a character, it never works. It's always better to just let it happen naturally and organically without planning too much, and it's amazing how many variations on something you can come up with just by playing around with line. I've been focusing a lot just on how lines are distributed on the paper, and how colors are placed on the page. This also stems out of procrastination—when I doodle, it keeps my mind free, but my hand busy. It doesn't result in good drawings, but I need to do something to keep from going crazy most of the time, so it helps.

The stage just before the final inked board is a newsprint underdrawing done in blue (and sometimes red and green) pencil, and there are a number of revisions being made as I do it. When this is complete, it's pretty close to the final artwork for the strip. On rare occasions, I'll change something after I ink it, replace a panel or sequence that I don't think makes sense, but that's pretty uncommon. When I begin this stage, I have the basic idea of what I want to do, but I'm making revisions to the flow and details as I go along. The flow is the most important to get right, so I'll rearrange panels or remove a panel to make smoother transitions from scene to scene. If it's not really clear, then there's something wrong with the flow or something's not working somehow. I definitely try to figure all this out at this stage, so I don't have to re-ink anything. I use a light box to get the newsprint penciled page to the final inked board—if I tried to pencil on the final board all of the erasures would make such a mess that it would be unusable.

I made a major last-minute change to this strip, in the penultimate panel. Originally I had a quotation there that tied everything together, but I hated it as a visual, and I thought in some way it ruined the flow of the text. Something about it was bugging me, and usually that's

a sign that something is fundamentally wrong. So I reread my Lewton source material for the millionth time, and I found a way to combine portions of a couple of letters that he wrote at around the same time, and sort of encapsulated what happened to him after 1943, all the way to his death in 1951. Probably not coincidentally, I was going through the same thing at this point. *The Chicago Reader* hadn't been running my strip in a while, and I had no idea why, but I was afraid to ask. I always have this creeping dread that I'm going to be fired and have no money and end up living in the gutter. Well, I can see why I've always been attracted to Lewton; we had pretty similar personalities in this regard. I wanted to do the strip as a tribute to him, and I imagine him looking over my shoulder as I draw it. I don't want to disappoint him. His films are filled with great humanist touches, and his screenplays are literate and packed with amazing details. Someone put them all online, which was a great resource for me. I was offended that I had to purchase his movies as bootleg DVDs and shoddy VHS tapes put out by fly-by-night companies. A travesty. Thankfully, there's finally a properly packaged, respectfully produced DVD collection of his films that came out recently.

I hate to re-ink panels and substitute things—I hate Wite-Out and pasting things over. I'm extremely anal retentive about the final inked page, to the point that if I barely smudge a line early on, I'll destroy the page, or save the paper so I can draw on the back since it's so expensive. If I make a mistake at that stage, like a smudge, or if the panel borders are too thick, I just can't start drawing on that page. I can't look at the sheet anymore—I like to have these clean boxes—it's a very strong impulse that I have [laughter]. I have a lot of confidence issues, so I need to have a solid foundation, or skeleton, to work with. I want the finished inked original to be as clean as possible, on nice paper; I always feel better when it's on nice heavy Bristol board. There's something substantial about the paper that I kind of like. You feel like you've achieved something. It's just a psychological thing that to me has an impact on how much work you're going to put on that page—if it's expensive paper, I feel that I have to do my best. It feels like it's more weighty, literally and figuratively. So I'll try to fix everything possible on the newsprint sketches, and it's very obvious on these where I struggle with certain elements. I think I'm going to start saving these as they're interesting for me to go back and look at to see how much I've struggled with each one. It might be heartening for me to look back on these and understand, "Oh, every strip is difficult!" But it makes you realize that you can solve problems—a lot of telling a story is problem solving, particularly when you're doing a one-page story. My entire fourth issue of *Schizo* is comprised of one-page stories. It's more of a challenge in this format, since I can't just take and move an entire tier of panels. Any limitation is very useful because it forces you to think about every line you put down.

Often I will make very minor changes in the inking stage—I tend to overplan, and I'm very meticulous at this stage of the penciling—but I tend to ink fairly spontaneously and sloppily in my mind, so minor mistakes will happen. This particular strip is kind of an exception, in that I have decided to make it pretty rectilinear. Lewton's writing is so precise, I wanted to make the strip a little bit like that. I've still allowed myself room to be loosey-goosey, like with the lettering and the arms and legs, which are more organic lines. Occasionally a penstroke will turn out differently than I'd planned, but if it looks okay, I'll go with it. When you ink one panel, it defines how you're going to ink the whole page. Things are always evolving as you're doing it, and you're always trying to tweak it just a little bit more at each stage. So when I'm coloring, I may have further ideas about how to add something, or make things more consistent, usually. I want a consistency throughout the page. That's what I'm ultimately striving to achieve: that every little mark I make has some reason for being there.

Produced by VAL LEWTON

Produced by VAL LEWTON

① RUTH LEWTON, WIFE (DISOWNED BY FAMILY FOR MARRYING HIM) ② THE FINAL DRAFT OF ALL HIS SCREENPLAYS WAS WRITTEN BY MR. LEWTON (UNCREDITED)
③ HAS A FEAR OF BEING TOUCHED ④ CAN READ ABOUT SEVEN BOOKS PER EVENING ⑤ A CONFLATION OF THREE SCENES FROM THE FILM. ~2d.

I just thought of something I haven't really articulated: when I'm doodling, it's sort of sloppy, but you get the basic idea of a strip. I want it to be able to flow, even without word balloons, so that it makes some sort of sense. I wish I could ink in a way that was as spontaneous as my doodling style. I doodle spontaneously, but when I pencil, I tighten it all up, so it's consistent from panel to panel, and then when I ink it gets sloppy again—never quite as sloppy as the doodle, which is what I would love, to have that little bit of roughness and spontaneity from that stage. The ink is sort of a compromise between how tightly I pencil and the gestural doodles. In a way I prefer my doodle style, which has its own charm, but it lacks consistency. With the ink I want to have a little bit of both sensibilities; this wasn't a conscious decision, but my inking is a way to try and somehow combine those two approaches. ■

(Opposite) *Wacky Packages,* uncut sheet of stickers, 1979 (Topps Chewing Gum). Copyright © 1979 by The Topps Company, Inc.

I had a few of these as a kid and coveted the whole collections of them that other kids had. I can remember one kid had a beat-up old refrigerator in his garage that wasn't being used anymore, which was plastered with *Wacky Package* stickers. It was almost like art to see all those stickers plastered all over this white surface. Maybe that's why I wanted to get this uncut sheet, which reminds me of a more organized version of that. What I've found really fascinating about looking at these now as an adult is how well drawn and lettered they are. A lot of the logos they're parodying were still at the point of being hand lettered; many later changed to machine type, but these parodies still refer to the logos that were most likely hand done. You can tell there was a shift in graphic design at about the time *Wacky Packages* were being created—logos that were originally created by hand, sometime in the seventies, being changed to machine type. They capture this moment when design was really changing, the massive shift from the charm of hand lettering to everything being done with machine type. They're really well done too. The parodies of the logos are beautiful on their own, in a weird way—and as a piece of history, since many of the underground cartoonists worked on them. But my interest is primarily rooted in my coveting of that set that I could never have as a kid.

I also see in this the appeal of something I've been obsessed with for the last few years, especially since I started teaching cartooning, which is the grid of items or objects. I like to draw series of old cartoon characters or self-caricatures in a grid, as they immediately read as some sort of system. I always tend to go back to this evenly spaced grid, which I really like—even my comics are like that: there's no break unless there's some compelling reason. I've always been attracted to that for some reason, the pleasing geometry of it, so seeing this uncut sheet of stickers was really appealing to me. ∎

These Japanese knock-offs of popular cartoon characters are really interesting to me—the jumbling up of different companies' characters, which you wouldn't see in America. But the heart of it is that these bootlegs always look a little bit wrong, which appeals to me. Often these Japanese images use a really thin line to contour the characters, which you don't really see in the official version. I like the way that looks—and of course the off-register colors give it something too—they often wouldn't use black, but a thin blue line to outline the characters . . . it makes them more fragile. It's something I might want to try and steal later [laughter]. It's interesting that you can still always tell who these characters are—they're fairly well done—but there's something really off about them, which makes them more human in a strange way. You can see the hand that made them more clearly; they're not an assembly-line product. Some guy had to copy these things or come up with them from memory. It shows me the personal relationship that somebody might have had to the character. They're exotic and don't look like the official version—they're wrong somehow, which I love. ∎

Japanese puzzle ring game, undated.

Again, these are imperfectly done, and the printing technique made the possibilities very limited in terms of the amount of detail they could achieve. They're interesting just because they're printed on that surface, which gives them something, some nice quality. Printing anything badly gives it a greater humanity—you can see that somebody made this. A lot of love still went into making them, as poorly as they're done, which is fascinating to me. ∎

Marbles printed with cartoon strip characters, undated.

Mickey Mouse printed knock-off, undated.

Japanese and European Mickey Mouse knock-offs tend to play up the impish quality of the character, which is something that was totally whitewashed as time went on in the American cartoons. He became so bland as to be a non-personality, but these images really capture the quality of the character that was there at the beginning of the cartoons—the idea was that he was mischievous and more like a mouse. He had more rodentlike qualities that were later discarded, and I like the fact that they captured that aspect of the character, which was unfortunately abandoned. They're exotic and don't look like the official version. The bottle of wine in this image is a nice touch. ∎

It's been said by Art Spiegelman that the great thing about *Nancy* is that you could reduce the image to an inch square and still be able to read it—and even get the joke. One of the many things that appeals to me about [Ernie] Bushmiller is his mathematically precise compositions, which are so well thought out and perfectly ordered. Even in a simple gag like this it's apparent, and it's actually quite daring in the use of white space. Not that this is the greatest example, but it's amazing how well thought out even his workaday strips are. I love studying cartoonists' originals because they're so physical: you can see the hand, the speed of the pen or brushstroke, see how the artist's mind works—the thought process, the working process, the different line weights, how many different pens and brushes are used—it's fascinating and always inspiring to see how much work goes into each page. I love comparing how artists do things, and the different emotional effects that small decisions might have on the reader—it gives each cartoonist's work an individual, idiosyncratic flair. ■

God knows why I bought this. It's like the saddest toy of all time. It has my favorite colors, of course. That dull avocado green is a color I never get right in my own comics. I can't figure out the perfect CMYK [cyan-magenta-yellow-black] combination for it. Anyway, this isn't even like a real gun. It doesn't fire any projectiles or anything. The woodpecker hits the tip of the barrel and makes a clacking noise. Pretty dumb. I like it. ■

Ernie Bushmiller, original art for *Nancy*, daily strip, December 22, 1951. Distributed by United Features Syndicate. Used by permission of United Media.

(Above, left) Toy tin gun, undated.

These are a couple of water-transfer decals I found at a toy show. They were obviously made by the same outfit, but interestingly, the house artist took a totally different approach with these images. Superman is drawn in a simplified, almost abstracted way, but the Yogi Bear drawing is almost too "real." He has five fingers, which gives him a disturbing anthropomorphic dimension . . . actually, it's more like pornographic verisimilitude. It's just wrong, and it makes him a lot less cute and a little more threatening. I can picture those hands strangling Boo-Boo's neck or something. ■

Water-transfer decals featuring unauthorized reproductions of Superman and Yogi Bear, undated.

Ivan Brunetti, original art for *Nancy* try-out Sunday strip, c. 1995. Copyright © by Ivan Brunetti.

My "Nancy Project" began because someone I knew from college, who had seen my strips and knew that I could mimic other styles, was working at United Features and called to ask me about *Nancy* and what I was doing with comics. He was a fan and got me involved when they were getting rid of Jerry Scott, who had been hired to revamp the strip and change the character design. I think they realized that maybe they should go back to the old *Nancy,* so a number of cartoonists tried out, and somehow they narrowed it down to just me and the team doing the strip now. I ended up drawing almost nine full weeks' worth of strips, during the middle of *Schizo* no. 1. I can tell exactly the time period in my work when I was doing these—the syndicate were such nitpickers about me copying Bushmiller's style exactly that my approach to cartooning got much more precise as a result. I went from doing strips just to amuse myself, without a grand plan, to focusing on formal aspects of cartooning much more: where to place a word balloon, the composition of every panel, and the flow of panels.

Paul Karasik and Mark Newgarden's essay "How to Read Nancy" was a great way to see how tightly constructed every single strip was. I realized that I wasn't that kind of really precise artist, but I became much more aware of those issues and tried to incorporate that thinking more into my own strips: consistency of scale and language; how to combine mechanical aspects, like zipatone, with organic elements, like hatching. These combinations become really strange, so you have to create some rules—but I don't think that Bushmiller thought it all out theoretically and made a set of rules that he had to follow—they just developed naturally. But when you're copying someone's style exactly, you can theorize about it, and actually break it down into a set of rules. So the way I was working by imitating him had almost nothing to do with the way he was working . . . I also realized that working this way was totally unpleasant, because there are very strict parameters you have to follow, rather than discovering the rules that work. The project was fun while I was discovering all of the rules; I would notice that he would never put certain kinds of marks next to one another because they'd look wrong. I became very aware of every penstroke, where he used a ruler, where it was freehand. He had an intuitive sense of what looked good, so for me it was trying to codify this into a set of rules, which made me realize the importance of the consistency of your cartooning vocabulary.

I discovered a lot, but at a certain point it wasn't fun at all, and I realized that I would never want this job. There was very little of myself in it—I hadn't even done my own first issue of *Schizo* at the time, only self-publishing a few comics years before, and it was so difficult dealing with so many people at the syndicate interfering with what you were doing. I realized that I couldn't handle it. I had moral qualms about copying, trying to do it respectfully—at first I thought I could bring something of my own to it, but then realized this wouldn't be allowed. I concluded at the end of it that I didn't want to do that job ever, and I figured that whoever got it would eventually deviate from copying Bushmiller enough that it would gradually become something else. The syndicate would lose interest as well, which is kind of what happened with the team that took it over. It's impossible for someone to copy someone else consistently and, really, why would you want to do that? ∎

Even in average examples, [George] Herriman's compositions were always interesting and a little offbeat. I love the flow of his pen line; you can feel his marks and his scratching out on the paper—some of his scraping out with a knife is even visible in the printed tear sheet. Looking at his work helped me free up my own cartooning a bit—he was drawing in this free, spontaneous style. One of the qualities of *Krazy Kat* that I aspire to, but haven't achieved yet, is his masterful combination of playfulness and austerity. It's a combination of qualities that is great for comics to possess. The nature of drawing cartoons seems inherently playful, having its roots in a playful kind of drawing, but because you're putting things into boxes and organizing pages into panels and shapes of rectangles and circles, it automatically has an architectural quality, too—and I think an austerity, due to that compositional geometry organizing the page, which is always present; otherwise, you don't have a comics page. Somehow, all together this creates a formal, austere structured sense, particularly with Herriman, who used a ruler on the panel border lines (which accentuates this architectural quality), but never inside the panels, where the forms are completely organic.

This is an approach I've used many times because I like the contrast; I think what happens when this is done well is that the panels become invisible. The more geometric they are, the more they disappear, as opposed to when they're drawn by hand and the shaky line is visible—then they really become a part of the artwork and narrative in each panel. An entirely different feeling is evoked based on these decisions, and I think what happens in *Krazy Kat* is a tension between the straight lines of the borders, which prevents the page from becoming totally chaotic, since he often used such unconventional structures. By using a ruler it creates a solidity that holds everything together. So this lets you enter an entirely different world that comes alive inside the panels—you have a whole different experience when reading it sequentially than when viewing the page as a whole. The world inside is completely different than the larger ordering shapes, which you totally forget about when getting into the narrative of the strip. You can go crazy looking at these things. I think it's completely intuitive on his part— I don't think he had a theoretical basis for doing this.

There are so many approaches to comics, I really think it's helpful for cartoonists to study artists they like, and notice the affinities. Not that one should only like work similar to one's own, but a lot can be learned by how many kinds of emotional effects can be achieved by slightly different ideas—even the simple notion of whether to rule or hand-draw the panel borders makes strips read a little bit differently, and it's hard to articulate why, exactly. Both approaches work great, and there are cartoonists I love who work in totally opposite ways. It's fascinating—like studying someone's handwriting in an attempt to figure out their psychology. ■

(Opposite) George Herriman, *Krazy Kat,* Sunday strip, July 10, 1938. Copyright © King Features Syndicate. Used by permission.

Wassily Kandinsky, *Trente,* 1937. Oil on canvas. Collection of the Musée National d'Art Moderne, Centre Georges Pompidou, Paris, France, AM 1976–860. Copyright © 2006 Artists Rights Society (ARS), New York/ADA3, Paris. Photo by Philippe Migeat. Photo credit: CNAC/MNAM/Dist. Réunion des Musées Nationaux/Art Resource, NY.

I have a print of a Kandinsky painting called *Trente,* which is comprised of thirty panels. He's not an artist you would associate with comics, and I would never argue that this is a comic strip, which it isn't—it's not a narrative per se. But looking at this painting has really helped me as a cartoonist, because what he was doing is just seeing how shapes play around each other. When you have a grid, the viewer automatically starts to structure and find relationships between things. When I look at this painting it reminds me of looking at a comic page that I haven't read yet: you immediately have an emotional reaction from the way the panels are put together. Here it's a really simple checkerboard pattern, with a grid comprised of slightly differently sized and proportioned rectangles, which immediately creates a structure and feeling of tension between opposites. It sort of has that *Krazy Kat* feeling, where straight lines create "panels," so to speak, that contain organic shapes playing around. There's no narrative, but a similar feeling is created. I can't go inside and have it come alive as I read it, so it's not really like a comic strip, but there are certain things to be learned about how comics work—and in a weird way about how he thinks about line. Lines are used to tell something of a narrative in that the eye goes from flowing shape to shape and we tend to

see things as having a beginning and end. And each shape is organized such that following it from its implied "beginning" is almost "reading" it. In a way, this is sort of like what's underneath comics, what we're not aware of—we're not only reading the panel but the formal process of the creation of the panel.

It's evident where the line delineating figures and forms starts, so you could play around with that, which Kandinsky does here. Straight and curved lines are combined with dots—he's interested in how these elements create space or a sense of flow. Again, I've often been spellbound by how rich this painting is, and how much is going on inside it— you can almost read it, spending a great deal of time within each "panel," as if it's a story. I like that the panels work as a set and on an individual basis. The best comics are like this as well—they can be appreciated as a whole and as individual panels, which you can linger on. He's stripped down the representational world and is asking us to look at things as shapes, and how they feel next to each other. His work is always very emotional, actually, which is the root of what he did—to use color, points, lines, and planes to achieve emotion. These are the building blocks of comics too, so he's a painter who can be instructive to cartoonists. ∎

L'intrépide, French collection of comic strips, 1950s.

This is a 1950s French collection of fairly uninteresting adventure comics, which inexplicably contains some *Nancy* strips that don't match the illustrative adventure strips at all. Of great interest, however, is the cover, which is the strangest image I've ever seen. Chris Ware must have thought so, too, because he bought this as a gift for me. He has a great eye for everything, as you might guess. Anyway the drawing makes no sense spatially—where anything exists in relation to other objects is a mystery [laughter]. There's a leash around Sluggo, who, judging by the space, should be floating in air—in fact, there are two Sluggos in the same image, which is disturbing enough. It's almost like an optical-illusion puzzle, because it exists in a completely nonreal space that is only heightened by the color, which makes objects appear to be negative space and solidifies the wrong areas. I think someone tried to fix the spatial problems with the coloring, but this just exacerbates the strangeness. Even a cursory study shows that it just doesn't work at all—but it is totally unsettling. It shows that even with a simple line drawing you can create an incredible, nonexistent space, here done inadvertently by some guy just hacking out a *Nancy* pastiche from swiped poses, too lazy to work it out so that it made sense. By combining poses from just a few strips, it turned into something very strange and fascinating. ∎

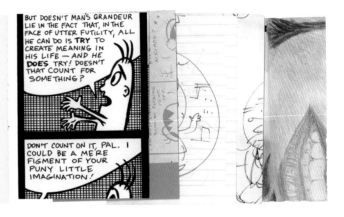

Ivan Brunetti, *Fragments of Ivan Brunetti,* handmade box, edition of 100, 2001. Copyright © 2001 by Ivan Brunetti.

In 2001 I made one hundred of these boxes assembled from chopping up all of my artwork—the note included in the box explains it. This was an intense emotional time for me, and this project represented a good purging. What was fascinating, which I didn't even think about at the time, is that I took all of these childhood drawings—obviously I'm the kind of person who would save as many childhood drawings as I could—and cut them through the center of the image in a way that is quite unnerving . . . to save something for thirty years and then cut it unceremoniously right through the center. I stacked everything up and cut them to create stacks of uniformly sized pieces. I tried not to compositionally frame any image, but to make the cuts completely random. The idea of taking your life and randomly feeding it through a slicer, and being left with whatever came out, was appealing to me. I didn't want to finesse anything—the feeling was supposed to be that you're getting a random fragment. Once they were cut, I had about forty or fifty stacks of types of items—childhood drawings, my college strip, college papers, sketches, photos, abandoned ideas, my high school journal, zipatone fragments, tear sheets, thumbnails, colored paper doodles, strips that never amounted to anything, my *Nancy* submissions, my original inked art from *Schizo.* Then I would distribute roughly one of each into a box. It was done intuitively with the idea that the owner could take everything out and place the scraps into any order they liked, but the first impression I wanted them to get was of the variety. I was so tired of having all this stuff I just wanted to start over, to make something else out of this garbage that was just taking up space . . . I realized I had too much stuff right after moving, and this was liberating, to look at it as the work of a completely different person, all the past that I didn't care about anymore—but I had to make something out of it. ∎

This is a little book published by the Wobblies (the International Workers of the World). It includes plays with titles like "The Gang Learns about May Day." The drawings are actually pretty nice. I like the deep, dark green against that aged, almost brown paper. I've liked stuff that was beautiful despite being on crappy paper and having maybe one or two colors. ∎

Bill Siegel, illustrations for *12 Plays for Boys and Girls*, c. 1930s (International Workers of the World).

This little gem uses only black and two colors (not counting the gold trim). I love these large areas of flat color with just white and maybe one other color for the highlights, and the black line holding it all together. In my own comics, I try to do little color thumbnails. I like the idea of all the colors organizing the composition of the page. I try to think of white and black as being equal to the other colors, using them as a sort of organizing principle as well. Balance is always important to me. I tend to use large areas of one flat color to dominate the page. Like I said, I'm a terrible colorist; my eyes are worse than ever. Simplifying the palette has been necessary for me. But even before that, I liked having one dominant color, with maybe one or two more colors as highlights and a balanced set of black lines and spaces. This is the kind of stuff that can drive you batty, and eventually you'll start pontificating about unified field theories based on plate tectonics or things like that. Ultimately, all you have is your own intuition to go on. The colors on the page either harmonize or they don't . . . ∎

Fair Japan, brochure, undated (Japanese State Railways).

I love the simplicity of this—it's pretty abstract. I was thinking of making a doll of myself using similar shapes. ∎

(Above) The Little King, wooden toy, c. 1940s. Copyright © King Features Syndicate. Used by permission.

(Right) Japanese wooden toy, undated.

This is an odd Japanese toy that I found—I'm unsure about the use. It's a bowling ball and pin and it seems really odd that the noses are composed of English letters. The strangest ideas for faces—these marks that were supposed to read as a nose and mouth, that still kind of make sense. Very odd. ∎

I'm not a huge fan of *Dennis the Menace,* but these napkins are sort of beautiful. [Hank] Ketcham definitely had something going—a really confident line—and the early examples are pretty vigorous and interesting. ∎

Hank Ketcham, *Dennis the Menace* Sip'n Snack Napkins, c. 1950s. Copyright © 2005, used by permission of Hank Ketcham Enterprises, Inc.

Ivan Brunetti, *Cocktail Napkins,* c. 2001. Copyright © by Ivan Brunetti.

Some Reasons why Some Men are Successful Fathers

By FRANK H. CHELEY

COMPLIMENTS OF *Chicago Y.M.C.A. College*

Frank H. Cheley, *Some Reasons Why Some Men Are Successful Fathers*, educational brochure, 1921.

I liked the cover of this pamphlet, but then flipping through it, I discovered that it's even weirder than I initially thought. The character designs are very strange: it's from 1921 and it demonstrates "proper fatherhood"—at least for 1921. When reading it you realize it's actually pretty demented, the father laughing at his son who has just been humiliated. These big-headed businessmen are pretty creepy, and the cartooning is very odd. "Why some men are successful fathers: They do not blame the boys for falling in love with the girls. They did themselves once, and are convinced that comradeship with the right sort of girls under reasonable supervision is the greatest tonic in the world to right living." It's filled with little gems like that. ■

I bought this set of *Peanuts* dolls because they look completely incongruously happy, and it makes me laugh to see them. Charlie Brown especially looks so cheerful. They capture something about the characters, even though they don't look exactly right. I guess it shows what a sentimental person I am, that a happy Charlie Brown somehow brings me happiness [laughter]. They just look so innocent . . . the really weird thing is they took these characters and almost made them seem like real children. The thing is, they're supposed to be children—but really aren't in the strip—and these dolls turn them into children somehow . . . even though they're already supposed to be children . . . which is very strange.

The Japanese matchbook is pretty sad. It's a difficult feat to make Charlie Brown even sadder than he already is. I'm sure this bar no longer exists. Could you imagine a similar bar in the United States?

This patch was a gift from Walt Holcombe, an underrated cartoonist. I hope someone publishes a collection of his stuff soon. Anyway, I think the patch is from Mexico. Why does Snoopy have that Yeti-like coat of brown fur? Why does Charlie Brown have so much hair? Why is Linus blond? Why does . . . oh, forget it. It's just a really strange and beautiful item. Like an artifact from a parallel dimension. ∎

Charlie Brown doll, c. 1960s.

Japanese matchbook for Charlie Brown Place bar, undated.

Mexican patch featuring *Peanuts* knock-off, undated.

Japanese bee toy, undated.

I'm kind of fascinated by certain proportions of cartoon heads—trying to get the perfect combination of cute, but not grotesquely cute, is very difficult. Only a few ways of doing it really work for me: if you move the eyes a little too far apart or the nose a little too far down, it becomes grotesque instead of cute. I know that's subjective and you could do an analysis through the decades of how the ideas of "cute" change, but there's got to be some mathematical formula for what works and what doesn't. I've always been fascinated that you could draw a circle and a couple of dots, a little squiggle for a nose, and another for hair, and you automatically see Charlie Brown. I'm very interested to look at how his head changed from decade to decade—even year to year, early on. If you look at him in 1950 versus 1965 versus 1995, he's completely different—but you always know he's Charlie Brown. So what's interesting to me is to ask: at what point would it not be Charlie Brown anymore? Can you come up with a mathematical threshold point, where if you stray far enough, it's not that character anymore? It relates to how we recognize letter characters, I think. Why do we recognize the letter "a"? There can't be infinite variations on "a"; at some point it becomes another letter, so it's fascinating to me how far you can stretch something like that.

I did an exercise with my class that was very instructive—you try to draw cartoon characters from memory. It's interesting how you mostly get them wrong, but get them kind of right at the same time. You always know who it's supposed to be, even though it doesn't have much of a resemblance at all. There seems to be some core to these characters that can be represented with just a few lines, or key elements, which is fascinating. If you tried to draw them exactly right, you'd have to get a reference, and any little mistake would stand out. But if you doodle really fast, it can be totally wrong, yet it reads closer to right than the copy. This is instructive because it shows that even having a photo reference to make sure everything is drawn correctly doesn't at all help cartooning—it doesn't help communicate anything. In fact if you begin to draw with a great amount of detail, you have to keep it consistent; if you're rendering perfectly detailed cars, any little mistakes later on will pop out. So using simple shapes to represent cars actually reads better. In a weird way, cartooning isn't about drawing per se.

I also often find that when drawing characters from memory, you get them so wrong that it's almost as if you're inventing new characters, and I've used that as the basis for new character design. This lets you see what your own style is, both when you try to copy something exactly and when you draw things from memory. You start to see connections with the way you draw and it helps you find your own voice. It's a good exercise for students—draw fifty characters from memory and you start to see certain things that connect how you draw. A cartoonist should focus on that trait, which is what makes one different or unique. ∎

Anna May Wong

Lilian Gish

Louise Brooks

This has nothing to do with cartooning, but maybe aesthetics, I suppose. I started obsessively collecting postcards of silent movie actresses, mostly from the 1920s. It's interesting that by the mid-thirties this whole genre goes downhill. The twenties were the peak somehow in that the postcards were very well constructed and posed. The aesthetics of the cards gets worse, and I'm trying to pinpoint what it is, the common characteristic—other than being infatuated with these actresses, which is part of it. I found I'm really picky about them and I tend to like closer portraits, but also space around the image. I think that during this period, photography was trying to emulate Renaissance painting—the idea of beauty and composition is tied more to painting—and they get away from that by the late thirties. Plus I think the standards of glamour photography begin to go downhill as a lot of the more famous guys stopped working around that time. I guess the similarity to cartooning would be just that I like things well composed, and I like open spaces.

I'm not sure how this started—always with collecting, you're trying to fill some emotional gap. I think I was pretty miserable, depressed, and lonely at the time, so it became a way to expend energy on something. I do like getting obsessed with things—I get a strange energy from wasting lots and lots of time obsessing over something and competing with people on auctions; it's such a cutthroat world, collecting old postcards. I think I got a crazy energy from that. It's difficult for me to articulate . . . but I believe that an artist should follow his compulsions to the bitter end, unless some sort of violence is involved, of course. I think of myself as a sloppy artist, but my ideal is order, which I guess shows in everything I collect. And of course you want to collect in an orderly way, to try and get at the root of whatever it is. For me collecting is about figuring out why I'm obsessed with something, which I never know when I start. It's not about getting things that I used to have, since I didn't have toys as a kid. Though I understand that urge of wanting to possess what you used to have as a child, there's not much like that from my childhood. I'm not sure what the urge is about, but I know it's not

(Above and following page)
Six film star postcards,
c. 1920s.

Bebe Daniels

Constance Talmadge

Dolores Del Rio

random. There's usually a catalyst, and it becomes about self-discovery—for example, I got a lot of postcards before I noticed how similar they all were to one another. At first it's like the ocean washing over you, some undefined aesthetic experience, and you don't realize that you're being driven by these subconscious desires, then as you go on, you begin to refine and see what doesn't fit.

I think that is related to cartooning or art in general in the sense that I have a million notes and doodles when beginning a comic, and I like sifting through all that stuff and finding the story. I tend to write things down immediately when they happen or come to me, so you get a sense of the visceral impression, or certain nuances will stick in your mind only if you write something down immediately before forgetting. But I tend to not draw things immediately—generally years will go by, and I like that process, of having a mountain of things to sift through, and finding the gem. That's kind of what collecting is about for me—this process of gradually coming into focus. When I figure out what it's about, I stop collecting. As soon as I discovered that my favorite postcards were made by a certain company during a certain period and that there were a finite number of them, I lost interest in them. I could probably make a parameter of which types I want, or make a list of those to collect, but actually it then becomes not interesting anymore. Then it's anticlimactic—I know exactly what I'm looking for . . . I'd just be going through the motions. I like to be surprised by finding one I never knew about, not to have a list and just buy those until I've completed it.

This totally mirrors how I work on my comics: I don't want to plan it all out beforehand, I want to allow room to surprise myself, even as I'm inking or coloring it, up until it's printed. I just don't like doing things where it feels like I'm merely fulfilling an obligation—there's always got to be a process of discovery as I'm doing it. Which is really odd since I'm so hyperanal and controlling about planning things out—it's hard to reconcile those two tendencies. Like anything else in life, the way you collect things mirrors everything else. It's always part of a larger piece, though you can't see it when you're doing it. ■

For a while, I was obsessed with Drew Barrymore, and I don't know why, other than she represents the opposite of me. As I was collecting these magazine clippings, I didn't know what it was, other than an infatuation with a certain type. In my mind, she's ultrafeminine—there's nothing masculine about her. She's very round, which we always associate with femininity—it's somehow ingrained in the human mind that straight edges are traditionally male, and roundness has to do with the female. Probably just having to do with biology.

This started around the time that she made a comeback from her problems as a child and started appearing in B-movies. In my mind maybe she's a free spirit, which is the exact opposite of me: she represents a part of me that I can't express in any way, or something. I'm so uptight and rigid . . . I couldn't figure out why I was drawn to that free-spirited quality, other than the fact that I viewed us as polar opposites. I collected images of other actresses as well, but got rid of boxes and boxes of those, only keeping the Drew Barrymore stuff. I think of my comics as a document of my life, and this seems to be as well. I hate to revisit my comics when they're done, as the temptation is to redraw everything, so I just view them as representing the best I could do from a certain time in my life. I look at my work as an evolving document, and this is a document of a time as well, although it's embarrassing to show people this stuff. Maybe I have a fear of the feminine side of myself . . . I liked the cutting, too [laughter]. It's sad isn't it? My searching got crazy at a certain point—magazine covers, clippings, eight-by-tens, paparazzi photos from eBay . . . I was searching through foreign magazines.

It ended at a certain point. I liked her better when she was a little fatter; now she's too skinny. Again, roundness is a key element, aesthetically—even in my cartoons I like having characters with round heads . . . it's really strange to me. "Why do I prefer that?" She's just round everywhere. This box of small clippings is the most embarrassing, since you can tell that I liked the cutting . . . there's something sadomasochistic about that. It's kind of sad; I think I was really depressed and lonely for so long that I liked going through things and cutting them up . . . yep . . . I don't really know what it's all about. I've never been a free spirit, always having a controlled, uptight life, and I think she was just the opposite of me—the feminine side of me that I've had to repress. As a child I was very introverted and shy, and kind of effeminate too, probably. I grew up in a working-class neighborhood with a father who hunts and fishes and stuff, so being feminine in any way was looked upon as bad. As I've gotten older, I'm trying to find the balance—I know I'm attracted to things that are undeniably fruity, for lack of a better term. What kind of guy collects postcards? I'm not sure what it's all about—something related to acknowledging that I like all this stuff, but I know that it makes me less of a man, so I'm ashamed of it all. The fact that I have to hide that collection and am embarrassed to show anyone . . . I don't know, it's like being a heterosexual gay man, if that's possible. The things I like are probably not very heterosexual, but on the other hand I'm always infatuated with women, and actresses, which is a recurring thing in my life—this feminine ideal. But the way I go about it is not very manly, maybe—I'm more like them, which is part of the problem, maybe . . . no woman would respect you [laughter].

I finally stopped . . . I got to a certain point where I didn't care anymore—the *Charlie's Angels* movie came out and I realized that I didn't want to start collecting *Charlie's Angels* . . . or have to start collecting things where she's part of a group. It made me rethink the parameter, and ruined the purity of just collecting images of her. It tainted it to me because I realized that I didn't want those other images, which made me realize my collection would always be incomplete, so I just lost interest . . . and she went on the Atkins diet and she didn't look the same anymore—people on that diet get dark circles under their eyes, their teeth get bad and their bodies get weirdly angular and muscular, which I don't like . . . like an Egon Schiele drawing—I prefer a more Klimt kind of fullness. ■

Magazine clippings and photographs of Drew Barrymore from Brunetti's collection.

Ivan Brunetti, *Haw!* cover
and two interior pages, 2001
(Fantagraphics). Copyright ©
2001 by Ivan Brunetti. Used
by permission of Fantagraph-
ics Books.

"Honey, we need to talk..."

"Ooh, look... a birdie."

I love gag cartoons and have always been attracted to them visually, the way the old *New Yorker* cartoonists drew. When I first envisioned *Haw!* I tried to find more work by those artists, and of course in the process you start finding the lesser gag cartoonists. You could certainly see that, with the exception of a few people like Virgil Partch, who never appeared in the magazine (actually he did, just once, I'm told), they definitely featured a high percentage of the best gag cartoonists. I became sort of fascinated by some of the bad cartoonists, a number of whom had a real energy, more of a raw style. The first cartoons I ever drew were single-panel, so they're something I've always liked; even through high school, I always had that idea in the back of my mind, but looking at these older artists I really began to think of how to compose these panels. I got an intuitive sense of how to make it work from having seen so many and from working a job as a proofreader, when I had a ton of time to just doodle to blow off steam.

I originally wanted the book to look exactly like a little collection of 1950s dirty cartoons, designed the same way so it looked like a different guy had drawn each cartoon . . . a collection of twenty-five or fifty styles. I liked the idea that gags and images in old men's digests had a lot of space around them, and I wanted to compose mine like that, though without making it a parody. I was going to try to do pastiches, combining styles rather than just copying an artist, but when I looked at all these cartoons I had done, I realized that they were just so angry and kind of immoral at times that to put this veneer of parody on top of them would become almost too callous. I was also scared that the directness of my doodles—the anger of these cartoons—would be lost. I actually waited four years to draw *Haw!* and by then had decided to do it in my natural style.

It's not a commentary on gag cartooning. The content was just so personal in a way . . . I don't know, my nerves were completely rubbed raw or something. I was really unnerved looking at these jokes I had come up with, so if I tried to make it like a parody then that's what it becomes about, and somehow that's too cold of a presentation. I wasn't trying to deconstruct the gag form—those cartoons were all about me getting my emotions out and I realized that such an approach would be totally wrong. I've never done anything like that—a self-reflexive gag that was about gag cartooning. I could, since I study them intently and use the tightly constructed gags in my class as examples. I could spend the time to do pastiches like that, which might be kind of fun, I suppose, but in the end I thought it worked better the closer I could get to my doodle style; it made more sense as a single person's vision, rather than an analysis of that form.

Gag panels are often underrated, because they're not accepted as "comics"—I don't know that I buy that distinction. I think of what those guys are doing as being a lot closer to what I'm doing, much more so than guys who draw superhero comics. I always think cartooning is more a way of looking at the world, a certain type of drawing that isn't drawing anymore. It's closer to calligraphy, and thus to writing. In my mind, that's what makes cartooning. One thing I wanted to do with an anthology I'm compiling is to show a great variety of approaches to cartooning. I tend to like things that are fairly diverse stylistically, but the one thing that I always kind of look for is something that is genuine, that really expresses an individual's view of the world. I'm not that interested in illustrative cartooning, so for the most part I stay away from that—although there are people I like that have a little of that in them. I definitely like work that is very considered. This isn't the same as overworking a page, but can come from a lifetime of having done cartooning, which creates a Zen-master quality that is visible in the calligraphy of the line to express something. You can only get that from drawing comics for a very long time—the only exception I can think of is Robert Crumb, who was a genius by age nine. His line seemed very informed, even at that age. But of course he has continued to develop over the years, where now when he puts a line down on a piece of paper, it has all of his years behind it. It carries a lot of weight—he can create a space, a sense of volume, with just a few lines.

It takes so long to be able to convey that. That's the thing about comics—there seem to be a good number of cartoonists who show promise, then they just peter out by a certain age. A lot of the work I'm including in the anthology is by cartoonists who've been doing it for a long time. I think there's something obviously gained by the experience; look at any cartoonist's work and in some cases the shift from early to later is just unbelievable. I haven't figured out yet what ties everyone in the anthology together, but there's something about stories I just continue to return to—everyone somehow has a clear sense about cartooning. In my mind, their work couldn't be anything else but comics—I guess it's from my intuition, having looked at so many comics, that I can trust my judgment to some degree. Stories about what it's like to be alive; stories that work as stories. I think I tend to avoid the fantastic—certainly my tastes are more toward mundane, existential quandaries, the small pleasures and pains of life. Stories that approach the complexity of literature, emotionally. ■

Ever since the *American Splendor* movie came out, I've been rereading all of Pekar's work, and I've forgotten how much of an influence he was. Definitely those that stand out are the Crumb collaborations—particularly the early strips. Those stories are amazing in that he would just depict these random thoughts, and I think Crumb had a really great control and really tapped into what was good about Pekar's writing. The way he draws is so organic that it fits perfectly with the Harvey Pekar lifestyle, in which you imagine everything has sort of a wobbly line. This was a perfect collaboration—Crumb is such a master at pacing and panel layouts—I think they brought out something good in each other and Crumb's work even changed after that. These had a big impact on me and really brought into stark relief what comics were about—how they read in a certain unique way, and have their own flow. You can't just illustrate text. ∎

Harvey Pekar and Robert Crumb, "How I Quit Collecting Records," *American Splendor* no. 4, splash page, 1979 (Harvey Pekar). Copyright © 1979 by Harvey Pekar and Robert Crumb.

The New Yorker, August 15, 1953. Copyright © 1953 by Condé Nast.

At first this seems like just another clever little cover illustration, but I think it brings up some really interesting points about comic art. For instance, I think it's great that the "realistic" painter can only paint as realistically as the cover itself. The level of "reality" of the entire scene is of course delimited by the draftsmanship of the artist. This then sets up parameters of what we, the viewers, would consider the more iconic approach and the abstract approach. The artist could have used a hyperrealistic painting for the most naturalistic one, but then that would take us "out of the picture" and make the cover idea too conceptual (and much too clever). I always try to stress consistency of the drawing vocabulary with each of my students. You can get into trouble when you start going crazy with Photoshop and inserting photographs with drop shadows into your pages. You have to be careful with that stuff and use it sparingly and with good cause. When the viewer or reader becomes too aware of "styles" clashing on the page, they become aware that they're reading and thus are interrupted from the natural flow of a story. This can sometimes work in a humorous story, and I've done it myself, but it gets dangerous when you have a serious story that needs an "even" flow, where the reader isn't too conscious of the act of reading. Again, extreme caution must be used in these cases. *David Boring* is brilliant in this respect, as it perfectly balances the clashing styles, and even interweaves this clash into the very fabric of the story. *Maus* has a few places where all of a sudden there is a technical drawing from a textbook, or a photograph. It's very subtly done and sparsely used, so it doesn't demolish the integrity of the pages. But then Art Spiegelman is a master cartoonist. Often, these graphic risks seem to backfire with lesser talents. The use of these devices in narrative have to be earned, in my opinion. You can't just throw this stuff in there willy-nilly. The only cartoonist that I've seen switch styles from panel to panel, and it works, is Gary Panter. It's amazing how he can do that. Again, though, he embraces this dissonance and it turns into something emotionally expressive that is integral to the work itself. ∎

Charles Addams, "Boiling Oil," uncaptioned cartoon, *The New Yorker*, December 21, 1946. Copyright © by Tee and Charles Addams Foundation. Used by permission.

A masterfully composed gag panel. I use this one in my class. First off, it's funny, especially because it's such a creepy, hateful joke. Note that it would be a lot less funny if the action depicted took place about two seconds later, and we would see the carolers screaming from the boiling oil charring their bodies. Actually, that could almost be funny, but you'd have no way of knowing they were carolers, so it would just seem cruel. This gag sort of straddles the knife edge of Schadenfreude. Anyway, it's a very dark panel, figuratively and literally. What is the lightest part of the composition? That vat of oil. Our eye is immediately drawn to it; the smoke emanating from it also helps point our eye there. The verticals of the house lead the eye from the vat of oil down to the carolers. The windows under the vat, which taper from two adjacent windows, then to one, and another one beneath that, create an implied visual path of the oil pouring down into a thinning stream as it hits the carolers. The carolers stand out in the composition because of the white snow around them. The shadows of the trees point us toward the carolers, as does the circle of footprints around them, which sort of spotlights them. The distribution of light and dark and the strong verticals of the composition help us read it in the right order. We see the vat of oil, and the verticals lead our eyes down the implied path of the oil, and then we see the carolers. We imagine that implied boiling oil about to hit them, and at that moment we get the joke: carolers are annoying. Again, the gag is perfectly timed. We get just enough info to see that they are carolers, and thus their implied impending pain amuses us. If all we saw was some people running around with their eyeballs melting, with no idea of the "backstory," all of this simply would be pointlessly cruel and much less funny . . . ∎

(Right) Ivan Brunetti, print for *The Gocco Set: 17 Prints by 17 Artists*, edition of 125, 2005. Copyright © 2005 by Ivan Brunetti.

The Gocco Set: 17 Prints by 17 Artists, edition of 125, 2005 (compiled by Onsmith). Copyright © 2005 by Onsmith.

Ryoko Oguchi, print for *The Gocco Set: 17 Prints by 17 Artists*, edition of 125, 2005. Copyright © 2005 by Ryoko Oguchi.

This was a project I did just for the fun of it. Sometimes when I'm in a horrible rut and I feel completely blocked, paralyzed by the thought of anyone reading what I perceive to be my substandard and horrible work, I try to regain a little bit of that sense of drawing as escape that I had when I was a child. In those instances, of which there have been many, I will draw a postcard and mail it to a friend. Or I will make something that very few people will see. My Erik Satie strip, for instance, was actually drawn as a gift for my friend Matt McClintock. I love Satie, don't get me wrong. But I wanted to draw something for him as a Christmas gift, and I know that Satie was his favorite composer. So that got me off my ass, and I drew the strip for him. Anyway, to get back "on topic," this Gocco Set project was meant to be for fun. I recently bought a Print Gocco kit, a Japanese device that makes tiny, postcard-sized prints (again with the postcards). I convinced my friend Jeremy (pen name: Onsmith), who was unemployed and depressed at the time, to organize fellow Gocco lovers and put together a set of these prints, essentially so that we could all do a big trade. Anyway, I designed the box, and he helped me print them. My print is actually from a doodle I did of my girlfriend. She was feeling pretty low at the time, so I wanted to give her a little gift. Blue is her favorite color. So no big mystery there. Like I said, sometimes it's important to remind yourself that drawing should be a pleasurable activity. Comics certainly can make you forget that. My favorite print in the set is by Jonathan Bennett; his design is the most complex and his image also happens to be the funniest. I think he's a good cartoonist and getting better all the time, by the way, and we'll be hearing more about him very soon. My other favorite print is by Ryoko Oguchi. Her style seems effortless, although I'm sure it isn't. Her drawing feels sweet and innocent but tinged by sadness at the same time. I think it's the delicacy of the line. Well, it's hard to explain this stuff. I just love her drawing, and I wish mine had the same qualities. ∎

Milt Gross, "Paid in Bull," *Judge,* single-page cartoon, May 23, 1925. Copyright © by the estate of Milt Gross.

Milt Gross is one of my favorites, and his work has a real human warmth to it. In just the way he draws a line, I see an empathy for humanity. Even though it's crazy and nutty, the way he draws anything gives me that feeling . . . I can't put it into words, I can't prove it, I can't quantify it, but I know it when I see it—I feel it when I see the pages. There's something amazing about someone who can draw any object and make it funny. Somebody who can do that must have something that really connects them to the rest of humanity—to be able to do that means you're human. I wouldn't trust someone as a person who didn't find Milt Gross funny—there's something missing in you as a human being if you look at one of his drawings and don't smirk a little bit. ∎

Selected Bibliography

General Comics History

Barrier, Michael, and Martin Williams, eds. *A Smithsonian Book of Comic-Book Comics.* Washington, D.C.: Smithsonian Institution Press and Harry N. Abrams, 1981.

Becker, Stephen. *Comic Art in America.* New York: Simon and Schuster, 1959.

Blackbeard, Bill, and Dale Crain, eds. *The Comic Strip Century.* 2 vols. Northampton, Mass.: Kitchen Sink, 1995.

Blackbeard, Bill, and Martin Williams, eds. *The Smithsonian Collection of Newspaper Comics.* Washington, D.C.: Smithsonian Institution Press and Harry N. Abrams, 1977.

Carlin, John, Paul Karasik, and Brian Walker, eds. *Masters of American Comics*, exh. cat. New Haven: Yale University Press, 2005.

Carlin, John, and Sheena Wagstaff, eds. *The Comic Art Show: Cartoons in Painting and Popular Culture*, exh. cat. Agoura, Calif.: Fantagraphics, 1983.

Carrier, David. *The Aesthetics of Comics.* University Park: Pennsylvania State University Press, 2000.

Couperie, Pierre, Maurice C. Horn, Proto Destefanis, et al. *A History of the Comic Strip*, exh. cat., Musée des Arts Decoratifs/Palais du Louvre. Trans. Eileen B. Hennessy. New York: Crown, 1968.

Daniels, Les. *Comix: A History of Comic Books in America.* New York: Outerbridge and Dienstfrey, 1971.

Dierick, Charles, and Pascal Lefèvre, eds. *Forging a New Medium: The Comic Strip in the Nineteenth Century.* 2nd ed. Brussels: VUB University Press, 2000.

Dowd, D. B., and Todd Hignite, eds. *The Rubber Frame: Essays in Culture and Comics.* St. Louis: Washington University in St. Louis, 2004.

Eisner, Will. *Comics and Sequential Art.* Tamarac, Fla.: Poorhouse, 1985.

Estren, Mark James. *A History of Underground Comics.* 1974. Berkeley: Ronin, 1987.

Feiffer, Jules. *The Great Comic Book Heroes.* New York: Dial, 1965.

Gifford, Denis. *The International Book of Comics.* New York: Crescent, 1984.

Goulart, Ron. *The Great Comic Book Artists.* New York: St. Martin's, 1986.

———. *Ron Goulart's Great History of Comic Books.* Chicago: Contemporary Books, 1986.

Groth, Gary, ed. *Misfit Lit: Contemporary Comic Art*, exh. cat. Seattle: Fantagraphics, 1991.

———, ed. Special Issue: The 100 Best Comics of the Century. *Comics Journal*, no. 210 (February 1999).

Harvey, Robert C. *The Art of the Comic Book: An Aesthetic History*. Studies in Popular Culture, ed. M. Thomas Inge. Jackson: University Press of Mississippi, 1996.

———. *The Art of the Funnies: An Aesthetic History*. Studies in Popular Culture, ed. M. Thomas Inge. Jackson: University Press of Mississippi, 1994.

———. *Children of The Yellow Kid: The Evolution of the American Comic Strip,* exh. cat. Seattle: Frye Art Museum and University of Washington Press, 1998.

Hatfield, Charles William. *Alternative Comics: An Emerging Literature*. Jackson: University Press of Mississippi, 2005.

Heer, Jeet, and Kent Worcester, eds. *Arguing Comics: Literary Masters on a Popular Medium*. Jackson: University Press of Mississippi, 2004.

Horn, Maurice, ed. *The World Encyclopedia of Comics*. New York: Chelsea House, 1976.

Inge, M. Thomas. *Comics as Culture*. Jackson: University Press of Mississippi, 1990.

Jones, Gerard. *Men of Tomorrow: Geeks, Gangsters, and the Birth of the Comic Book*. New York: Basic, 2004.

Kunzle, David. *The Early Comic Strip: Narrative Strips and Picture Stories in the European Broadsheet from c. 1450 to 1825*. Berkeley: University of California Press, 1973.

———. *The History of the Comic Strip: The Nineteenth Century*. Berkeley: University of California Press, 1990.

Kurtzman, Harvey. *From Aargh! to Zap! Harvey Kurtzman's Visual History of the Comics*. New York: Prentice Hall, 1991.

Magnussen, Anne, and Hans-Christian Christiansen, eds. *Comics and Culture: Analytic and Theoretical Approaches to Comics*. Copenhagen: Museum Tusculanum Press, 2000.

McGrath, Charles. "Not Funnies." *New York Times Magazine,* July 11, 2004, pp. 24–33, 46, 55–56.

Nyberg, Amy Kiste. *Seal of Approval: The History of the Comics Code*. Studies in Popular Culture, ed. M. Thomas Inge. Jackson: University Press of Mississippi, 1998.

Phelps, Donald. *Reading the Funnies: Essays on Comic Strips*. Seattle: Fantagraphics, 2001.

Raphael, Jordan, and Tom Spurgeon. *Stan Lee and the Rise and Fall of the American Comic Book*. Chicago: Chicago Review Press, 2003.

Robbins, Trina. *A Century of Women Cartoonists*. Northampton, Mass.: Kitchen Sink, 1993.

Robinson, Jerry. *The Comics: An Illustrated History of Comic Strip Art*. New York: G. P. Putnam's Sons, 1974.

Rosenkranz, Patrick. *Rebel Visions: The Underground Comix Revolution, 1963–1975*. Seattle: Fantagraphics, 2002.

Sabin, Roger. *Comics, Comix, and Graphic Novels*. London: Phaidon, 1996.

Walker, Brian. *The Comics After 1945*. New York: Harry N. Abrams, 2002.

———. *The Comics Before 1945*. New York: Harry N. Abrams, 2004.

Ware, Chris, ed. *McSweeney's Quarterly Concern*, no. 13 (2004).

Waugh, Coulton. *The Comics*. New York: Macmillan, 1947.

Wertham, Fredric, M.D. *Seduction of the Innocent*. New York: Rinehart, 1954.

Witek, Joseph Patrick. *Comic Books as History: The Narrative Art of Jack Jackson, Art Spiegelman, and Harvey Pekar*. Studies in Popular Culture, ed. M. Thomas Inge. Jackson: University Press of Mississippi, 1989.

Wright, Bradford W. *Comic Book Nation: The Transformation of Youth Culture in America*. Baltimore: Johns Hopkins University Press, 2001.

Ivan Brunetti
Collected Works

Haw! Seattle: Fantagraphics, 2001.
Hee! Seattle: Fantagraphics, 2005.
Schizo, nos. 1–4. Seattle: Fantagraphics, 1995–2006.

Interviews and Further Reading

Groth, Gary. "The Ivan Brunetti Interview." *Comics Journal,* no. 264 (November 2004): 134–182.

Charles Burns
Collected Works

Big Baby. Seattle: Fantagraphics, 1999.
Black Hole. New York: Pantheon, 2005.
El Borbah. Seattle: Fantagraphics, 1999.
Close Your Eyes. Marseille: Le Dernier Cri, 2001.
Skin Deep. Seattle: Fantagraphics, 2001.

Interviews and Further Reading

Coleman, Les. "Charles Burns: Big Baby in Curse of the Molemen." *Escape,* no. 8 (1986): 41.
Raney, Vanessa. "Review of Charles Burns' *Black Hole*." *ImageText* 2, no. 1 (Summer 2005).
 www.english.ufl.edu/imagetext/archives/v2_1/reviews/raney.shtml.
Sullivan, Darcy. "Charles Burns." *Comics Journal,* no. 148 (February 1992): 52–88.

Daniel Clowes
Collected Works

Caricature. Seattle: Fantagraphics, 1998.
David Boring. New York: Pantheon, 2000.
Ghost World. Seattle: Fantagraphics, 1997.
Ice Haven. New York: Pantheon, 2005.
Like a Velvet Glove Cast in Iron. Seattle: Fantagraphics, 1993.
The Manly World of Lloyd Llewellyn: A Golden Treasury of His Complete Works. Seattle: Fantagraphics, 1994.
Pussey! Seattle: Fantagraphics, 1995.
Twentieth Century Eightball. Seattle: Fantagraphics, 2002.

Interviews and Further Reading

Gehr, Richard. "Clowes Encounter: The Bleak World of *David Boring.*" *Village Voice Literary Supplement,* September 2000.

Glenn, Joshua. "An Interview with Daniel Clowes: He Loves You Tenderly." *Hermenaut,* no. 15 (Summer 1999): 92–101.

Groth, Gary. "Daniel Clowes Revealed!" *Comics Journal,* no. 154 (November 1992): 46–92.

Parille, Ken. "A Re-Reader's Guide to *David Boring.*" *Comic Art,* no. 7 (Winter 2005): 68–76.

Raeburn, Daniel. "The Fallen World of Daniel Clowes." *Imp,* no. 1 (1997): 2–28.

Silvie, Matt. "The *Velvet Gloves* Are Off: A *Boring* Interview with *Ghost World*'s Daniel Clowes." *Comics Journal,* no. 233 (May 2001): 52–77.

Sullivan, Darcy. "Back to the Drawing Board: How Dan Clowes Creates His Worlds on Paper." *Comics Journal,* no. 250 (February 2003): 163–173.

Robert Crumb
Collected Works

The Complete Crumb Comics, vols. 1–17. Seattle: Fantagraphics, 1987–2005.

R. Crumb Sketchbook, vols. 1–10. Seattle: Fantagraphics, 1992–2005.

Waiting for Food: Restaurant Placemat Drawings. Amsterdam: Oog and Blik, 1996.

Waiting for Food Number 2: More Restaurant Placemat Drawings. Amsterdam: Oog and Blik, 2002.

Waiting for Food Number 3: More Restaurant Placemat Drawings. Montreal: Drawn and Quarterly, 2004.

Interviews and Further Reading

Beauchamp, Monte, ed. *The Life and Times of R. Crumb.* Northampton, Mass.: Kitchen Sink, 1998.

Crumb, Robert. *Your Vigor for Life Appalls Me: Robert Crumb Letters, 1958–1977.* Ed. Ilse Thompson. Seattle: Fantagraphics, 1998.

Crumb, Robert, and Peter Poplaski. *The R. Crumb Handbook.* London: MQ, 2005.

Fischer, Alfred M., ed. *Robert Crumb: Yeah, But Is It Art?* exh. cat. Cologne: Museum Ludwig, 2004.

George, Milo, ed. *The Comics Journal Library,* vol. 3, *R. Crumb.* Seattle: Fantagraphics, 2004.

Holm, D. K., ed. *R. Crumb Conversations.* Conversations with Comic Artists, ed. M. Thomas Inge. Jackson: University Press of Mississippi, 2004.

Mercier, Jean-Pierre, ed. *Who's Afraid of Robert Crumb?* exh. cat. Angoulême, France: Centre National de la bande dessinée et de l'image, 2000.

Jaime Hernandez
Collected Works

Dicks and Deedees. Love and Rockets, book 20. Seattle: Fantagraphics, 2003.

Flies on the Ceiling. Love and Rockets, book 9. Seattle: Fantagraphics, 1991.

Ghost of Hoppers. Love and Rockets, book 22. Seattle: Fantagraphics, 2006.

Hernandez Satyricon. Love and Rockets, book 15. With Gilbert Hernandez. Seattle: Fantagraphics, 1997.

Locas: The Maggie and Hopey Stories. Seattle: Fantagraphics, 2004.

Locas in Love. Love and Rockets, book 18. Seattle: Fantagraphics, 2000.

Love and Rockets, Sketchbook One. With Gilbert Hernandez. Seattle: Fantagraphics, 1989.

Love and Rockets, Sketchbook Two. With Gilbert Hernandez. Seattle: Fantagraphics, 1992.

Music for Mechanics. Love and Rockets, book 1. With Gilbert Hernandez. Seattle: Fantagraphics, 1989.

Whoa Nellie! Love and Rockets, book 16. Seattle: Fantagraphics, 2000.

Interviews and Further Reading

Frauenfelder, Mark. "In Depth: The Jaime Hernandez Interview." *Graphic Novel Review,* 2004. www.graphicnovelreview.com/issue2/jhernandez_interview.php.

Gaiman, Neil. "The Hernandez Brothers Interview." *Comics Journal,* no. 178 (July 1995): 91–123.

Groth, Gary, Robert Fiore, and Thom Powers. "Pleased to Meet Them: The Hernandez Bros. Interview." *Comics Journal,* no. 126 (January 1989): 60–113.

Hignite, Todd. "Jaime Hernandez's 'Locas.'" In *The Rubber Frame: Essays in Culture and Comics,* pp. 46–59. St. Louis: Washington University in St. Louis, 2004.

Knowles, Chris. "The Mechanic of Love: Jaime Hernandez Talks About Life with Maggie and Hopey." *Comic Book Artist,* no. 15 (November 2001): 56–64.

Nichols, Natalie. "Viva Locas!" *Los Angeles City Beat* 2, no. 51 (December 16–22, 2004): 16–20.

Sullivan, Darcy. "Back to the Drawing Board: 'I'm Drawing What I Want to Draw . . . ' How Jaime Hernandez Creates His World Class Cartooning." *Comics Journal,* no. 150 (May 1992): 60–65.

Gary Panter
Collected Works

100.1 Drawings by Gary Panter. Brooklyn: Plywood, 2004.

Cola Madnes. New York: Funny Garbage, 2000.

Dal Tokyo. Paris: Sketch Studio, 1992.

Invasion of the Elvis Zombies. New York: Raw Books and Graphics, 1984.

Jimbo: Adventures in Paradise. New York: Pantheon, 1988.

Jimbo: Raw One-Shot #1. New York: Raw Books and Graphics, 1982.

Jimbo in Purgatory. Seattle: Fantagraphics, 2004.

Jimbo's Inferno. Seattle: Fantagraphics, 2006.

Satiroplastic: The Sketchbook of Gary Panter. Montreal: Drawn and Quarterly, 2005.

Interviews and Further Reading

Epstein, Daniel Roberts. "Gary Panter." *SuicideGirls.* suicidegirls.com/words/Gary+Panter+-+Jimbo+in+Purgatory/.

Heer, Jeet. "Gary Panter's *Jimbo in Purgatory*." *National Post,* September 4, 2004. Archived at www.jeetheer.com/comics/panter.htm.

Heller, Steven. "Quiet Chaos." *Metropolis Magazine*, April 2001. www.metropolismag.com/html/
 content_0401/heller/.
Kelly, John. "Gary Panter Interview." *Comics Journal*, no. 250 (February 2003): 206–244.
Temple, Kevin. "Gary Panter." *Now*, May 19–25, 2005. www.nowtoronto.com/issues/2005-05-19/
 cover_story.php.

Seth
Collected Works

Bannock, Beans, and Black Tea. With John Gallant. Montreal: Drawn and Quarterly, 2004.
Clyde Fans Book One. Montreal: Drawn and Quarterly, 2004.
It's a Good Life if You Don't Weaken. Montreal: Drawn and Quarterly, 1996.
Vernacular Drawings: Sketchbooks of the Cartoonist Seth. Montreal: Drawn and Quarterly, 2001.
Wimbledon Green. Montreal: Drawn and Quarterly, 2005.

Interviews and Further Reading

Epstein, Daniel Roberts. "*Palookaville–Clyde Fans* Creator Seth." *SuicideGirls*. suicidegirls.com/
 words/Palookaville+-+Clyde+Fans+creator+Seth/.
Groth, Gary. "Seth." *Comics Journal*, no. 193 (February 1997): 58–93.
Heer, Jeet. "Seth and Nostalgia." *National Post*, February 16, 2002. Archived at www.jeetheer.
 com/comics/seth.htm.
Miller, Bryan. "An Interview with Seth." *Bookslut*, June 2004. www.bookslut.com/features/2004_
 06_002650.php.
Portis, Ben. "Shadow Lands." *Present Tense: Contemporary Project Series*, no. 31, exh. brochure.
 Art Gallery of Ontario, 2005.
Raeburn, Daniel. "Fashionably Late: The Vintage World of Seth." *Village Voice Literary Supple-
 ment*, October 1999.

Art Spiegelman
Collected Works

Breakdowns: From Maus to Now, An Anthology of Strips. New York: Belier Press and Nostalgia
 Press, 1977.
Comix, Essays, Graphics, and Scraps (From Maus to Now to Maus to Now). [Florence]: Sellerio
 Editore-La Centrale dell'Arte, 1998.
In the Shadow of No Towers. New York: Pantheon, 2004.
Jack Cole and Plastic Man: Forms Stretched to Their Limits. With Chip Kidd. San Francisco: Chroni-
 cle, 2001.
Maus: A Survivor's Tale, vol. 1, *My Father Bleeds History*. New York: Pantheon, 1986.
Maus: A Survivor's Tale, vol. 2, *And Here My Troubles Began*. New York: Pantheon, 1991.
"*The Wild Party*": *The Lost Classic by Joseph Moncure March*. Drawings by Art Spiegelman. New
 York: Pantheon, 1994.

Interviews and Further Reading

Geis, Deborah R., ed. *Considering "Maus": Approaches to Art Spiegelman's "Survivor's Tale" of the Holocaust.* Tuscaloosa: University of Alabama Press, 2003.

Groth, Gary. "The Art Spiegelman Interview." *Comics Journal,* no. 180 (September 1995): 52–106.

———. "Art Spiegelman, Part II." *Comics Journal,* no. 181 (October 1995): 97–139.

Juno, Andrea. "The Very Briefest Taste of a Part of the Early History of Comics." In *Dangerous Drawings: Interviews with Comix and Graphix Artists,* 6–31. New York: Juno, 1997.

Kartalopoulos, Bill, ed. *Indy Magazine,* Winter 2005. www.indyworld.com/indy/index.html.

Spiegelman, Art, and Dore Ashton. "The Debate over Popular and Museum Culture: Dore Ashton and Art Spiegelman Visit 'High and Low' at the MoMA." *Art International* (Paris), Spring–Summer 1991, pp. 60–64.

Chris Ware
Collected Works

The Acme Novelty Date Book. Montreal: Drawn and Quarterly; Amsterdam: Oog and Blik, 2003.

The Acme Novelty Library. New York: Pantheon, 2005.

The Acme Novelty Library, no. 16. Chicago: Acme Novelty Library, 2005.

Jimmy Corrigan, the Smartest Kid on Earth. New York: Pantheon, 2000.

Quimby the Mouse. Seattle: Fantagraphics, 2003.

Interviews and Further Reading

Eggers, Dave. "After Wham! Pow! Shazam!" *New York Times Book Review,* November 26, 2000, pp. 10–11.

Groth, Gary. "Understanding (Chris Ware's) Comics." *Comics Journal,* no. 200 (1997): 119–178.

Juno, Andrea. "Chris Ware." In *Dangerous Drawings: Interviews with Comix and Graphix Artists,* 32–53. New York: Juno Books, 1997.

Kidd, Chip. "Please Don't Hate Him." *Print,* no. 51.3 (1997): 42–50.

Raeburn, Daniel. "The Smartest Cartoonist on Earth." *Imp,* no. 3 (1999): 1–20.

———. *Chris Ware.* New Haven: Yale University Press, 2004.

Index of Names